150 CLASSIC CAMERAS

Paul-Henry van Hasbroeck

150 Classic Cameras

From 1839 to the present

Sotheby's Publications

Text and photographs © Paul-Henry van Hasbroeck 1989

First published 1989 for Sotheby's Publications
by Philip Wilson Publishers Ltd
26 Litchfield Street
London WC2H 9NJ

Distributed in the USA by Harper & Row, Publishers, Inc.
10 East 53rd Street, New York NY 10022

British Library Cataloguing in Publication Data
Hasbroeck, Paul-Henry van
 150 classic cameras: 1839–1989
 1. Cameras, to 1989
 I. Title
 771.3

ISBN 0 85667 363 3
LC 89-060469

Designed by Alan Bartram
Colour Photographs by Colin Glanfield and Matthew Ward,
assisted by Stephen Dobson

Typeset by Modern Text, Southend-on-Sea, Essex
Printed by BAS Printers Ltd., Over Wallop, Hants
Bound by Dorstel Press Ltd., Harlow

Contents

The Cameras

Colour Illustrations

between pages 24 and 25

Acknowledgements

However short this small history of camera development may seem, it could not have been achieved without the assistance of many kind and helpful people. Firstly, I am extremely grateful to Philip Wilson and Anne Jackson, whose immediate interest in the initial outline was most encouraging. To the editor, Antony Wood, with whom I spent many enjoyable afternoons, my deepest thanks for shaping the text in its final form. To Jane Bennett, whose endless energy has helped smooth out the innumerable problems that arise with a new book, I am very grateful.

To Colin Glanfield, who never faltered in his assistance and enthusiasm to the extent that he sacrificed most of Christmas 1988 to read the text, I am extremely grateful. Many of his comments were taken into account, and, needless to say, all errors, inaccuracies and omissions are of my own creation. To Marja Petts, who must have typed the text many times over, my sincere thanks.

I have a special debt of thanks to my late father, whose enthusiasm and encouragement was so vital in the early days of the creation of this book. My mother succeeded him in this role and my thanks go to her.

Finally, my gratitude to my wife Sally, whose perseverance in keeping me busy writing many an evening was essential to this project. She unselfishly abandoned the festive activities of 1988 and many of her comments were of great assistance.

In memory of my late father
ROBERT-HUBERT VAN HASBROECK

Introduction

When the Daguerreotype process was made public in 1839, demand for its typical product, the small portrait, exploded. Photographic 'apparatus' became commercially available almost immediately. Within the next decade manufacturers all over the world had responded to insatiable demands for photographic equipment and supplies. Daguerre profited handsomely. Over the next few years, each new development in chemistry or optics met with a new camera. Later in the century men such as George Eastman were to build empires that stretched across the world.

It is difficult for generations reared on newspapers, the cinema and television to imagine the enormous impact made by photography in its early days. To record the memorable moment seems always to have been a deep human desire, and the taking of the visual record, hitherto the province of the gifted few, artists of brush and pen, had now passed within the gift of anyone who could afford it. Within a few decades, the necessary equipment would be part of everyday life for ordinary people.

The first photographic apparatus, however, was expensive and virtually impossible to operate for anyone not knowledgeable in both optics and chemistry. The cameras of the first twenty years or so of photography consisted of two boxes, one sliding within the other. In the field these cameras were inconveniently heavy, and much further equipment was needed for processing. In 1840 the Paris optician Charles Chevalier produced 'Le Grand Photographe', a camera of reduced size when collapsed; it also had the first combination lens, of which an interchangeable element was used for either landscapes or portraits. This development was not taken up by many photographers in the 1840s, but Thomas Ottewill resurrected the idea in 1853. He produced a folding camera of double box construction; both sides were hinged and collapsed when the front and back panels were removed. This type of camera came to be much used by landscape photographers as it had solved the size problem but, being made all of wood, it was still too heavy to be easily carried around.

Stage by stage, movements were introduced into the construction of cameras. The earliest of these was that for raising the lens panel in 1850, essential for architectural photography; the swinging back movement appeared at the end of the 1860s. About this time, too, bellows cameras were developed; lightweight and portable, they solved the chief difficulty so far encountered with wooden folding cameras such as Ottewill's, although they met with some initial resistance from photographers as they were not particularly rigid and light-tightness was not always assured. The flexible bellows camera allowed greater movement than the sliding box, and could be used for close-up photography by the addition of an extension to the bellows.

Until the 1880s sensitised plates were so slow that long exposures were required, hence there was no need for a shutter other than a lens cap. Cameras possessed neither rangefinder nor viewfinder, all focusing adjustments being made through the ground glass viewing screen. The introduction of relatively fast dry plates in the late 1870s led to great changes in camera design. After 1880 most cameras became hand-held with built-in shutters; they often had magazines or cut film changing mechanisms to bring forward each plate or film for successive exposures. But these systems were prone to jamming, and it was only from 1888 onwards, with the appearance of Eastman's first Kodak, using roll film, that hand-held cameras became popular. Simple and reliable, the popular and epoch-making Kodak was pre-loaded and did not require a dark room. Eastman started the photofinishing industry, Kodak loading and unloading the camera and processing the film. Popular snapshot photography came about with the appearance of folding roll film cameras in 1890, and entered its modern era in 1925 with the appearance of the Leica.

Throughout the 1880s and '90s, a passion for detective cameras gathered momentum. Small cameras were concealed in spy glasses, binoculars, canes, handbags, watches and pens; they prepared the market for the serious miniature cameras that were to follow in the 1920s.

Viewfinders were developed in the late 1880s, ultimately to be combined with the camera itself in the single lens reflex. Slowly metal began to replace wood in the construction of cameras. The advent of colour photography towards the end of the century brought about cameras that produced tri-coloured images later to be superseded by colour emulsion technology.

In the twentieth century the trend has once again been towards small cameras with smaller negatives, with sensitised materials becoming more and more refined. A major breakthrough came in 1913 with the first camera using 35mm film. In 1925 the Leica was born, and many other 35mm innovations followed. The year 1928 saw the first interchangeable lens 35mm camera, 1932 the first interchangeable lens camera with coupled rangefinder, 1937 the 35mm single lens reflex, and 1948 the pentaprism reflex. Another major breakthrough in sensitised material came in the 1950s with Dr Edwin Land's discovery of the instant image process, later named 'polaroid'.

It is not the aim of this book to cover all aspects of the history of camera development, but only to highlight the most interesting of them. All the cameras selected have played either a significant or a major role in the development of the photographic art or craft, or responded to new market demands or new production technologies. Some were historical or technical landmarks, others set trends or their production was made possible by a development in some other field. For example, the 1963 Kodak Instamatic with its drop-in foolproof cassette was made possible by advances in the precision moulding of plastics. Certain cameras were produced to meet a particular need, such as the demand for a miniature high-quality camera for spies, which led to the Minox, produced in 1938 in Latvia.

All hundred and fifty cameras shown in this book may still be used. The old bellows cameras may not be light-proof but they can still be repaired, and the 1925 Leica, if well serviced, will perform just as well as its 1985 descendant. One of the criteria of selection, and a most important one, is that the chosen cameras have no built-in obsolescence. This explains why the electronic gadget cameras of the late 1970s and '80s have not been included. Whatever their initial price, manufacturers themselves can no longer repair them after a few years. Massive output, low prices and built-in obsolescence are the key marks of today's cameras, with the exception of a handful of manufacturers with long pedigrees, such as Leitz, Hasselblad and Rolleiflex.

The cameras included come from a variety of countries: France, England, Japan, Germany, the United States, the Soviet Union, Czechoslovakia, China, Switzerland, Italy, Hungary and Belgium. They illustrate the intermingling and cross-fertilisation of ideas that have occurred all over the world. Together they represent a fascinating display of manufacturers' ingenuity in responding to both specialised and popular demand. France, England and Germany were most certainly the pioneers, and America led the field until World War I. The inter-war years were dominated by Germany, and post-war Japan has taken the lead in producing vast quantities. The average number of cameras per household has now reached an impressive level as cameras have become cheaper than ever.

This book is addressed not only to collectors, professional photographers and keen amateurs, but also to any non-expert with a historical interest in cameras. The terminology has therefore been kept basic, and a glossary and chronology are provided.

The Birth of Photography

On either side of the English Channel, two very similar kinds of men, Joseph Nicéphore Niepce and William Henry Fox Talbot, both country squires, accidentally and each quite independently of the other, stumbled upon the essential prerequisites for photography. Yet they both missed leading opportunities, and it was to be another Frenchman, Louis-Jacques-Mandé Daguerre, who would reap the full advantages and honours resulting from the discovery of photography.

One vital principle of photography, the 'pinhole effect', the ability of light passing through a tiny hole in the wall of a darkened room to produce an inverted image on the opposite wall, had been known for centuries. Leonardo da Vinci describes one such *camera obscura,* and later in the sixteenth century optical lenses were used to increase the brightness and sharpness of the projected image. By the early nineteenth century, three different kinds of camera obscura were in use, mainly for drawing outlines and sketching. The first was a darkened room with a lens and mirror in the roof producing an image on a table inside the room. The second was a similar arrangement with a portable tent. The third and simplest was that of a box camera producing an image on translucent paper, and it was with this that pioneers such as Niepce, Daguerre and Fox Talbot worked.

The Daguerreotype process

Photography begins with Joseph Nicéphore Niepce (1765-1833). This son of a Burgundian lawyer had first been destined for holy orders, but the revolution made him into an army officer. He eventually retired to his properties near Lyon. A widely cultured man, he continued his investigations into the possibilities of photography in the spare time left to him after his duties as a landowner. From his letters to his brother Claude (ninety-three of which are conserved in the Museum of Photography at Châlon-sur-Saône) we learn that as early as 1816 Niepce was able to fix images on pieces of paper impregnated in silver chloride with the help of nitric acid, and exposed to light in a camera obscura.

The testimony of Niepce's son is also clear in its assertions. Between 1816 and 1821 Niepce obtained faint photographs not only on paper but also on glass and pieces of copper which he had prepared with bitumen of Judaea dissolved in animal oil; this became known as the heliographic process, depending on the fact that exposure to light hardens a film of bitumen and renders it insoluble in light petroleum.

The process was used by Niepce in the following way. The essential oil of lavender was added to pulverised bitumen of Judaea and gently warmed until the essential oil was saturated with the colouring matter of the bitumen. A small quantity of this varnish was applied cold to a highly polished tablet of pewter. The plate was then placed upon a hot iron to expel all traces of moisture. Prepared in this way, the plate could be exposed to light in a camera for many hours. Alternatively, it could be exposed under an engraving which had been treated with oil so as to make the paper transparent. Light, where it struck the bitumen varnish, rendered it insoluble in light petroleum. The exposed plate was therefore washed with a solution made of one part of essential oil of lavender and ten parts of light petroleum. This treatment revealed the image. The bare metal might then be darkened by treatment with iodine vapour. The result was a positive picture with the bitumen representing the light parts and the bare metal representing the dark parts of the subject. Niepce visited England in 1827 and presented two heliographs of engravings to Francis Bauer, Secretary of the Royal Society; these are now part of the Royal Photographic Society Collection on display at the Science Museum, London. Niepce experimented with silver copper plates, subjecting them to iodine vapours, but could not overcome the problems of inordinately long exposure and faint and fading image.

Around 1826 Nicéphore Niepce commissioned his cousin and neighbour, a Colonel Niepce, to go to Paris to buy a camera obscura from the famous opticians Vincent and Charles Chevalier, also entrusting a couple of heliographs to him. Whilst purchasing the camera obscura from the Chevaliers' shop, Colonel Niepce showed the owners the heliographs. Astonished by the impact the heliographs made upon the Chevaliers, the Colonel proceeded to tell them of his cousin's discovery. The two opticians were flabbergasted.

Around that time a frequent customer of the Chevaliers was none other than Daguerre, who was always buying lenses for his camera obscuras and asking many questions about cameras in general. Daguerre had also told the Chevaliers of his photographic experiments, but had never shown or told them of any positive results. Through the Chevaliers Daguerre eventually obtained Niepce's address and in 1826 wrote to him to obtain further details of his experiments. Louis-Jacques-Mandé Daguerre was a totally different man from Niepce. Born in 1789 at Cormeilles en Parisis, he was almost a Parisian. He became a painter of note, and his decoration of part of the Paris Opéra enhanced his reputation. However, it was the Diorama that made him famous: a long building filled with gigantic views of Paris and other areas of France. The Diorama ran to packed audiences and was a source of considerable income for Daguerre. Like many artists of his period, he made extensive use of the camera obscura for his drawings and for the paintings that would sometimes find their way to the Diorama.

Niepce answered Daguerre courteously but was rather suspicious of his correspondent's curiosity and gave little information away. In 1827 Daguerre wrote again to Niepce, this time requesting a heliograph. Niepce refused to send him one. However, when Daguerre sent Niepce a small painting Niepce relented, and in the summer of 1827 he sent Daguerre one of his heliographs.

In September 1827 Niepce made his way to England to visit his dying brother at Kew. Stopping in Paris on the way, Niepce, in the company of Daguerre, visited the Diorama. The two had many conversations, Niepce being thrilled by the Diorama.

In England, Niepce sent a memo to the Royal Society outlining his research in heliography, but the Society did not respond with encouragement. Returning to France in 1828 after the death of his brother, Niepce began to feel old. He was also much preoccupied by financial matters. This made him decide to launch his discovery in collaboration with a younger man – he chose Daguerre. The agreement of 14 December 1829 recognises the invention as that of Niepce and describes it as 'a new method of fixing the views of Nature without using a draughtsman'. The operating method was as follows. A piece of highly polished silver copper was covered with a coating of bitumen of Judaea. The copper plate was then exposed to the light and the parts of the coating touched by light became soluble proportionally to the exposure received. Oil of lavender or later oil of petroleum was used to process the plate which was then washed in warm water.

From the time the contract was signed to Niepce's death on 5 July 1833 very little progress seems to have been achieved, although Niepce was thought to have been secretly experimenting with colour. Exposure was still very long, sometimes twenty minutes. Later plates of iodes were sensitised in a mercury box and the metallic vapour would affect the parts of the plates touched by light. On Niepce's death his son Isidore became Daguerre's legal partner. In 1835 Daguerre insisted on a modification of the contract which reduced the importance of Niepce, and in 1837 a further modification dispensed with the name Niepce altogether and the invention was renamed 'Daguerreotypie'.

In 1838 Daguerre launched a public subscription but this failed, although many

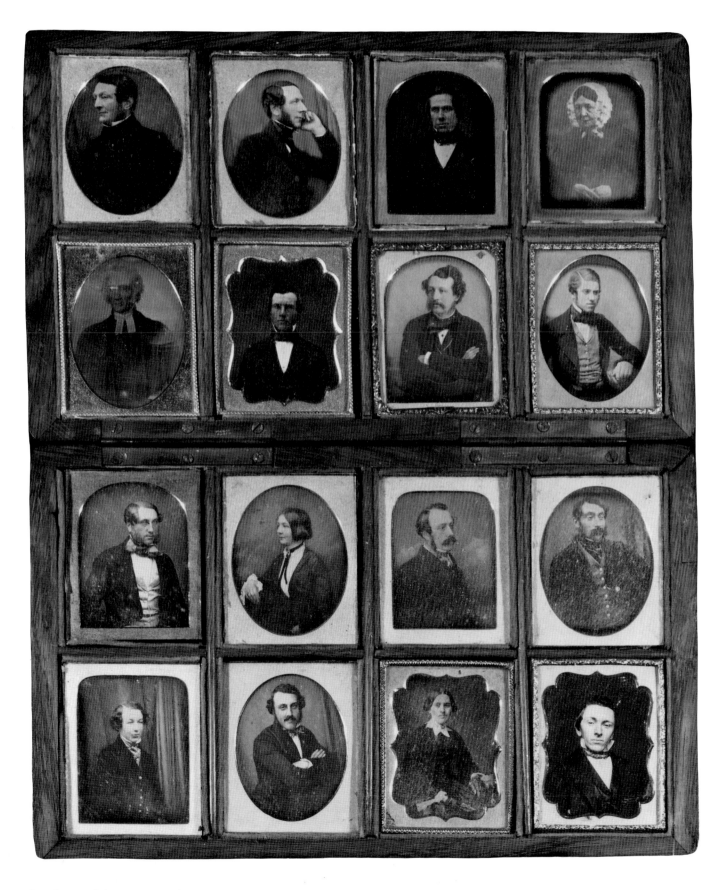

Sample case of sixteen quarter-plate
daguerreotype portraits, *c.*1845. This extremely
unusual case would have been used by a
photographer to illustrate possible poses.

scientists were interested. England offered £10,000 for the secret of his process plus £1,000 per annum for life. Isidore Niepce was keen to accept but the French Academy of Science was also interested. The most famous scientists of the age, Humboldt, Biot and Arago, visited Daguerre in his studio and examined his various views of Paris taken by his process. On 7 January 1839 Arago spoke to the Academy of the invention. Daguerre and Isidore Niepce were looking for 200,000 francs. The French government asked Arago to enter into negotiations on their behalf with the two owners of the Daguerreotype process. On 3 March 1839 the accidental burning down of the Diorama left Daguerre virtually bankrupt and keener than ever to sell the process. In June 1839 the French Parliament voted that an annual life pension of 6,000 francs should be awarded to Daguerre and one of 4,000 francs to Niepce. On 19 August at the Academy of Science Daguerre made public his process for fixing images. The Daguerre process produced direct positives on metal, but unlike Niepce's process it used silver salts. The process as described by Daguerre was as follows:

1. A thin sheet of silver-plated copper was polished.
2. The plate was sensitised by being exposed to iodine vapours.
3. The plate was exposed.
4. The image was developed through vapours of mercury.
5. The plate was fixed by washing in a saline solution.

During the next two years four small but not negligible improvements were made to Daguerre's process. Sir John Herschel, the celebrated astronomer, replaced the common salt solution by sodium thiosulphate, later commonly known as 'hypo'. In 1840 John Frederick Goddard increased the speed of the plates by using bromine vapour as well as iodine vapour in the sensitising step of the process. Fizeau also improved the process in 1840 by suggesting gold-toning of the image by treating the finished daguerreotype with a solution of gold chloride. This served to strengthen the faint image and make it less likely to tarnish. In 1841 Claudet, by then a noted daguerreotypist, published a sensitising process using chlorine and iodine. From 1841 the daguerreotype process remained essentially the same throughout its use.

Daguerre's minimising of the importance of Niepce in the invention of photography was evident to the French scientific community, but did not affect Daguerre's relationship with the public. Within the space of a few weeks he became a great man; messages of esteem from all over the world were sent to him, but the scientific community was still not taken in by him. This was even more the case in England, as Francis Bauer of the Royal Society had met Nicéphore Niepce during his visit to England and had examined some of his work. In 1839, to further his cause, Daguerre published the *Historique et description des procédés du Daguerréotype et du Diorama,* consisting of seventy-six pages of confused attempts to refute his many critics. Isidore Niepce realised he had been duped, and in 1841 published the *Historique de la découverte improprement nommée 'Daguerréotypie'.*

But daguerreotype mania had overtaken the world and nothing could stop it. Daguerre died on 10 July 1851 world-famous and rich. It was only in 1867 that Victor Foque published *La Vérité sur l'invention de la photographie: Nicéphore Niepce, sa vie, ses essais, ses travaux.*

The Calotype process

On the other side of the Channel, in September 1840, William Henry Fox Talbot (1800-77) discovered that briefly exposing photogenic drawing paper to light produced a latent image which could be developed with gallic acid. The process was at first called 'calotype' and was later known as 'talbotype'. It was patented by William Henry Fox Talbot in 1841. The process was as follows. Writing paper was washed with silver nitrate solution on one side only, and dried. It was then placed in a solution of potassium iodide for a few minutes. After a brief washing with water the paper was again dried. The iodised paper could be kept for any length of time if not exposed to light. When the paper was required for use it was treated with a freshly prepared solution of silver nitrate, gallic acid and acetic acid, then lightly dried with blotting paper. The sensitised paper so prepared was best used within a few hours; an exposure of a minute at about f8 was sufficient in bright sunlight. The image was brought out on the paper by washing it once more with gallo-nitrate of silver, and the negatives were then washed with water and fixed with solutions of potassium bromide or sodium thiosulphate. Positives were made from the negatives by the photogenic drawing process.

The photogenic drawing process, the first to give fixed negatives, had been used by Fox Talbot as early as 1834, and until he discovered a means of developing the latent image in September 1840. The process was as follows. Good quality drawing paper was dipped into a weak solution of common salt and wiped dry. A solution of silver nitrate was then applied to one surface only and the paper dried in front of a fire, after which it could be exposed in a camera; a negative image would be obtained after 30 to 90 minutes. The image could be fixed with a saturated solution of common salt. Later, other fixatives such as strong solutions of potassium bromide, potassium iodide or sodium thiosulphate were used. Some time between 1835 and 1839 Talbot began to make positives by placing the negative in contact with a second sensitised piece of paper and exposing the new sheet to light transmitted by the negative, which was sometimes oiled to make it more transparent.

The calotype was virtually the only negative/positive process in use before the wet collodion process invented by Frederick Scott-Archer, using glass negative plates, in 1851. But Fox Talbot did not achieve full commercial exploitation of his method, and his work did not lead to specially designed cameras, as had the Niepce-Daguerre technique. Although patented amateurs were allowed to use the process from the mid-1840s, full practical details were not widely publicised, and before the days of photographic journals and societies it was difficult for an interested person to find such basic information as the type of paper best suited for the process or the amount of washing required to remove the fixative, without lengthy experiment. Another obstacle hindering the widespread use of the process was the fading of the results, which happened to even the best calotypists. When prints were first produced they were reddish-brown, but within a few months many would show no more than a faint image.

150 Classic Cameras

The Daguerreotype, Calotype and Collodion Era

1839 onwards

Once the Daguerreotype process had been made public at the Académie des Sciences, many experiments began. The optician Charles Chevalier copied some of the cameras exhibited at the Academy. Another optician, Nicolas Lerebours, went to Italy and took some magnificent daguerreotypes of Italian towns and historic buildings.

The main problem of daguerreotypes was the long exposure required. In the case of landscapes or towns this did not prove too great a problem; people walking across the photographed view would merely appear as streaks. In the case of portraits a 15 or 20 second exposure proved difficult. Eyelashes would be blurred and the sitter would take on a tense, ferocious look. A special stand with a neck hold was developed to assist in immobilising the head but nothing could be done for the facial expressions.

The cameras recommended by Daguerre were sold with a seal; they were manufactured and sold by Alphonse Giroux & Cie, 7 rue du Coq Saint-Honoré, Paris. The contract between Daguerre and Niepce on the one hand and Giroux – who was a relative of Giroux's wife – on the other was signed on 22 June 1839. The Giroux camera covered the format 164 × 216mm, which was later known as whole plate. The camera and all the processing equipment cost some 400 francs and weighed nearly 50 kilos. To Charles Chevalier the fact that he had not been awarded the construction of the first ever commercially produced camera was a great blow, and especially so as it was through him that Niepce had originally met Daguerre. The 37cm f15 achromatic lens, however, is attributed to Chevalier. The lens has a swinging lens cap as a shutter. The camera bore a seal with the maker's name and the signature of Daguerre.

In August 1839 Alphonse Giroux & Cie also published Daguerre's instruction manual, the *Historique et description des procédés du Daguerréotype et du Diorama*.

The Giroux camera certainly showed improvement on the earlier cameras developed by Niepce and Daguerre for their experiments. Focusing was achieved on a ground glass screen by the sliding box principle, an adaptation of the early camera obscuras. A 45° mirror reversed the image.

Charles Chevalier lost little time in designing his own camera. Less than a year later he introduced the 'Grand Photographe'. It is incredible that barely a year after the daguerreotype process had been announced, camera design had already reached the second major stage of its development. The Grand Photographe was not only of a revolutionary design in that it was collapsible for ease of transport. It also had the world's first combination lens, Chevalier's own 'Photographe à verres combinés'. The camera was for the whole plate format, as had been the Giroux. When the lens panel and focusing screen or slide were removed, the hinged side collapsed. Chevalier's basic design was much imitated. In the 1850s Hornes' improved folding cameras were intended primarily for use with paper or glass: these cameras were merely adaptations of Chevalier's design. The 1853 Ottewills, sliding box folding cameras, although for wet collodion, were also very close in design to Chevalier's camera. In 1840 Charles Chevalier published his *Nouvelles Instructions sur l'usage du daguerréotype. Description d'un Nouveau Photographe*.

In 1851 Frederick Scott-Archer introduced wet collodion. The wet collodion process consisted of the following steps. Collodion, made by dissolving gun-cotton in ether containing a little alcohol, was iodised by being treated with a saturated solution of potassium iodide in alcohol. The iodised solution was then poured onto a glass plate and the excess removed by tilting the plate. Once an even coating had been obtained, the plate was sensitised by dipping it into a silver nitrate solution. After one or two minutes the plate was removed from the sensitising solution and, while still wet, placed in the dark slide of a camera and

Albumen print (16 × 20cm) by Louis Ghemar of Nadar's balloon the *Géant* arriving in Brussels on 26 September 1864 at the invitation of King Leopold I of Belgium. The crowd was so huge that barriers had to be erected, and such barriers are to this day called Nadars.

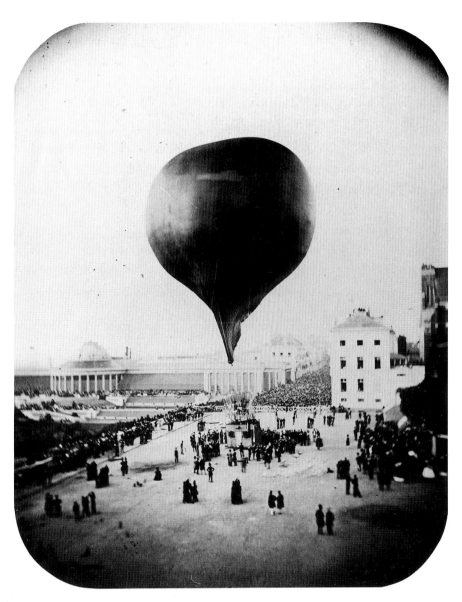

exposed. Immediately after exposure the plate was developed with pyrogallic acid solution or ferrous sulphate solution. The developed plate was fixed either with sodium thiosulphate or potassium cyanide solution. The wet plate process detail of the image was nearly as great as that obtained with the daguerreotype process. By the early 1860s wet collodion had all but replaced the daguerreotype process in Europe. In the United Kingdom according to the 1851 census there were 51 photographers, and by 1861 the number had grown to 2,534, the majority of whom would have gone over to wet collodion.

In the Frederick Scott-Archer process the glass plates were sensitised and had to be exposed whilst still wet, hence the term 'wet collodion'. It was essential for the wet collodion coating not to be dry when the plate was exposed. As the plate started to dry, formations of silver nitrate crystals would appear on it and eventually render it unusable. This was the main disadvantage of this process and, further, the exposed plate had to be processed as soon as possible. Photographers required a dark room, hence the dark room wagons and tents as used by Fenton in the Crimean War. As Frederick Scott-Archer did not patent his discovery the use of it spread rapidly.

The most usual method of obtaining prints on paper from wet collodion glass negatives was by the albumen process. Paper which had been treated with white

of egg (albumen) could be purchased. This paper was immersed in a solution of common salt for a few minutes, dried, and then sensitised by floating the sized surface on a solution of silver nitrate. After drying in the dark, the paper was ready to use. The paper was used for printing-out, i.e. it was exposed beneath the negative in a printing frame until the image appeared – there was no development stage.

An interesting and popular development from the wet collodion method produced glass collodion positives. It was noticed that glass collodion negatives when mounted in front of a black surface appear as positives. They became cheap alternatives to daguerreotypes and were mounted in a similar fashion. They were very popular in America in the 1850s and 1860s and became known as Ambrotypes.

In 1854 a major advance was made with the perfection of dry instead of wet collodion. (Dry collodion should not be confused with the gelatin emulsion dry plates produced by Dr Richard Maddox in 1871.) But dry collodion plates were unfortunately nowhere near as sensitive as wet collodion plates, requiring very long exposures, and hence the process was unpopular and short-lived.

The first photographer to devise a popular method of preparing plates which could be used dry was the French chemist J. M. Taupenot in 1855. He coated the collodion with a layer of iodised albumen and found that these collodion albumen plates could be dried and used several weeks after their preparation. However, Taupenot plates were much slower than wet collodion plates.

The first of the illustrated items is one of the earliest photographic lenses by Charles Chevalier. The lens can be dated at around 1841. A typical French daguerreotype of around 1843 is next illustrated with a slightly later Chevalier lens[2]. The work of the celebrated British optician Andrew Ross is represented by an unusual rare conical-shaped lens of around 1850[3]. A single lens camera by Horne & Thornwaite of 1852, an elaborate cased outfit by George Hare for the Maharajah of Punnah of 1875[8], a stereo by Dallmeyer of 1862[6] and a rare Pantascopic camera by Johnson & Harrison of 1862[7] conclude the wet plate era. The paper negative era is represented by a collapsible single lens camera by Horne & Thornwaite of 1858[5].

A bellows stereo wet plate camera[12] and a collapsible bellows wet plate[13], both of around 1880, illustrate development of wet plate cameras from sliding box to bellows. The portrait and carte de visite period is also highlighted by a four lens and a twelve lens camera of 1880.

It must be remembered that the various periods of photography do not start and cease at precise moments. Depending on many conditions, such as licensing laws, certain processes were more developed in certain countries and hence survived longer. This is the case in particular with the daguerreotype process in America. In the 1880s when most European photographers had gone over to the wet collodion method, many a fine American photographer was still using the daguerreotype process.

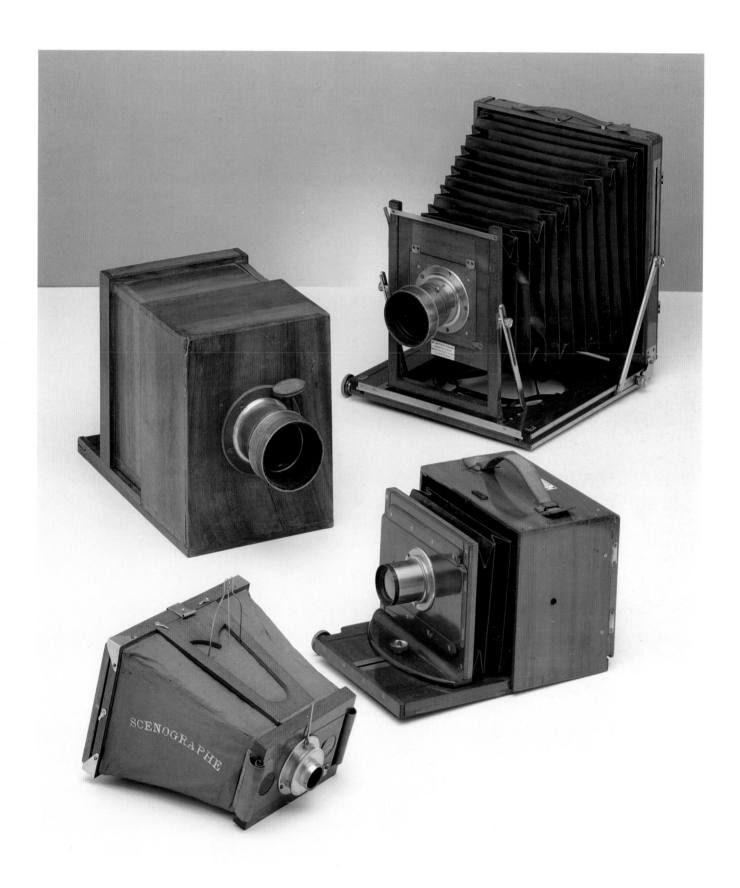

PLATE I
(clockwise from top left)
French Daguerreotype plate camera, *c.*1843 [2]
Watson's Acme field camera, *c.*1900-10 [22]
Hare box bellows camera, *c.*1890 [17]
The Scénographe, *c.*1875 [14]

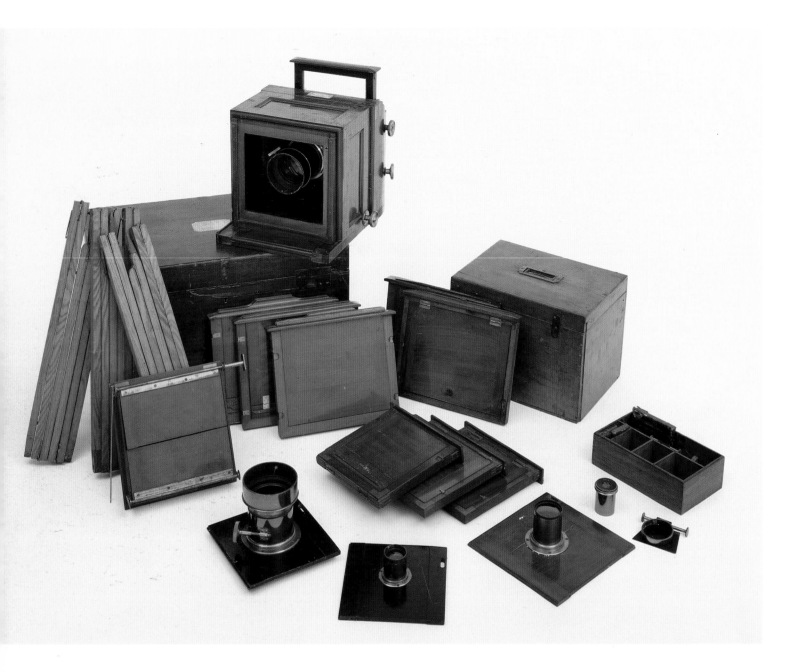

PLATE II
Hare sliding box camera, *c.*1875 [8]

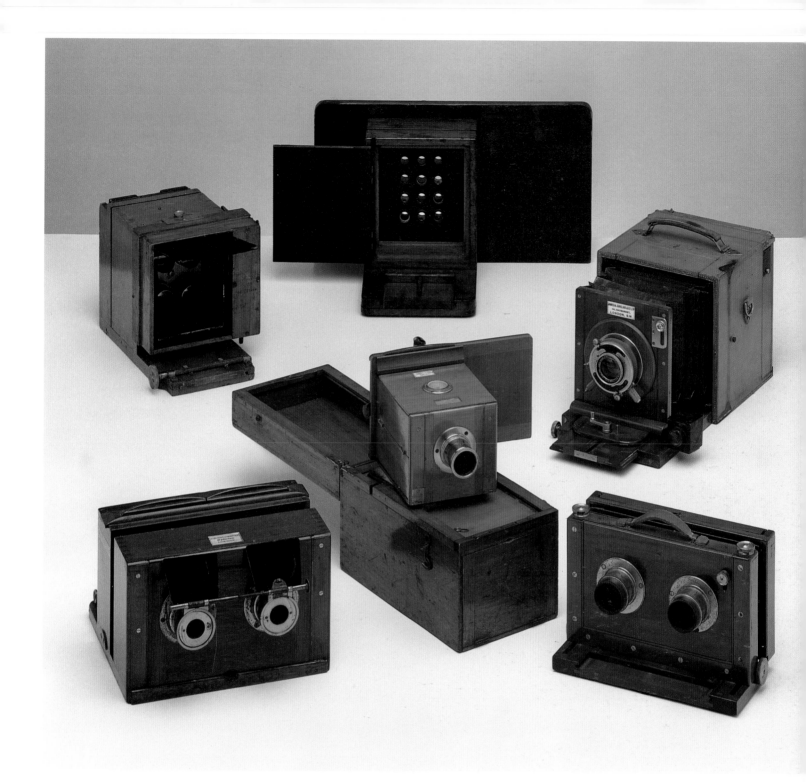

PLATE III
(clockwise from bottom left)

Binocular wet collodion stereo camera, *c.*1862 [6]

Four lens camera, *c.*1880 [10]

Twelve lens camera, *c.*1880 [11]

Voigtländer Bijou, *c.*1908 [26]

Bellows stereo wet plate, *c.*1880 [12]

Horne & Thornwaite collapsible single lens stereo camera, 1858 *(centre)* [5]

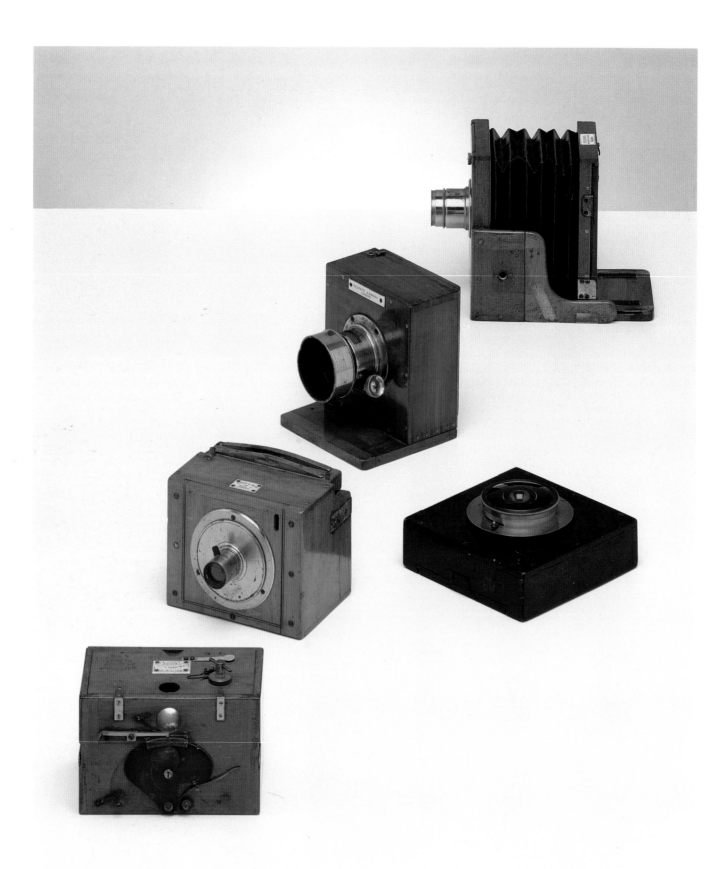

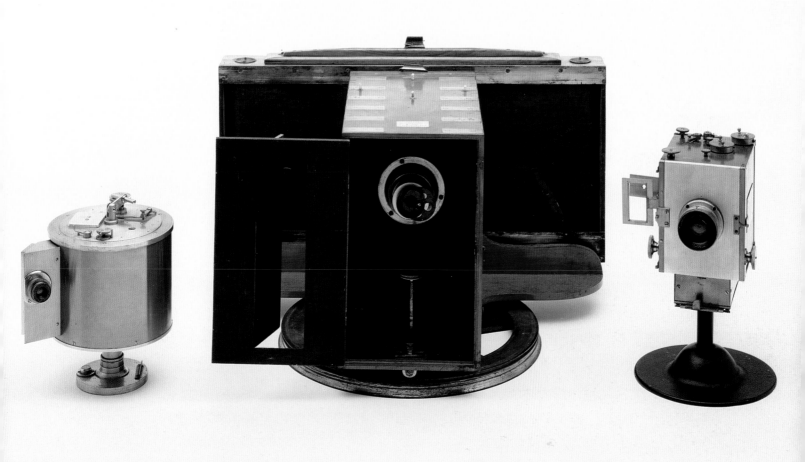

PLATE V
(left to right)

Périphote, 1901 [48]
Johnson & Harrison's Pantascopic, 1862 [7]
Cyclographe, 1896 [47]

PLATE IV (OPPOSITE)
(top to bottom)

Meagher tailboard camera, c.1900 [21]
Single lens box camera, c.1890 [18]
Wooden box camera, c.1875 [9]
Luzo, 1889-99 [44]
Robin Hill Cloud camera, 1924 *(right)* [34]

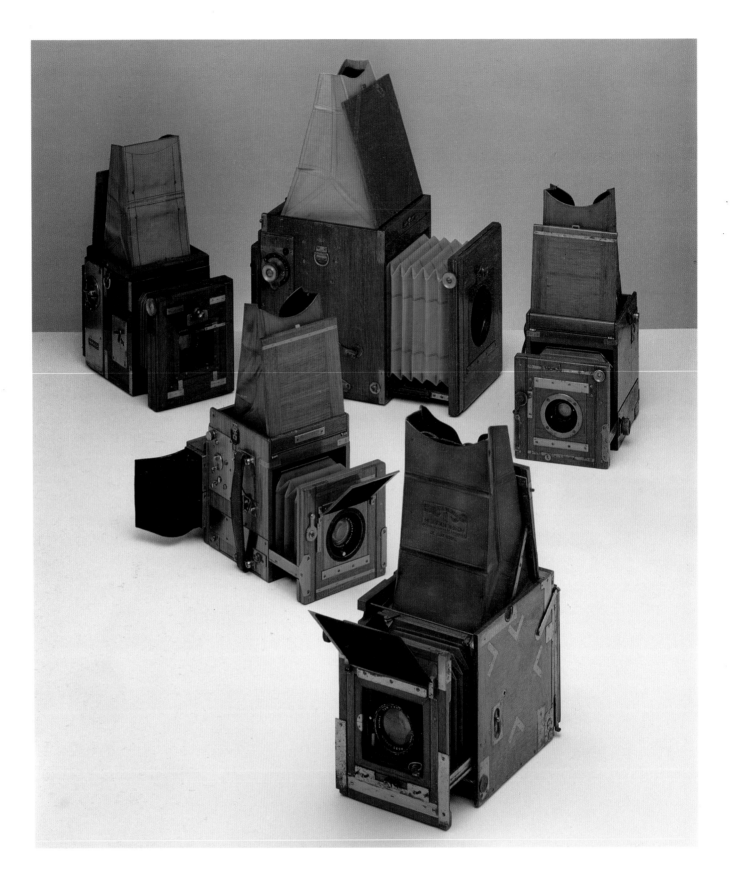

PLATE VI
(top row left to right)
Duplex Ruby Reflex, *c.*1930 [37]
Ruby De Luxe Tropical Reflex, *c.*1930 [39]
Soho Tropical Reflex, *c.*1930 [36]
Soho Tropical Reflex, *c.*1917 *(centre)* [30]
Minex De Luxe Tropical Reflex, *c.*1920 *(bottom)* [32]

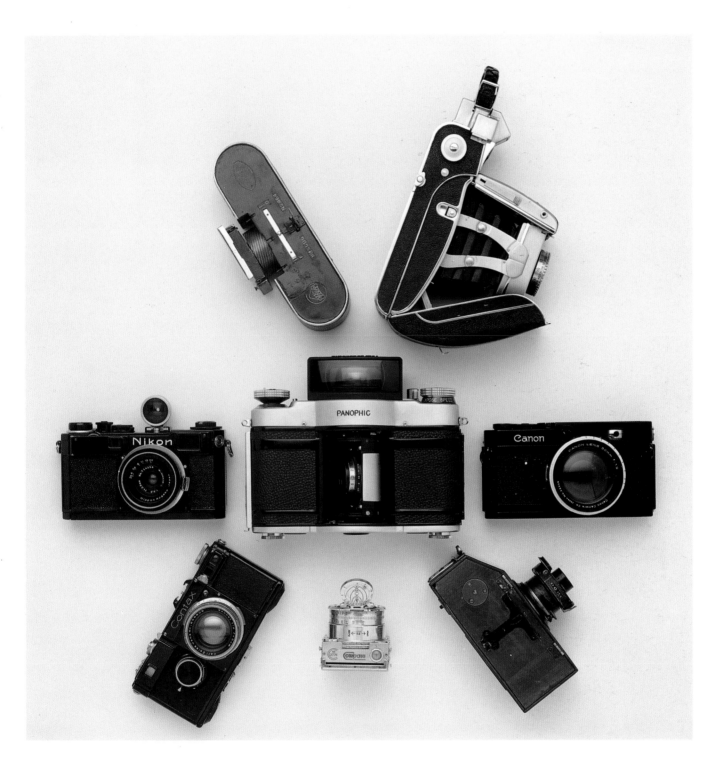

PLATE VII
(clockwise from left)

Nikon S2, 1955-58 [116]
Eka, 1924 [84]
Kodak Super Six-20, 1938-45 [59]
Canon P, 1958-61 [122]
Sico, 1923 [83]
Compass, 1938 [42]
Contax I, 1932-36 [91]
Panophic, *c.*1968 *(centre)* [76]

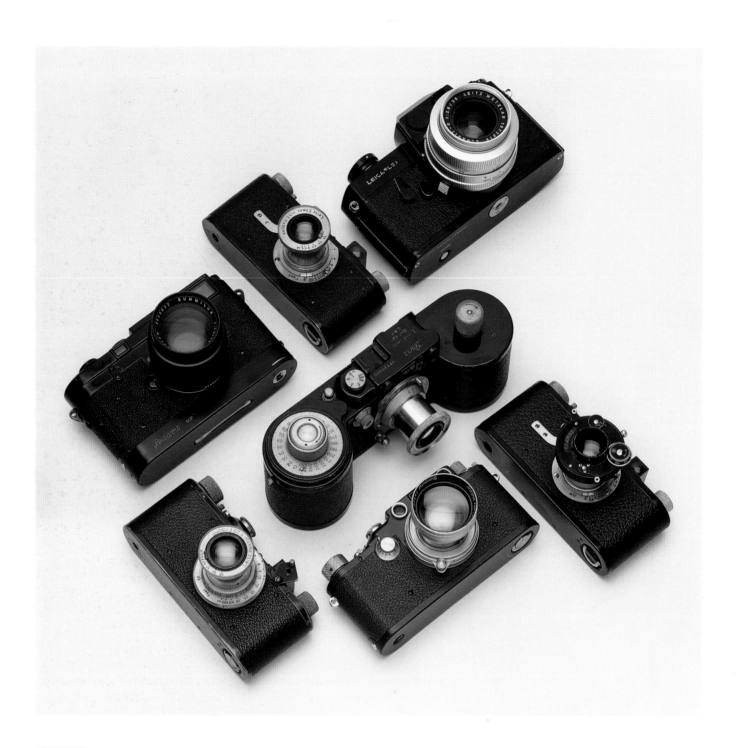

PLATE VIII

(clockwise from bottom left)

Leica I Interchangeable, 1930 [88]

Leica MP, 1956-58 [117]

Leica I, 1925 [85]

Leicaflex, 1965-68 [133]

Leicacompur, 1926 [87]

Leica III C grey, 1941 [104]

Leica 250, introduced 1934 [93]

Chevalier's Photographe à verres combinés

I

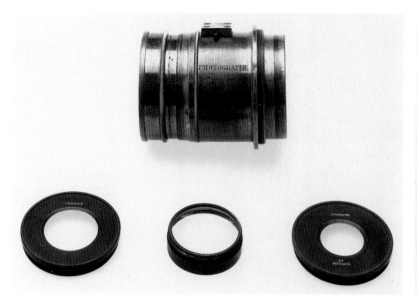

c.1841

Rear of lens 65mm diameter, front of lens 70mm diameter, focal length 32cm
'Inventé par Charles Chevalier, Ingénieur, Opticien, Palais Royal 163, Paris'

Charles Chevalier (1804-59) and his brother Vincent were very much involved in the birth of photography. It was through their Paris optical shop that Nicéphore Niepce met Louis-Jacques-Mandé Daguerre.

Recognising the need for a lens of a much greater aperture than that of the single landscape lens, the Société d'Encouragement of Paris in 1840 offered a prize for the best portrait lens to be submitted to them before the end of the year. Charles Chevalier won the prize with his 'Photographe à verres combinés', although another entry, the Petzval lens, was later considered by photographers to be a superior portrait lens and achieved much greater fame. The Chevalier lens was the earliest convertible lens and two alternative front lenses were provided to give a choice of focal lengths. One of these lenses was marked 'Paysages' (landscapes). The second and more powerful was marked 'Portraits'. If required, both front lenses could be used together, making the rear component a triplet lens. The diaphragm was placed a short distance in front of the lens system, or it could be inserted between the lens components. Three different diaphragms were available, marked as follows: 1. 'Paysages et gravures', 17mm diameter. 2. 'Portrait et paysages'. 21mm diameter, 3. 'Portraits', 33mm diameter.

The 'Photographe à verres combinés' was made from about 1841 to 1859. The rear component of the lens was an achromatic landscape lens; with the front element it was possible to take portraits with apertures from approximately f4. The lens had a rack and pinion focusing mechanism.

In 1844 Charles Chevalier produced 'Le Grand Photographe'. This camera was an oblong box, the long sides of which were divided and hinged in the middle. When the lens panel and the plate-holder were removed from each end, the body collapsed to take up very little room. When the camera was in use the inner sliding box which carried the plate-holder could be moved backwards and forwards for focusing. The lens, of course, was Charles Chevalier's own 'verres combinés'.

In the Science Museum, London, there is a Charles Chevalier lens once used by W. H. Fox Talbot for calotype photography.

2 French Daguerreotype plate camera

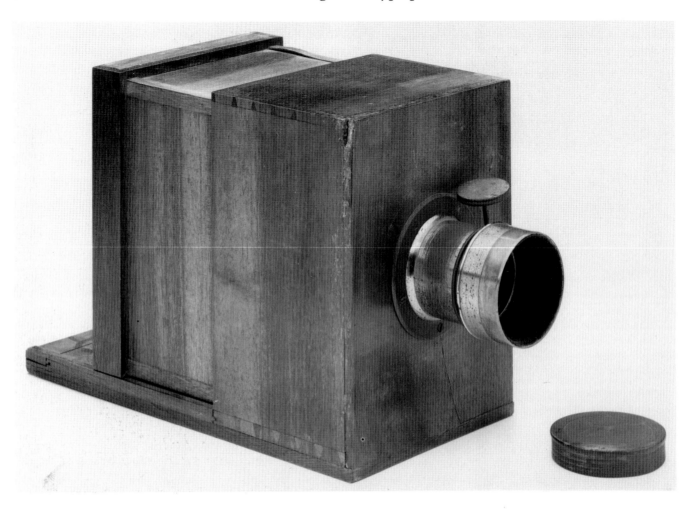

c.1843
Lens 7in f8 brass-bound, inscribed 'Photographe à verres combinés inventé par Charles Chevalier ingénieur. Arthur Chevalier fils et successeur, Palais Royal 158, Paris'

See colour plate I

The camera illustrated is a single lens camera of the 4 × 6½ in format for the Daguerreotype process. Under licence from Daguerre, Alphonse Giroux produced the world's first commercially available camera with an achromatic lens attributed to Charles Chevalier, the most important pioneer photographic optician.

The camera is of the sliding box variety, the edges of the inner sliding box being strengthened in the manner typical of such cameras. The lens is the very first combination lens to be produced, one of the famous Chevalier 'Photographes à verres combinés'; it has a rack and pinion for fine focusing, crude focusing being achieved through the sliding box. The camera is rather basic in its manufacture, as one might expect of the early days of photography when the optician dominated the manufacturer.

3

c.1850
SN 3078
Rear diameter of lens 4½in, front diameter of lens 2in; brass-bound, of 12in focal length, complete with two washer stops

Andrew Ross conical lens

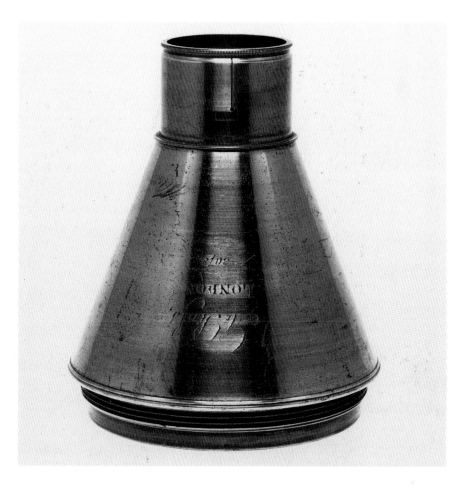

Andrew Ross (1798-1859) is England's most celebrated early photographic optician. Of Scottish parentage, he was an apprentice to a scientific instrument maker at an early age and became both a mathematician and an optician.

Andrew Ross discovered the doublet lens with its additional flatness of field and was the first to produce separated lenses in England. In 1841 a doublet lens was designed for Henry Collen, a friend of Fox Talbot and his first licensee for the calotype process. Ross's portrait lens, using two pairs of cemented components, had an aperture of about f4. At this aperture, however, the field was so curved that the calotype negative paper had to be held against a curved glass. Shortly after this Voigtländer introduced separated photographic lenses into England which were constructed on principles laid down by the eminent mathematician Petzval. So closely were Ross's lenses followed by Petzval's or, as they were commonly called, Voigtländers, that they encouraged belief in one of those singular coincidences in the annals of invention: two of the most eminent men discovering the same formula at the same time in different countries. Petzval's mathematical calculations are the basis upon which all the best lenses have since been manufactured, but how these basic principles have been established, corrected and modified in working practice by opticians is difficult to ascertain.

The Andrew Ross lenses were expensive. According to *The Photographic Journal* for 15 October 1859, its trade price was £21 15s. Andrew Ross died on 8 September 1859 aged sixty-one, leaving a fortune of some £20,000.

Thomas Ross, Andrew's son, had from his schooldays assisted his father with many of the optical products of the establishment. It was actually Thomas Ross who had persuaded his father to develop the photographic side of the business. Thomas Ross was one of the earliest members of the Royal Photographic Society. He must be credited with taking over from the optician Frederick Cox in 1861 the patent for the wide-angle water-filled Sutton lens.

4 Horne & Thornwaite wet collodion camera

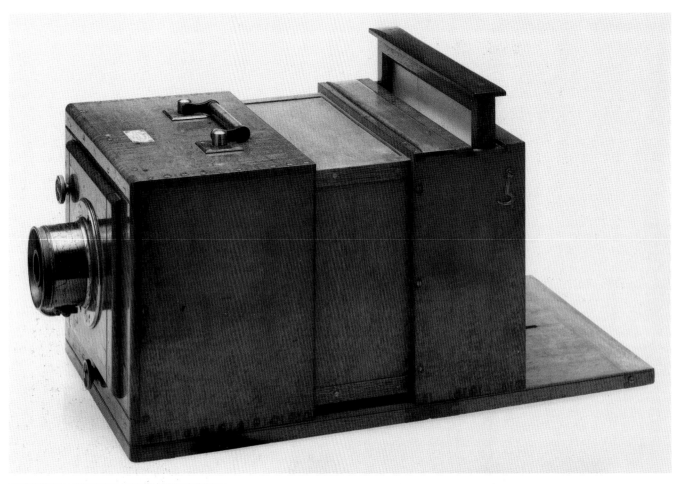

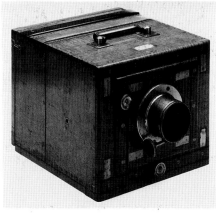

c.1858
Made by Horne & Thornwaite,
121/122/123 Newgate Street, London

This is a wet collodion wooden sliding box camera for whole plate photography (9 × 7in). The wet collodion dark slide has the provision for either upright or landscape positions for the plates. There is also a reducing frame for the half-plate format (6 × 5in). The camera is of an elaborate construction with a folding tailboard and a rising and cross front panel, a good example of an early wooden camera with a brass-bound front panel.

The camera came with two lenses; a Horne & Thornwaite 9in landscape lens no.2950 and a Horne & Thornwaite 12in portrait lens no.3085. The landscape lens was a single achromat working at about f14 and the portrait lens was of the Petzval type with an aperture of about f4.

This wet collodion is of an unusually high quality, as could be expected from a maker such as Horne & Thornwaite.

5 Horne & Thornwaite collapsible single lens stereo camera

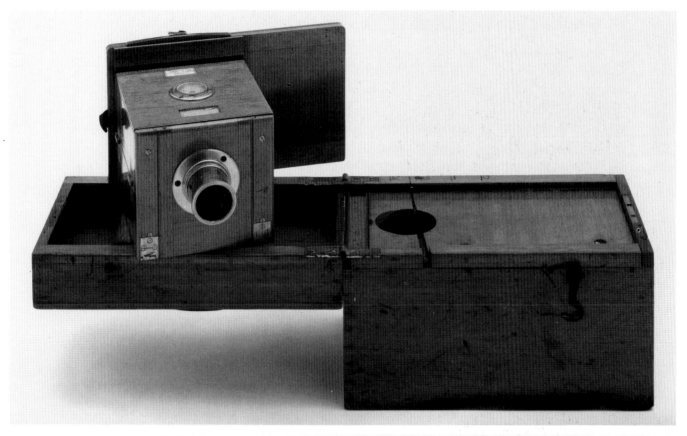

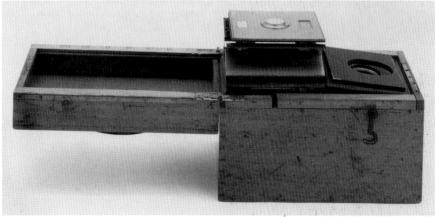

1858
Lens 5in f11, brass-bound, by Horne &
Thornwaite, 121/122/123 Newgate
Street, London
Designed by John Harrison Powell
(design no.4143) and manufactured by
Horne & Thornwaite

See colour plate III

This is the world's first collapsible single lens stereo camera, a tribute to the
ingeniousness of the camera designers of the mid-Victorian period. It was for use
with any of the dry processes and would produce stereo photographs of the
6 × 3in format. Four double dark slide plates could be stored inside the camera.

Once the lens and slide-holder were removed the camera would collapse. The
lens was fitted with Waterhouse stops and a spare lens element was mounted in
the box. The slide-holder and four slides would be stored inside the camera
mounting box.

In the erected position the camera would slide along a track enabling two
exposures to be made of distances of up to 12in apart. The camera could also
rotate on its axis to a small degree by means of a screw on the mounting box. John
Harrison Powell registered the design of this camera on 27 December, 1858.

In the *Photographic News* of January 1858 the camera received its first review.
'The object in the construction of this apparatus has been to make it as portable,
and at the same time as simple as possible, so that it may be easily put together; also
to avoid the use of loose pieces, which are objectionable from their liability of being
left behind when packing up.'

6 Binocular wet collodion stereo camera

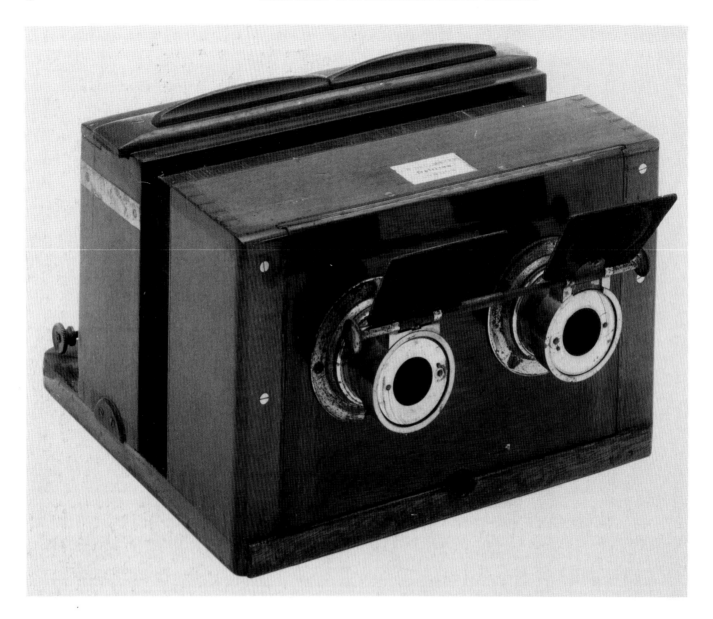

c.1862

Lenses: two single 5 ¼ in achromatic
lenses by A. Ross, London, consecutively
numbered 5814 and 5815
Manufactured by J. H. Dallmeyer,
London

See colour plate III

This fine example of an early 1860s stereo wet plate is a typical wooden sliding box for stereo photography. For focusing the camera has a rear rack and pinion. Finer focusing could be achieved by adjusting the sliding tubes of the lenses. Early lenses were not always of exactly the same focal length. Each lens has a flap shutter; they could be used simultaneously or independently.

The wet collodion dark slide-holders took 6 ¾ × 3 ½ in plates and the camera came complete with two slides. The first slide-holder has a single slide, and the other two separate slides were for use when single exposures were made. This is an unusual feature and is not often found with stereo wet plate slides. Further, inside the camera the septum is of the self-retracting variety; hence the camera could also be used for landscape photography with an accessory single lens on a separate lens panel.

7 Johnson & Harrison's Pantascopic

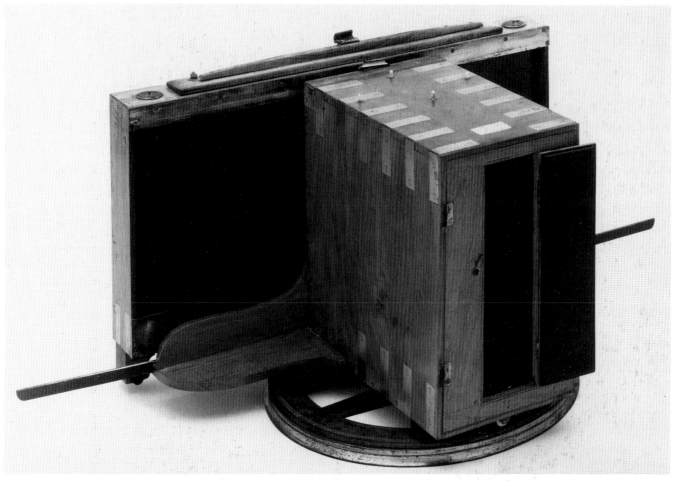

1862
SN 100
Lens 8in f8, Grubb patent 2603
Designed and manufactured by Johnson
& Harrison, London. English patent
dated 5 September 1862

See colour plate V

This camera was designed for panoramic photography and was much used by
Adolphe Braun (1815-77) to produce stunning views of the Alps. It is a rare and
historically important camera, and the serial number 100 indicates that the
example illustrated may well have been the first produced. The camera was used
for either wet or dry collodion plates of the 7 × 12in format. The field of view

Pantascopic *continued*

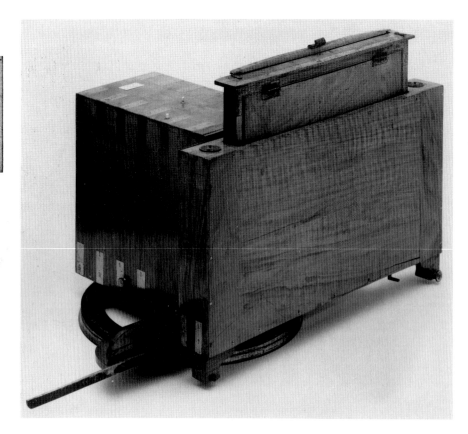

would be assessed from the four removable ivory markers on the top of the camera. The camera rotated on its axis along the circular base whilst the plate-holder laterally moved the rear slide only. The slide moved slowly across a small opening (7 × 1 ½in) in synchronisation with the rotation of the camera.

The angle of view is approximately 110 degrees, rotation being effected through a spring wound mechanism. To obtain an even exposure throughout the rotation, small pales below the lens regulated the speed. Pales of different sizes were available to vary the rotational speeds.

The camera is built in light mahogany and is brass-bound. The blind in the rear part of the camera is of a thick black material.

I acquired this camera in the late 1970s, having learned of its existence in the USA some years previously when it was up for sale by a teacher in the Mid-West. The asking price had been fair but substantial, a multiple of the total budget for my American trip! After fruitless searches for a Pantascopic years later, I eventually found exactly the same camera in a Belgian collection. The teacher from the Mid-West had sold the camera to a New York dealer and it had then been sold to a Belgian collector, to whom I am very grateful for having given me the opportunity to purchase this camera despite the international interest it aroused. It was exhibited in Brussels in 1988 ('La Photographie des origines à nos jours', Item No.21, Passage 44, April-June).

8 Hare sliding box camera

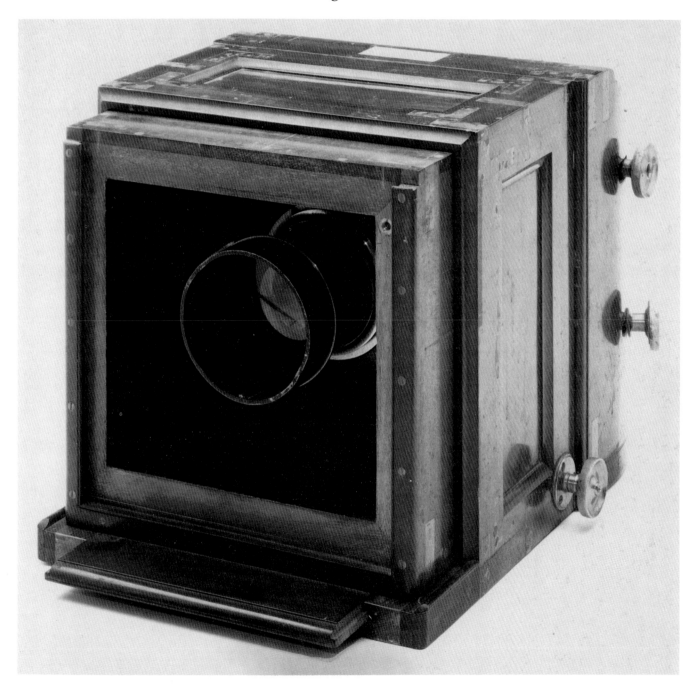

c.1875
Made by George Hare

See colour plate II

On the top of this camera is a small ivory label with the following inscription: 'manufactured expressly for H. H. the Maharajah of Punnah, Bundelgund'. The chest containing the camera has a silver plate with the coat of arms of the Maharajah. The lenses, slides and other accessories are contained in a separate smaller box. The camera is of half-plate size for either upright or landscape photography and it can be used with either wet collodion or dry slides.

From the construction point of view this camera is highly complex. This was to be expected from George Hare, the most illustrious of Thomas Ottewill's former apprentices who manufactured it to an important commission. There are two positions for lens panels, one on the front of the camera and another recessed within. Using the black painted inner lens panel, a wooden flap shutter, which was linked on from the outside, could also be used. When using the ouside lens panel either a small individual lens shutter or a lens cap would be used. The

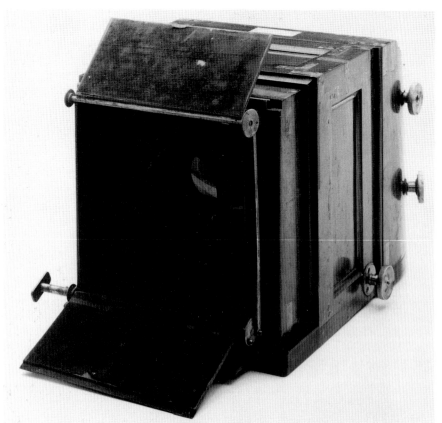

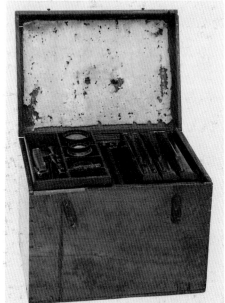

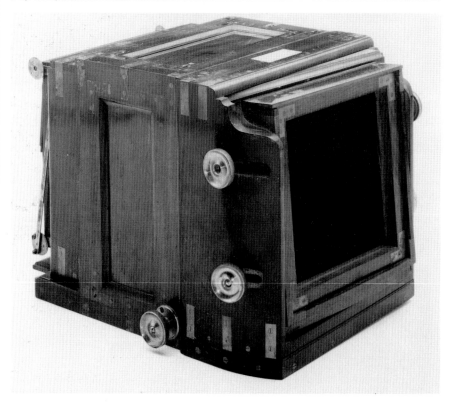

camera has a rack and pinion focus and the tilt and swing back is unusually operated by means of two knob screws. This is a most elaborate system, and very advanced for the 1870s.

The camera came complete with three wet collodion dark slides and four double dark slides for dry plates. The camera, shutter and tripod are all

Hare sliding box camera *continued*

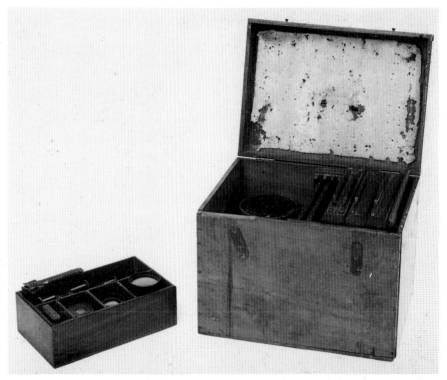

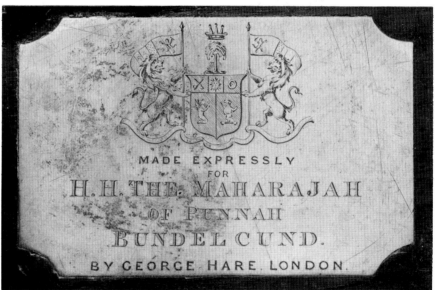

contained in the big chest. The small box contains the following Ross lenses:

8 × 5in SA Doublet No.18104, 10in
7 ¼ × 4 ½in OA Doublet No.18027, 6in
7 ¼ × 4 ½in OA Doublet No.17066, 4 ½in with wheel diaphragm and internal
shutter, lever operated
No.1 Cabinet, SN 20664, 9in with Waterhouse stops
No.2A Extra Rapid, SN 20845, 8in with Waterhouse stops

The Doublet lenses are a variation of the Rapid Rectilinear. The Cabinet and
Extra Rapid lenses are portrait lenses.

I acquired this camera after protracted negotiations in Calcutta in 1975.

9 Wooden box camera

c.1875
Lens 3 ½ in f8 Periskop, SN 7050 by
Steinheil, Munich
Manufactured by Murray & Heath,
69 Jermyn Street, London

See colour plate IV

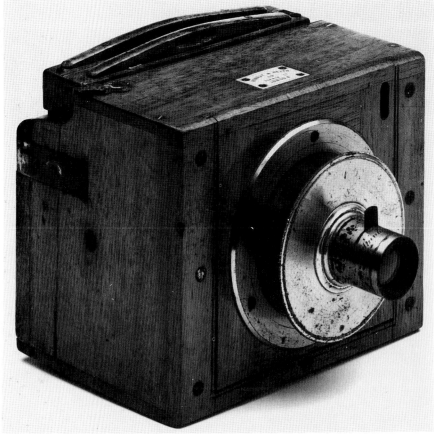

This small box camera covers the transitional period from wet plate to dry plate. (Murray & Heath were at 69 Jermyn Street until 1883.) The plate size is 3 × 4in and came with a double dark slide for dry plate use. The width available for the slide position and stains at the bottom of the camera suggest that this camera was used for wet plate photography.

The camera is of a fixed focus variety but the lens has a sliding tube focus facility. The 3 ½ in f8 Steinheil lens on a rising panel of a Periskop design has ¼ in plug-in Waterhouse stops. The Periskop was introduced in 1865 by C. A. (the father) and H. A. (the son) Steinheil and was called the Periskop lens: it consisted of a symmetrical pair of meniscus lenses on either side of a diaphragm, correcting barrel or pincushion distortion.

The lens for this particular camera format is wide-angle and would lead us to believe that the camera would not have been for studio but for landscape or architectural photography.

10 Four lens camera

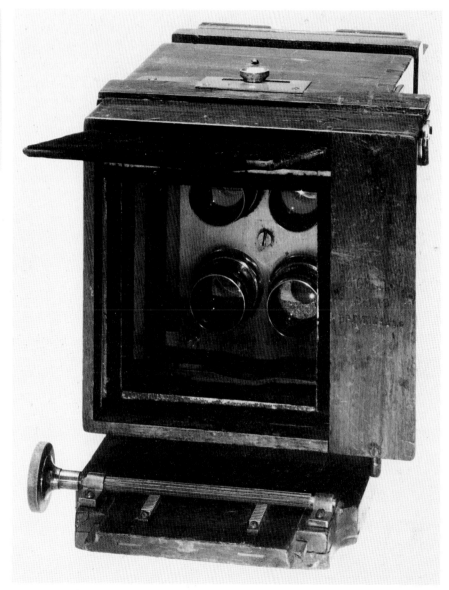

c.1880

Manufacturer unknown

See colour plate III

This is a four lens sliding box camera for the quarter-plate dry collodion format.

The four brass lenses are mounted on a brass plate and would have been individually adjusted for focus. The camera is of the sliding box construction and focusing is by rack and pinion. Initially the camera would have had a wooden flap shutter. This has been replaced later by a C. I. Guerry of Paris shutter, which has a velvet flap and could be pneumatically operated by a hose bulb. This type of camera would have been much used in portrait photography studios in the late 1880s in an effort to overcome the huge costs associated with portraits.

11 Twelve lens camera

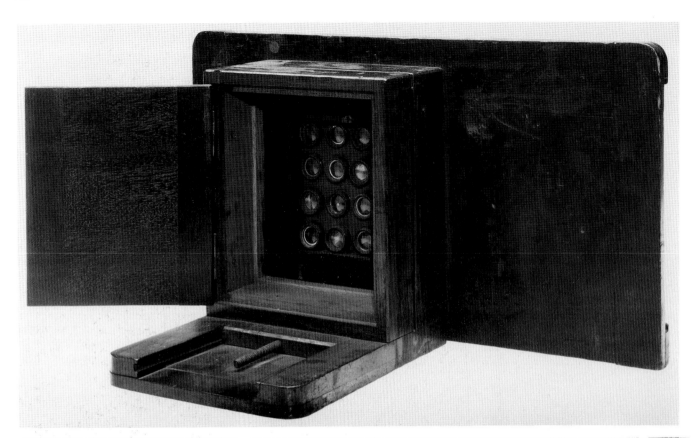

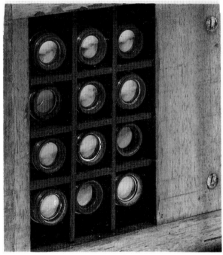

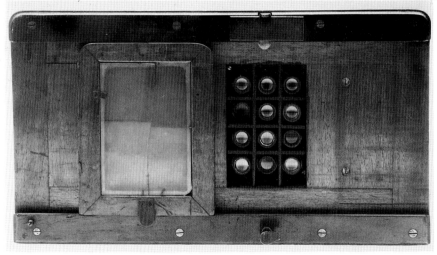

c.1880
Manufacturer unknown

See colour plate III

In the 1880s a craze began for cameras that could produce many small photographs at the same time. This type of camera was mainly used for portraits, enabling a sitter to have a number of small photographs for a reasonable price. Later on such small photographs were to become known as stamp photographs.

The camera shown here has no maker's name and is for quarter-plates of the dry collodion variety. The twelve small lenses are mounted on a brass panel and each lens has been individually adjusted for focus, because of the practical limitations in the 1880s on grinding twelve lenses to precisely the same focal length.

The camera has a sliding box construction with a screw-thread focus adjusted by the handle at the rear. The long back would suggest a repeating back facility, but this is not confirmable as the slides are missing, although the focusing screen is present. Exposure would have been effected by using the front flap.

12 Bellows stereo wet plate

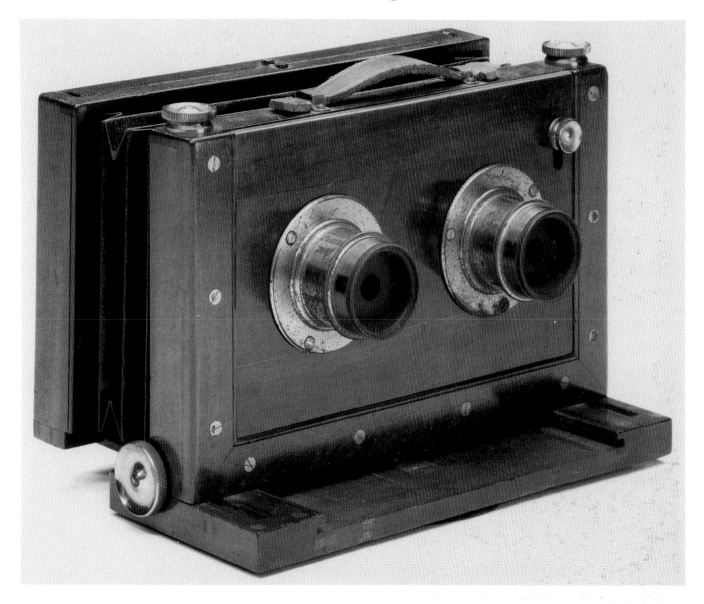

c.1880
Lenses: two 2in f2 Grubb Patent B,
SN 1467/1468
Manufacturer unknown

See colour plate III

This is a very early bellows camera for 6½ × 3in exposures. It is particularly rare in being for stereo photography using the wet collodion process. The two small Grubb lenses are located on a rising panel; each has two pill-box apertures of ⅜ and ⅝ in diameter. Exposure is accomplished by means of caps. Focusing through the ground glass screen is achieved with the aid of the rack and pinion. In the retracted position the camera is extemely compact. It comes complete in a wooden outfit case with five wet plate slides.

The camera is built of mahogany which is dove-tailed and finished to a particularly high standard.

13 Collapsible bellows wet plate

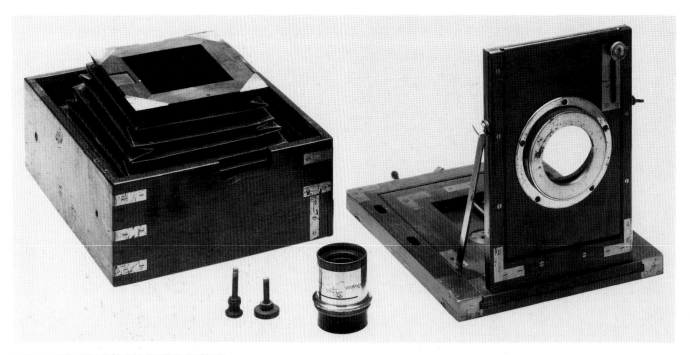

c.1880
Lens 15in, Ross No.11 Symmetrical,
SN 44430 with Waterhouse stops
Designed and manufactured by
W. W. Rouch, Manufacturers,
180 Strand, London

This camera for the 10 × 8in format using wet collodion plates is unusual in that the introduction of bellows came at the end of the Wet Plate Era, and also in that it is collapsible. The front panel incorporates a rising front but is also hinged at the base. In the erect position the front panel is held in place by two struts. The bellows are firmly attached to the rear of the camera which is screwed onto the baseboard of the camera. The focusing screen is stored inside the camera and has to be moved in the focal plane position for ground glass screen adjustment. In the collapsed position the camera is extremely compact and the fragile ground glass screen is protected by the dark slide. The camera has a handle akin to that of scientific instrument cases such as those found on microscope boxes.

The camera came complete with focusing screen and one 10 × 8in wet plate slide. It was of a very high level of workmanship. W. W. Rouch had been in the business of manufacturing photographic apparatus since 1851 and they offered an extensive range of interesting and varied cameras.

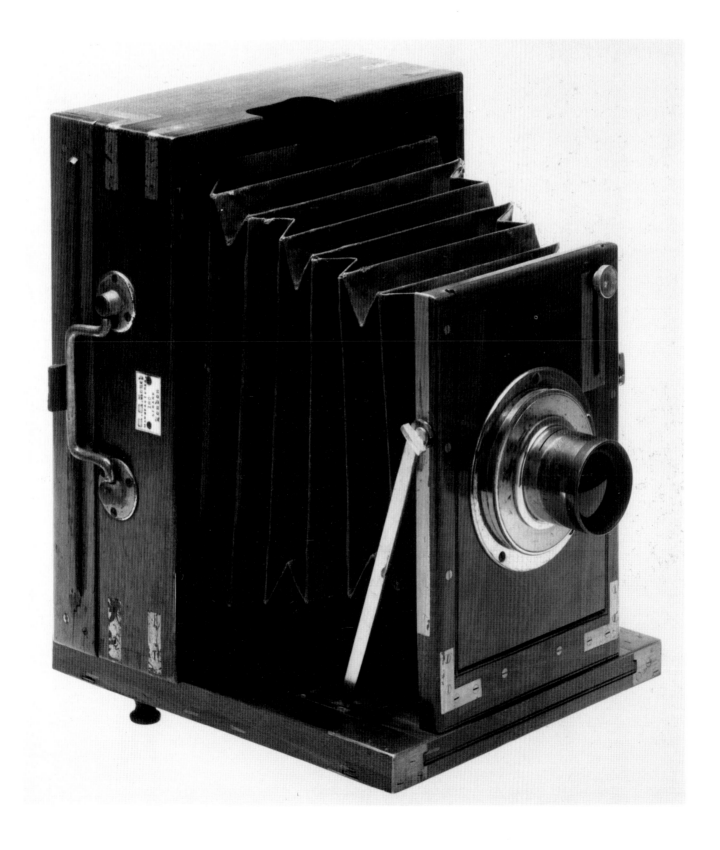

The Dry Plate Era

1871 onwards

A major step in the popularisation of photography came in the 1870s with the introduction of gelatin emulsion dry plates. The very first to be produced were by Dr Richard Maddox in 1871. Gelatin plates were not only faster than wet plates, but could be kept for months without deterioration. In 1873 commercially sensitised dry plates were made available by John Burgess of London; previously it had been customary for photographers to make and sensitise their own plates. In 1878 Charles Bennet discovered a method of increasing the sensitivity of gelatin silver bromide plates by keeping them at elevated temperatures with an excess of bromide. This method became known as 'ripening'. These 'Instantaneous' plates, as they were called, were some forty times faster than the wet collodion plates being sold. Manufacturers now adopted to some degree uniform sizes (whole-plate, half-plate, quarter-plate) and speeds. The comparison of rival products provided the impetus for the scientific study of the characteristics of sensitive materials. From now onwards the dry plate process was constantly perfected, and it is still very much in use in professional fields of photography, when the utmost definition is required.

The standardisation of plate sizes and shutter speeds that followed the introduction of gelatin emulsion dry plates that would keep enabled the demand for easy-to-handle, light-weight apparatus to be satisfied, and a greater range of cameras to be produced for diverse uses, such as detective cameras. Photography now became a popular activity for the first time.

This section starts with the Scénographe of 1875 [14], which was not only extremely light-weight but also probably the only camera to have silk bellows – bright green ones. Brin's Patent camera of 1891 [19] is one of the smallest of plate cameras (25mm in diameter) and certainly the only one concealed in a spy glass. It was probably used in opera houses before cameras were barred. The turn of the century is represented by a small tailboard camera of the important Meagher design [21]. The French craze for stereo photographs is illustrated by a 1903 stereo camera by Gaumont [23], more noted for the Pathé-News than for camera manufacture. The Voigtländer Bijou of 1908 [26] is highly important in that it is the first single lens reflex for the new popular vest pocket size. The Thornton Pickard aerial camera of 1915 [29] is amongst the very first of the aerial cameras and probably saw action hanging from a Sopwith Camel. The Minex de Luxe Tropical Reflex of c.1920 is without doubt the most elegant of all classic cameras [32], of the most exquisite craftmanship. The Robin Hill Cloud camera of 1924 [34], although designed for metereological stations to photograph clouds, is the ancestor of the now famous non-distortion free fish-eye lens. The Makina I of 1930 is not the first collapsible bellows camera for 6.5 × 9cm exposures, but is the most famous as that which remained longest in production [40]. The Mikut of 1937 is one of the most ingenious of all tri-colour cameras [41]. The section is concluded by a British-designed Swiss-built watch-like precision camera, the Compass of 1938 [42].

14 The Scénographe

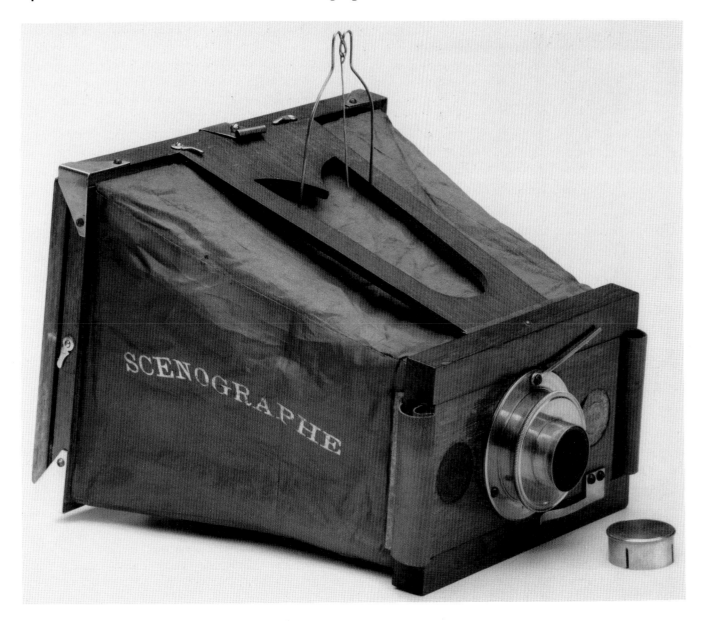

c.1875
SN 211
Lens 180mm f20 Darlot Achromatic
Designed by Docteur Candèze of
Glain-lez-Liège and manufactured by
E. Deyrolle & Fils, Paris

See colour plate I

The Scénographe is one of the earliest strut-type cameras, and its green bellows
make it most attractive. Compared to its contemporaries it is very light in weight.
Its design was patented in France on 23 March 1874, No.102.784. Docteur
Candèze was a noted Belgian inventor and not only a medical doctor but also an
entomologist and President of the Belgian Association of Photography.

The camera is of a collapsible bellows construction for 11 × 16cm collodion/dry
plates. The front and back plates are held in position by means of two removable
'strut-type' hollowed pieces of wood. The inner surface of the bellows is of a
thick black cloth, whilst the outer surface is of an attractive green, silky material
with the manufacturer's name embossed in gold.

Brass pill stops can be inserted into the lens, which has a fixed aperture of f20,
and retained by a brass ring. Focusing is effected by sliding the lens and exposure
by removing the lens cap. Stereoscopic photography is also possible by inserting a
wooden septum inside the camera.

15 Patent Eureka detective camera

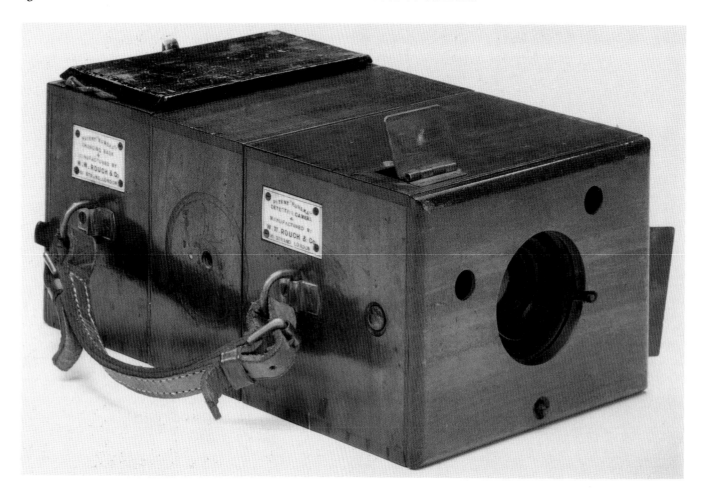

*c.*1888
Lens 6in f6 brass-bound
Instantaneous doublet, SN 8231 by
W. W. Rouch & Company, 161 Strand,
London
Designed and manufactured by
W. W. Rouch & Company

This camera takes up to twelve quarter-plate size exposures on film or sheet. The 150mm f6 brass instantaneous doublet is set in a roller blind shutter (two blinds travelling vertically) with speeds of either 1/15, 1/40 or 1/80sec requiring respectively one, five or fifteen turns of the roller blind spring. Focusing is by the sliding box principle, *ie* the front part of the camera slides out, disclosing a small brass plate with the engravings of 'infinity, 15 feet and 10 feet.' The lens is recessed in the camera and the front panel has to be removed to alter the apertures which stop right down to f32. There are two waist-level viewfinders; one for vertical and the other for horizontal exposures, both having brass flaps to avoid extraneous light.

The magazine back holds up to twelve quarter-plate plates and the changing bag is of chamois leather. This magazine back had first been patented by Arthur Newman in 1886. The camera is built of mahogany with dove-tail angles, leather handles and two tripod bushes – unusual in a detective camera.

The camera measures 23 × 12.7 × 10cm, hence it is hardly small. The Rouch Eureka won first prize at the Crystal Palace Exhibition for Inventors in 1888. The Eureka quarter-plate was listed at £6 12s 6d. Also available were the 3 ¼in square model at £5 17s 6d and the very large 5 × 4in model at £8 10s.

The Eureka detective camera was a most successful design and it was used, for example, by Melton Prior, war correspondent of the *Illustrated London News,* who covered all the campaigns of the Ashanti War. Snapshot photography had come into its being in the 1880s and the Eureka was part of that movement.

16 The Actinograph

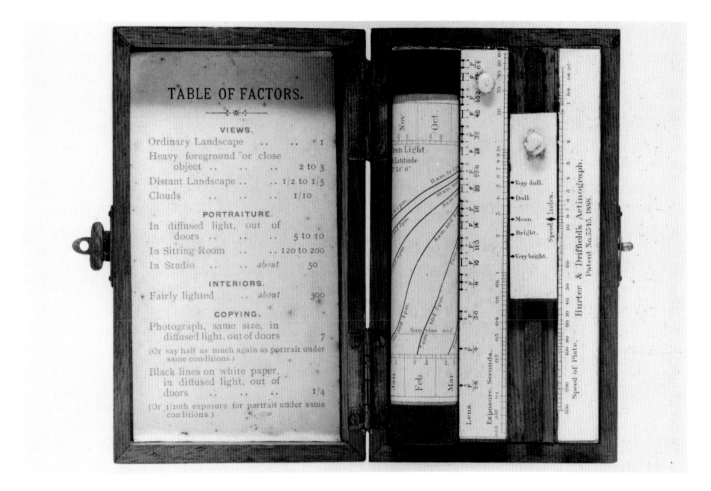

1888 onwards

Designed and manufactured by
Ferdinand Hurter & Vero Driffield of
England

The Hurter and Driffield Actinograph was patented on 14 April 1888 by
Ferdinand Hurter and Vero Driffield. It consists of a type of cylindrical rule with
a table of factors. A revolving scale is first set to the date and time of day, and
then the speed index of the plate is set on the speed scale. A slide is then moved
until the aperture can be read off for five light conditions: very dull, dull, mean,
bright and very bright. Each of the Hurter & Driffield Actinographs was sold
for one particular latitude.

The Actinograph was one of the most successful of the early exposure
calculators and sales rolled along for many years. From 1888 until 1892 the
Actinograph was marketed by the inventors. From 1892 onwards it was sold by
Marion & Company of London.

Correct exposure has always been a critical factor in making a good
photograph. In the early days of photography correct exposure was determined
from previous experience. During the wet collodion era plates had to be
processed immediately, thus if a bad exposure had been obtained another one
could be taken. In the late 1870s with the advent of dry plates an exposure table
or guide became a useful accessory, becoming more so as plates became faster
and were produced under controlled conditions, making them more predictable
in response to light.

17 Hare box bellows camera

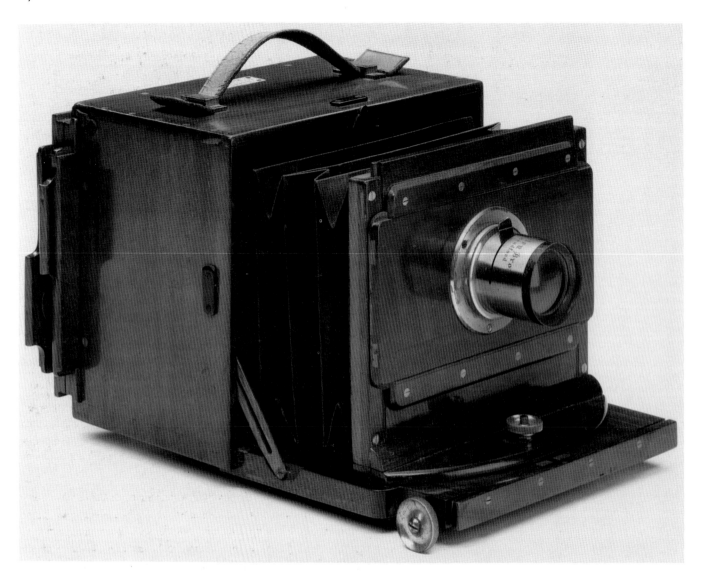

c.1890
Lens 7in f8, brass-bound, marked 'Riley
Brothers'
Designed and manufactured by G. Hare,
Manufacturer, 26 Calthorpe Street,
London

See colour plate I

The Hare Box Bellows is a single lens plate camera for the 4 × 6in format using the
dry plate process. It incorporates no optical or other means of viewing besides
the ground glass screen. In a sense this camera is an ancestor of the much later
immensely popular hand and stand cameras.

The 7in f8 Riley lens is mounted on a panel with both lateral and vertical shift.
Viewing and focusing are achieved on the ground glass screen. Focusing is
accomplished by using the bellows and the finder, focusing through the rack and
pinion of the lens.

The camera is outstandingly well manufactured in that, for example, the
mahogany is dove-tailed at the corners. The bellows are of a dark red leather
which was very much in fashion during the period. The screw-heads are all
turned in the same direction which is typical of the cameras manufactured by
George Hare.

18

c.1890
Lens 3in f8, J. H. Dallmeyer, SN 56100,
brass-mounted and with rack and pinion
focusing
Designed and manufactured by Negretti
& Zambra, London

See colour plate IV

Single lens box camera

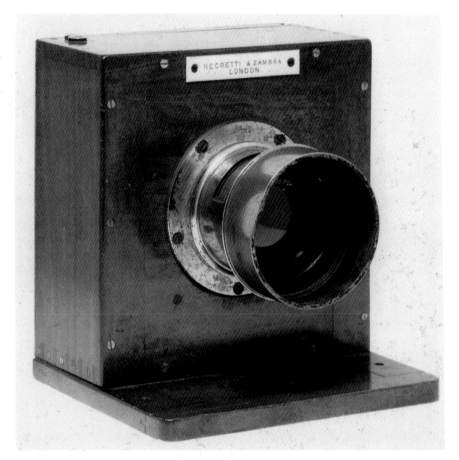

This simple box camera for 2⅜ × 2⅜in dry plates is a most unusual single lens
camera, especially in such a small format. In construction it is akin to a wet plate
camera as it has no means of focusing other than by the lens. Even though the
plates are missing, this camera cannot be a transitional wet plate to dry plate
model as the width for the plate-holder is rather narrow, only approximately
3mm wide.

The Dallmeyer lens, dating from 1890, has, however, a rack and pinion
focusing mechanism. The lens is slightly telephoto and the camera was probably
used for protrait photography, for which the square format is most appropriate.
The camera is made of fine mahogany, the joints are dove-tailed and the brass
screw-heads are all in the same direction. The base of the camera extends
forward to give more stability.

19

1891
SN 517
Patent No.17143

Brin's Patent camera

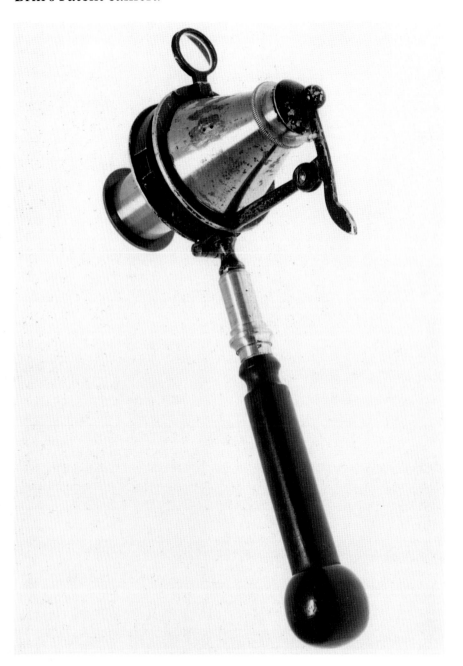

The Brin's Patent is a miniature camera in the form of a spyglass. Once the small plate-holder, containing 1 ⅛in diameter plates, was removed, the camera could be used as a spyglass and the rear eyepiece could be used for focus. The ³⁄₁₆in lens is a fixed focus and of f3.5 fixed aperture. The shutter is of the spring-loaded flap variety and a small removable optical glass acts as a viewfinder. In the 1880s and 1890s the so-called 'detective' cameras were in vogue. These were small hand cameras designed to resemble familiar objects such as parcels, handbags or watches. Most were toys incapable of any decent results, but they set a trend towards the development of miniature cameras.

20 Frennet stereo reflex

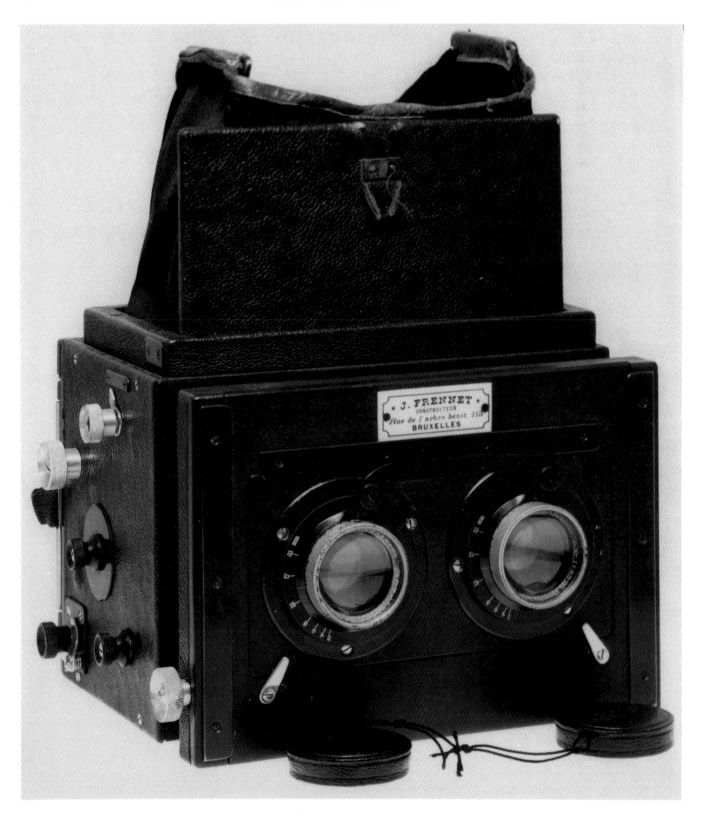

c.1900
Lenses: pair of 112mm f4.5 Tessars by
Carl Zeiss, Jena
Designed and manufactured by
J. Frennet, Constructeur, 113 rue de
l'Arbre Bénit, Brussels

This is a particularly well designed stereo reflex camera by a little known Belgian
manufacturer from whom few products are known. It takes 60 × 130mm format
dry plates. The lenses are on a rising front and the lens apertures are cross-
coupled. The lens bellows are made of black leather and the stereo focusing hood
of thick black cloth. The shutter consists of two cloth blinds travelling vertically
and the speeds are from approximately 1/20 to 1/250 sec.

The camera is constructed of wood covered by black leatherette; the knobs are
aluminium and the other fittings nickel.

21 Meagher tailboard camera

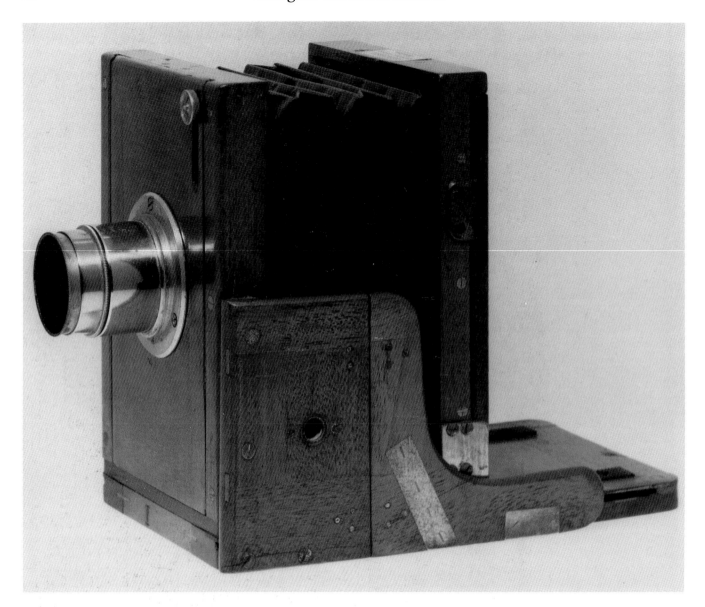

c.1900
SN 1
Lens 5in brass-mounted, Ross, London,
SN 12533
Manufactured by Meagher, London

See colour plate IV

This is a beautiful example of a Meagher tailboard camera, and one with an extremely small format of $3\frac{1}{4} \times 4$in using the dry plate process. The Roman numeral I stamped on the front of the baseboard may indicate that this was a sample camera or one of a small run. The Ross lens is in sliding tube focusing and with pill-box stops. The outstandingly important design of the tailboard camera, invented by Meagher, enabled plate cameras to be compact without forsaking rigidity. Further, the folding of the camera helps to protect the focusing screen. The illustrated model is unusual in being vertical whereas most tailboards are horizontal.

Focusing is achieved by operating the rack and pinion of the camera or by sliding the tube of the lens for finer focusing. The camera has red leather bellows and the focusing screen is hinged, hence it cannot be mislaid.

22 Watson's Acme field camera

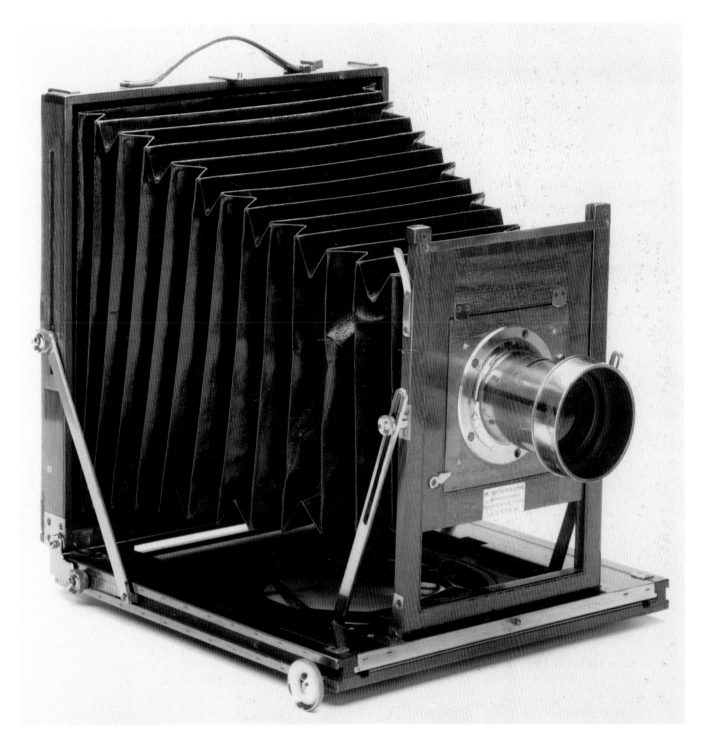

c.1900-10

Lens 13in f5.65 No.1 Universal Paragon,
SN 5081 by J. Swift and Son,
81 Tottenham Court Road, London
Designed and manufactured by
W. Watson and Sons, 313 High Holborn,
London WC1 and 16 Forrest Road,
Edinburgh

See colour plate I

The Watson Acme plate camera, a folding field camera for 8 × 9in dry plates or
film, combines lightness, compactness and efficiency to a remarkable degree.
Launching it as 'The Acme', Watson's claimed that this camera represented a
'perfection of apparatus for tourist use both as regards convenience
and workmanship'.

The Universal Paragon lens stops down to f45.2 and focuses up to 3ft.
Focusing is achieved through the ground glass screen and the rack and pinion
facilitates accurate focusing. The focusing screen is built into the camera; it is
hinged and cannot be separated.

The camera is built of mahogany, is brass-bound and has brass fittings. The
bellows are of a deep red leather. The Acme was available in sizes from half-plate
to 15 × 12in.

23 Stereo Gaumont

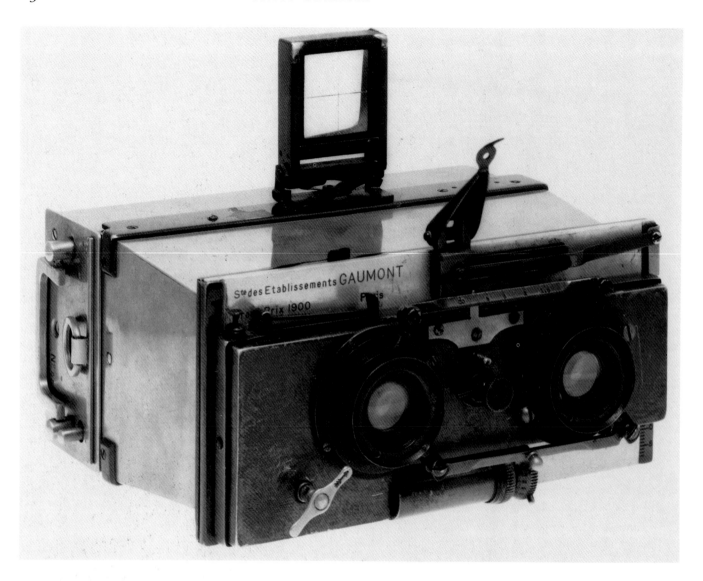

1903
SN 3311
Lenses: pair of 84mm f6.3 Tessars,
Nos 223617 and 223614
Designed and manufactured by Société
des Etablissements Gaumont, Paris

A stereo camera for 6 × 13cm plate or sheet film. The lenses are set in a pneumatic shutter with speeds of 1 to 1/120 sec and B. The lens focuses to 5m and the magazine back carries up to twelve plates or sheet film in special holders. This sort of camera was most popular in France for the production of stereo cards for which many stereo viewers, either of the hand-held or the table model varieties, were available.

The camera is beautifully constructed of nickelled brass with black fittings, but at some 2.5 kilos extremely heavy for a portable camera. Gaumont also made stereo cameras of 9 × 18cm and 4.5 × 10.7cm format. Gaumont went on to become film distributors, particularly within a newsreel context, as Gaumont-Pathé and Gaumont-British.

24 Ruby Patent Stereo

1905
Lenses: two 5 ¾in f6 Anastigmat by
Aldis SN, 100438 and 100447
Designed and manufactured by
Thornton Pickard, Altrincham,
Manchester

A folding bellows camera for 6 ½ × 4 ¾in stereo photographs. The two brass-bound
5 ¾in f6 Aldis Anastigmats are on a rising front panel. The lenses stop down to
f24 and a small Thornton Pickard shutter is attached to the front of the two
lenses. The shutter speeds are T, 1/15, 1/30, 1/45, 1/85 and 1/90 sec. The
inter-lens distance can be adjusted and a small plate has markings for 3 ¼, 3 and
2 ¾. The camera is made of mahogany with brass fittings and red bellows.

25

1906-15
Lenses: fifteen f8 lenses in five rows of
three
Designed and manufactured by
W. Butcher & Sons, Camera House,
Farringdon Avenue, London E.C.

Royal Mail Postage Stamp camera

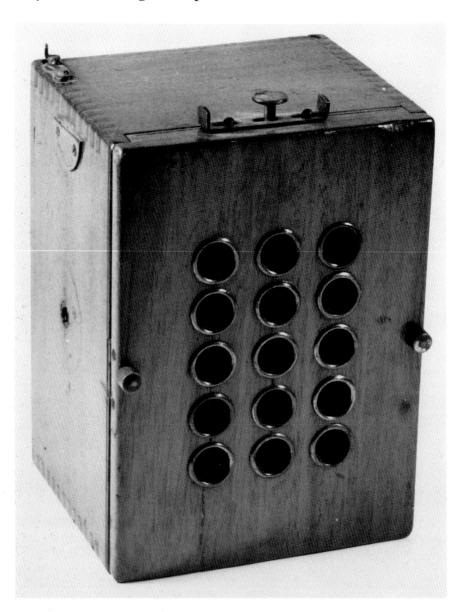

The Royal Mail Postage Stamp Camera was designed to produce fifteen small photographs on a 3 ¼ × 4 ¼ in plate. When printed the photograph would resemble a sheet of stamps, hence the 'postage stamp' name of the camera. The simple lenses are set in a guillotine shutter. The front lens board could be removed; another model existed with only three lenses on a sliding panel to give six exposures on the same plate size. The cameras were supplied with special printing masks. The photographs resulting from the Postage Stamp Camera were very popular at the turn of the century and a German version of the Royal Mail Postage Stamp Camera was produced by Hüttig under the name of the 'Briefmarke'.

The Royal Mail Postage Stamp Camera was built of polished wood with a leather handle. The manufacturer, William Butcher, founded his business is 1866 and was a noted supplier of a vast and diverse range of photographic apparatus. William Butcher later became Houghton-Butcher and then Ensign.

26 Voigtländer Bijou

1908
Lens 4in f4 wide-angle Xpres,
No.207054 by Ross, London
Designed and manufactured by
Voigtländer, Braunschweig

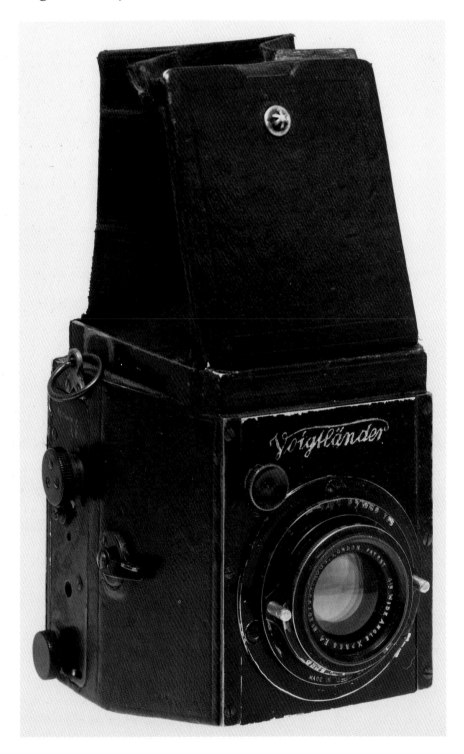

The Voigtländer Bijou was the first miniature single lens reflex camera.
Introduced in 1908, the Bijou used the newly popular 'vest pocket' plate size,
45 × 60mm.

 The camera is of an all-metal boxed body tapered towards the front. The
standard lens was an f4.5 Heliar in a helical focusing mount; the lens in the
illustrated example is of a later period. The lens was set in a rising front enabling
perspective control. A focal plane shutter consisting of two vertically travelling
cloth blinds had speeds of Z, M and 1 to 1/200 sec.

27 Small dry plate camera outfit

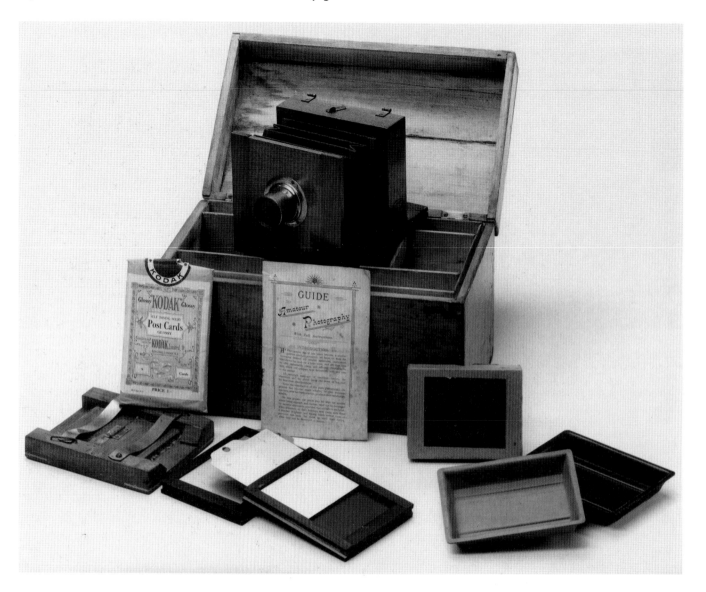

c.1910
Manufacturer unknown

This is a small collapsible camera in an outfit case containing all the necessary equipment for photography. It is very much the beginner's or junior's kit as found in the early 1900s. Many a budding photographer must have started with such a simple outfit.

The outfit consists of a small collapsible bellows camera for 4 ¼ × 3 ¼ in plate. The baseboard of the camera folds, making it very compact. The camera is made of wood, and the bellows, of the crocodile version are of strengthened cloth. The lens is of a single-element f8 5in focus set in a fixed mount. Pill-box apertures would adjust the maximum aperture. Two double dark slide-holders are manufactured of wood and metal numbered 1 – 4. In addition there are the following items:

a printing frame;
two processing Bakelite dishes, one brown and one orange;
a contact printing frame;
a box of a dozen glass Wellington 'extra speedy plates' of 4 ½ × 3 ¼ in format by Wellington & Ward, Elstree, Hertfordshire, speed 350 H + D;
a packet of nine Kodak self-toning solio post-cards, price 1 shilling.

The camera is unmarked, as is the lens. However, it can be safely attributed to British manufacture.

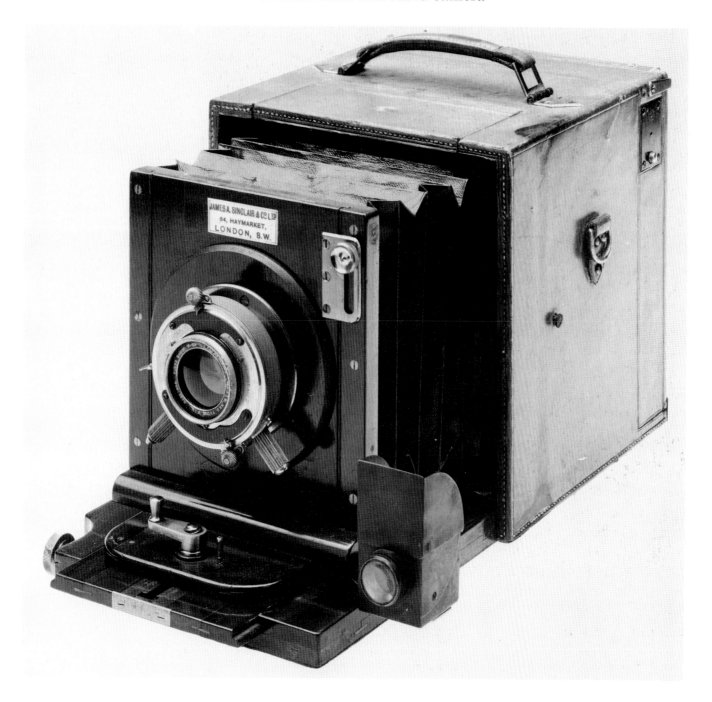

28 Sinclair hand and stand camera

c.1915
Lens 7in f2.8 Goerz Dagor in Bosch &
Lomb shutter
Designed and manufactured by James
A. Sinclair, 54 Haymarket, London SW

See colour plate III

This camera for 5 × 4in plates could be either held in the hand or secured on a
tripod, hence its appellation 'Hand and Stand'. It is a luxury model in that not
only is it covered in pigskin but it also incorporates two shutters, the first being in
the Goerz Dagor lens and the other in the focal plane. The focal plane shutter
has speeds of 1/10 to 1/200 sec, and the Bosch & Lomb speeds of T, B and 1 to
1/100 sec. The lens is set on a rising front and an opening flap on the top of the
camera allows for architectural photography. The waist-lever finder is of the
folding optical variety. The camera has a handle on the top and also has two
lugs for straps on either side.

James A. Sinclair manufactured many different hand and stand cameras of
which a few are in tropical finish and fewer still are covered in pigskin.

Thornton Pickard Type C aerial camera

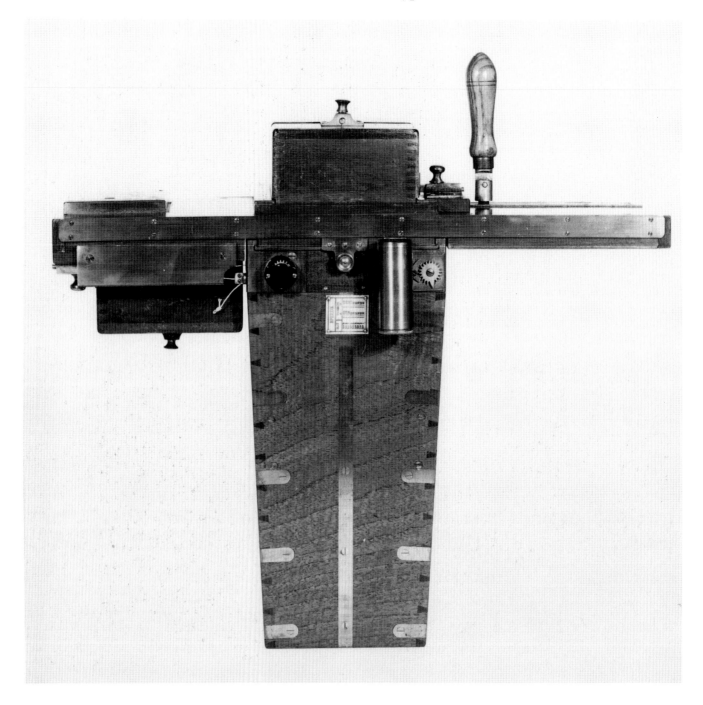

c.1915
SN C192
Lens f4.5 10¼in Ross Xpres
Designed and manufactured by
Thornton Pickard, Altrincham,
Manchester

The Thornton Pickard Type C aerial camera is a World War I model accepting plate magazine backs for up to eighteen 5 × 4in exposures. The camera has a self-capping focal plane shutter consisting of two vertically travelling cloth blinds with choice of speeds from 1/120 to 1/500 sec. Viewing is through a detachable cylindrical brass viewfinder.

The camera has War Department markings and was built to the requirements of the Royal Flying Corps. The first model (Type A) had a Mackenzie-Wishart back but the replacement Type C (as illustrated) had a quick-change magazine back. The camera illustrated started life as a Type A. Brass screws can be seen blocking off holes where the original leather hand grips were attached. Also there is a small brass plate blanking off the position of the original shutter wind-on. One can only assume that this camera never saw service as a Type A, but with the introduction of the Type C was uprated in the factory to Type C specification and given the serial number C192.

30 **Soho Tropical Reflex**

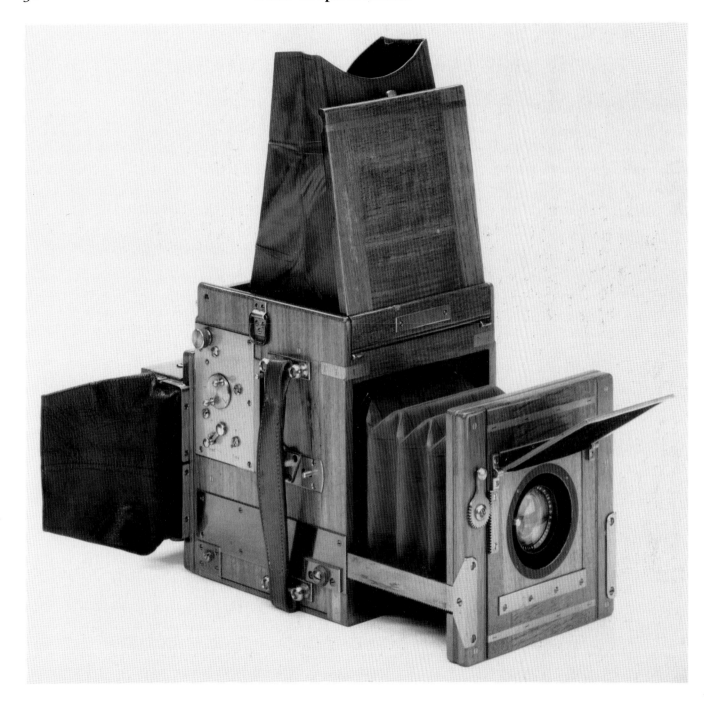

c.1917
Lens 15cm f4.5 Tessar, No.122155 DRP
142294 by Carl Zeiss, Jena
Designed and manufactured by Marion
& Co, 3 (later 22 & 23) Soho Square,
London W1

See colour plate VI

This reflex camera for 4 × 5in plate or film is of exquisite manufacture, built of teak with brass inlays, and having red leather bellows and focusing hood. The 15cm f4.5 Tessar stops down to f45 and focuses to 1ft. The lens is on a rising panel and the whole back rotates, allowing either landscapes or portraits. The focal plane Kershaw patent shutter consists of two cloth blinds travelling vertically with speeds of T and 1/16 to 1/800 sec. The camera has a non-returning mirror, *ie* the mirror has to be lowered after each exposure. The camera comes complete with three double dark slides and a magazine back for twelve slides, either plate or film.

31 Detective box camera

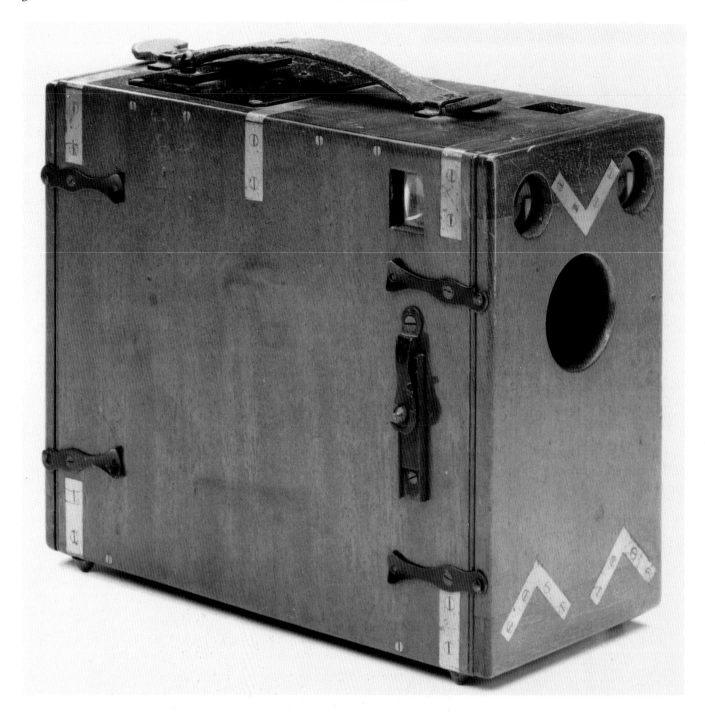

c.1920

This is a hand-held detective box camera with no maker's name (either on body or lens) which contains a plate-changing mechanism for up to twelve 8.5 × 11cm plates.

The 12cm f8 brass lens is a single achromatic which stops down to f32. The lens is set in a spring-loaded sector shutter with settings marked 1, 2 and 3. For any adjustment other than firing the shutter the front panel of the camera would have to be opened. Two small waist-level viewfinders are built into the camera, which could be used either for horizontal or vertical shots.

Unlike most detective cameras this specimen is brass-bound and finished in highly polished wood; it may well be that it was intended for use in the tropics.

32 **Minex De Luxe Tropical Reflex**

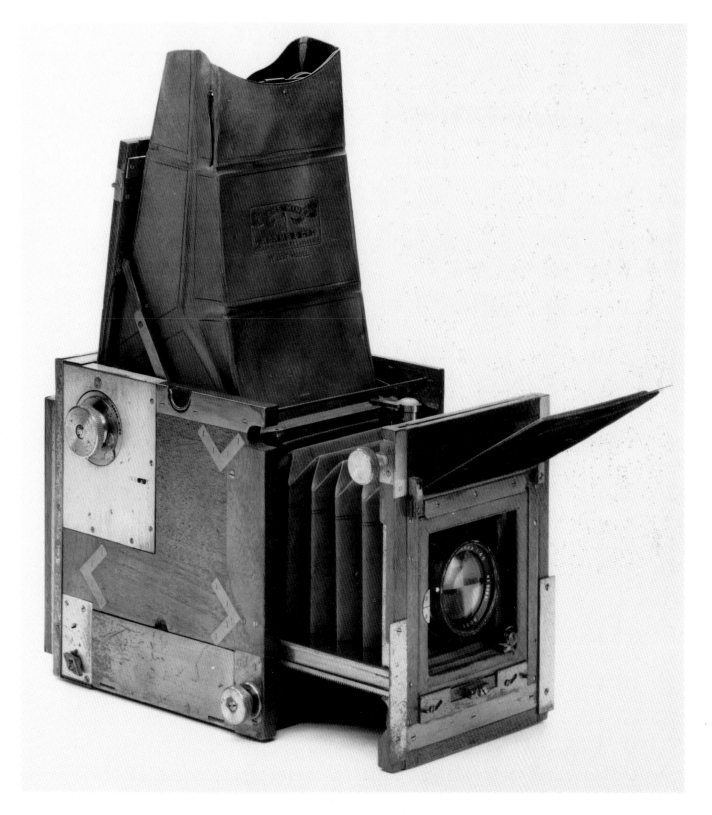

c.1920
Lens 7 ¼in f4.5 Xpres, SN 98641 by
Ross, London
Designed and manufactured by
Adams & Co, 24 Charing Cross Road,
London WC

See colour plate VI

The Adams Minex Deluxe Tropical Reflex, a 5 × 4in single lens reflex, is an
outstanding example of the tropical reflex cameras of the early 1920s. The Xpres
lens stops down to f32 and is deeply recessed in a rising front interchangeable
panel. The shutter is of the focal plane variety, consisting of two vertically
travelling blinds with speeds of T, B and 1/8 to 1/1000 sec. The entire back
rotates, allowing either upright or horizontal images to be taken.

Viewing and focusing are achieved either through the reflex system which has

Minex De Luxe Tropical Reflex
continued

a built-in magnifier or through the ground glass screen. The rack and pinion focusing knob adjusts the focus. An unusual feature is the storage facility for two slides within the lower part of the camera body.

The camera body is built of teak and the parts are brass-bound. The bellows and the focusing hood are in tan leather. The Minex Tropical was manufactured up to the early 1950s, although only in very limited quantities. It can truly be considered as the ultimate tropical reflex camera of the period and certainly the most lavish and expensive. In the 1912 *Photographic Almanac* the Tropical and Expedition model is listed at £32, excluding lens but including two slides. The Tropical and Expedition is described as 'the finest piece of scientific cabinet work ever manufactured, as well as the most substantial and reliable.'

33 Collapsible metal stereo camera

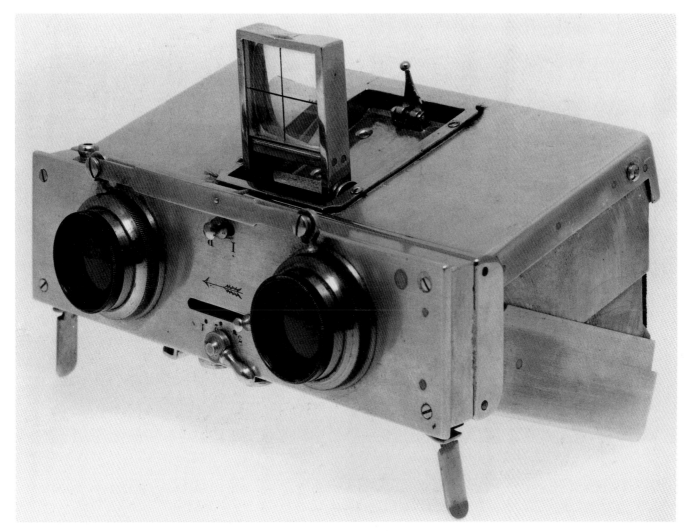

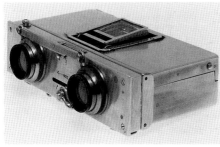

c.1920
Lenses: pair of Rectiligne Balbrack
Manufacturer unknown

This is a small stereo camera made of aluminium and collapsible in the same way as the Lopa or Cyko. When the slide-holder containing the 110 × 40mm plate is withdrawn, the camera can be collapsed from the rear. The lenses are made of brass and the only inscription is: 'Rectiligne Balbrack' with no indication as to focal length or aperture. Further, the camera has no maker's name. As the lenses are French, one would assume that this camera is of French origin, and probably an experimental model. Although single lens cameras collapsing in this fashion were produced, such as the Cyko and Lopa, it would appear that no stereo version was ever produced.

The aperture settings are 1, 2, 3 and 4 and are cross-coupled. There is no provision for focusing the lens and it would seem that this camera was probably for landscape use to produce the stereo cards so popular in the 1930s in France. A small sliding bar acts as a sector shutter and the optical viewfinder on the top of the camera is also folding.

34 Robin Hill Cloud Camera

1924
Lens f8 fish-eye, brass-bound, engraved
'Hill's Cloud Camera 180°',
Patent No.31931/23
Designed and manufactured by
R. J. Beck, London

See colour plate IV

First produced in 1924, based on a patented 1923 design by Beck, this camera incorporates the first fish-eye lens, which has a deeply curved outer surface refracting light from a 180° view into a cone of about 90°, producing a circular photograph of about 2 ½in in diameter on a quarter-sized plate. The lens has wheel stop apertures and also a built-in filter. Exposure is achieved by use of a cap and focusing is through the ground glass screen.

This camera was much used by metereological stations, hence the name 'Cloud Camera'. It was later produced in very small quantities over a great many years. Later models were of a metal construction with a built-in shutter and the diaphragm was extended from f32 to f64.

This is a very rare and historically important camera which was widely used later in architectural photography and other specialist applications.

35 New Special Sybil

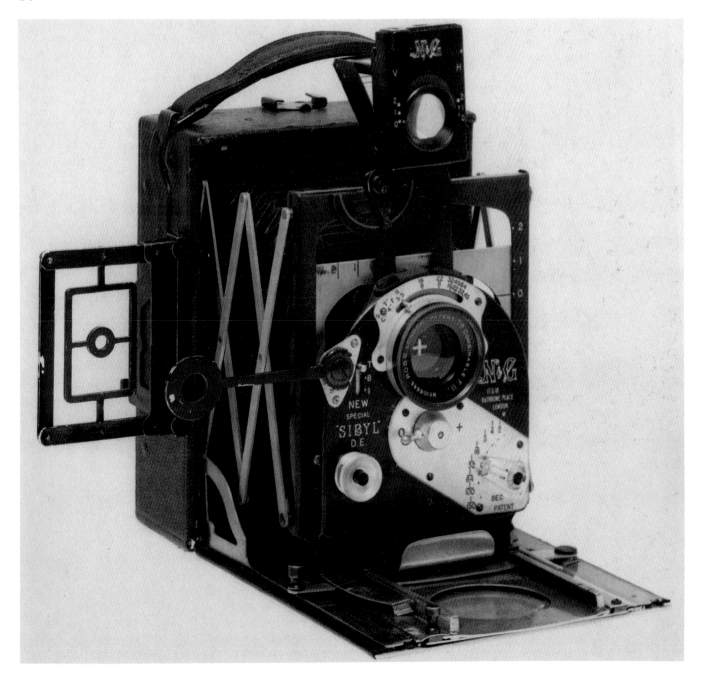

c.1928
Lens 7in f11, Combinable SN 108646 by
Ross, London
Designed and manufactured by
Newman & Guardia, 17 and
18 Rathbone Place, London

The Newman & Guardia Special Sybil is a small collapsible hand and stand
camera for 2 ¼ × 3 ½ in exposures on plate or roll film using 120 film in a special
back. The lens is set in a small D-shaped sector shutter with the following
speeds: T, B and 1 to 1/150 sec. The lens panel/shutter unit slides out of the body
on to the baseboard, and nickel-finished lazy tongs give it rigidity. A small
collapsible waist-level viewfinder incorporating two case-levels and a parallax
adjustment can be folded when the camera is in the retracted position. On the
one side there is also a collapsible frame viewfinder. This particular frame
viewfinder does not appear on production models. Since this camera was
acquired from the buyer of the Newman stocks, it could be an experimental
model. The camera is constructed of aluminium and covered in black leather
with nickel fittings. It comes with an accessory lens, a Goerz Dagor 7.5cm f9 lens
No.1876015 by Carl Zeiss of Jena.

The accessories with this camera are unusual. They comprise a compendium
lens hood, a shade for the waist-level finder, a roll-film back enabling eight
2 ¼ × 3 ⅛ in exposures, a filter, a tripod adaptor and a special cable release. The
New Special Sybil was a light-weight, well-engineered, most successful design.

36

c.1930
Lens 5 ½in f6.3 Homocentric, SN 69364
by Ross, London
Designed and manufactured by
Soho Ltd, 22/23 Soho Square,
London W1

See colour plate VI

Soho Tropical Reflex

The Soho Tropical Reflex is a magnificent example of the most famous of all the tropical reflexes. It takes 5 × 4in plate or film, and has a rotating back to enable either horizontal or vertical exposures.

The Homocentric lens stops down to f22 and focuses to 4in by means of the single extension bellows. Focusing is achieved through the reflex on to the ground glass screen. The mirror of the reflex system has to be lowered after each exposure.

The focal plane shutter consists of two vertically moving cloth blinds and is of the Kershaw patent variety granted in 1904 (Patent No.22698). The shutter has speeds of T, 1/16, 1/24, 1/36, 1/75, 1/150, 1/300 and 1/800 sec. The success of the shutter was partly due to the fact that the only adjustment necessary to vary the speeds was that of changing the width of the curtains. This meant that there was no varying of the shutter tension which would inevitably have weakened the springs. The winding knob is on the right of the camera and the shutter release is coupled to the rise of the mirror.

The camera is built of teak and both the bellows and focusing hood are made of red leather. It was assumed that tropical cameras would be subjected to high temperatures and great humidity, hence teak was considered the most resistant wood. Further, the teak was brass-bound and, unlike the mahogany cameras, the wood was not covered by leather which would absorb moisture and therefore be prone to mildew.

37 Duplex Ruby Reflex

c.1930
Lens 6in f4.5 Cooke Anastigmat,
SN 62495
Designed and manufactured by
Thornton Pickard, Altrincham,
Manchester

See colour plate VI

This camera is a tropical reflex for 4 × 5in plates or film. The Cooke Anastigmat lens stops down to f32 and owing to its double bellows extension focuses up to 1ft. The camera has a revolving back giving either landscape or portrait format. The focal plane shutter is patented (Patent No.628312), and consists of two vertically travelling cloth blinds with speeds of T and 1/10 to 1/1000 sec. The reflex viewing system has an instant returning mirror facility. Focusing and viewing are either through the reflex hood or through a ground glass screen fitted in place of a dark slide. The lens is sunk into an interchangeable panel with a flap covering the actual front element of the lens.

The camera is constructed of brass-bound teak with tan bellows, hood and focusing screen. The camera comes complete with three teak brass-bound double dark slides and one Mackenzie-Wishart daylight slide-holder, patented by Mackenzie and Co, Glasgow.

38 Williamson's Pistol Aircraft Camera

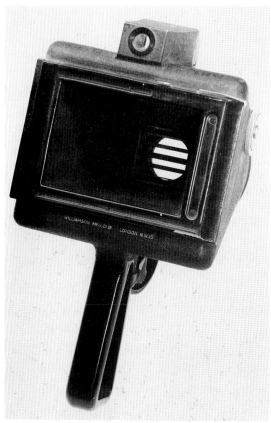

c.1930
SN 314
Lens 136mm f8 Ross Xpres
Designed and manufactured by
Williamson Manufacturing Co,
Litchfield Garden, Willesden Green,
London NW10

This is the earliest hand-held aerial camera. It is for 2 ¼ × 3 ½ in exposures on plate, roll film or film pack. The Ross Xpres 136mm f8 lens is set at infinity and is protected in the cone area of the camera. The shutter is of the Venetian blind type and has the speeds of B, 1/50, 1/100, 1/150 and 1/200 sec. The shutter is operated by a trigger in the handle. There is a special optical viewfinder for direct vision.

The camera is extremely sturdy and is built entirely of metal with a crackle paint finish. In the *British Journal Photographic Almanac* for 1931 the Williamson's Pistol Camera is advertised at £19 10s for air use or £25 for air and ground use.

39

c.1930
Lens 21cm f4.5 Tessar, SN 355073 by
Carl Zeiss, Jena
Designed and manufactured by
Thornton Pickard, Altrincham,
Manchester

See colour plate VI

Ruby De Luxe Tropical Reflex

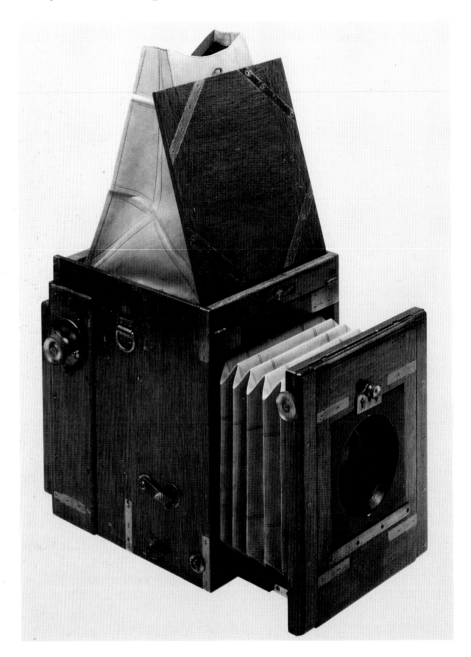

This camera is a most attractive model of a reflex camera for 6 ½ × 4 ¾ in plate or
film negatives. The Tessar stops down to f45, and focuses to approximately 2ft.
The lens is on a rising front panel as such cameras could often be used for
architectural photography. The focal plane shutter consists of two cloth blinds
travelling vertically with speeds of T and 1/10 to 1/1000 sec. The camera
incorporates an automatic mirror return system.

Focusing was achieved either through the folding reflex holder or on the
ground glass screen. The rack and pinion knob assisted in focusing. The entire
back of the camera was revolving, allowing either landscape or portrait images.
The camera came complete with a film pack adaptor for 4 ¾ × 6 ½ in format, and
also three double dark slides in teak, brass-bound, for the 4 ¾ × 6 ½ in format. An
unusual feature was the hinged hood giving access to the screen, were the latter
to be replaced.

The camera was manufactured of teak with brass fittings. The focusing hood
and bellows were of a light calfskin leather, the handle was also of leather, and
there was a facility for a neckstrap. At some three kilos, the weight was rather
heavy for a hand-held model.

40

1930
Lens 10cm f2.9 Anticomar, SN 83219 by
Plaubel & Co, Frankfurt am Main
Designed and manufactured by
Wauckosin & Co, Frankfurt am Main

Makina I

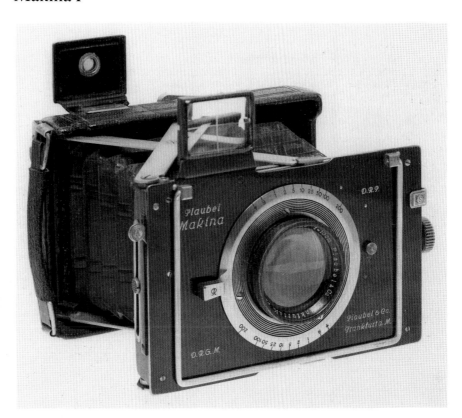

This camera first came onto the market in 1912 in the form of a small metal collapsible strut camera for the 4.5 × 6cm format (vest pocket) and the 4.5 × 10.5cm (stereo size) format. A 6 × 13cm Stereo Makina was also introduced in 1928. But it was the 6.5 × 9cm Makina first introduced in 1925 that became the most popular. The 6.5 × 9cm Makina was constantly improved with the introduction of bayonet-mounted lenses and from 1933 onwards with the introduction of a coupled rangefinder. The last Makina was the flash-synchronised model IIIS which was in production until 1961. With a total production period of twenty-six years, the Makina 6.5 × 9cm certainly ranks as one of the most successful cameras ever designed.

The Makina I, which was particularly popular with continental press photographers, is a collapsible bellows camera for 6.5 × 9cm exposures on sheet film or dry plate. The 10cm f2.9 Anticomar is set in an integral rim-set Compur shutter with speeds of T, B and 1 to 1/200 sec. A lever marked 'S' cocks the shutter, which is released by a lever marked 'A' on the opposite side of the front lens panel. The lens stops down to f25 and focuses to 1.5m. A knob on the right of the lens sets the focus distance which is determined by estimation or through the ground glass screen. The Anticomar lens is unusual in that its elements may be removed and replaced by either wide-angle or telephoto components. The camera has both a folding frame finder and a folding optical viewfinder. The camera is built of leather-covered aluminium and brass with leather bellows and nickel fittings. The very sturdy construction and the simplicity of the design of the Makina ensured that the Makina 6.5 × 9cm concept, albeit in an updated form, survived well into the 1960s. In design it closely resembles a Klapp model with the scissor movement resembling contemporary Contessa Nettel press cameras.

Present times have seen the re-birth of the Makina name in the Japanese-produced 6 × 7cm coupled rangefinder collapsible bellows cameras. Now produced in Japan with Japanese Nikkor lenses, these cameras were designed in Germany by the son of the original designer.

41 Mikut

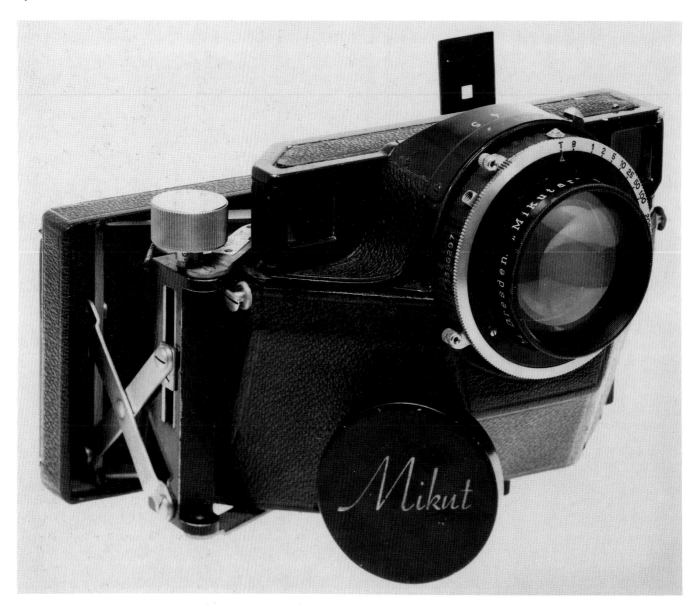

c.1937
Lens 130mm f3.5 Mikutar, SN 43691
Designed and manufactured by
Oskar Mikut, Dresden

The Mikut is an interesting specimen of a compact tri-colour camera and is not only an early colour camera but one of the few working to such a small format. Like all of its type it was doomed in that colour separation negatives need different developing times, which was not possible using a single plate. The later advent of colour negative materials made tri-colour cameras obsolete.

The Mikut colour camera uses a single plate of 4.5 × 13cm format giving three separate 4 × 4cm colour separation negatives of the subject. The lens is set in a rim-set Compur shutter with speeds of T, B, and 1 to 1/200 sec and stops down to f22. A knob focuses the camera via bellows which are held rigid by lazy tong struts. The camera has a built-in optical viewfinder incorporating a rangefinder, or alternatively the ground glass screen may be used. The unusual position of the lens and shutter unit is necessitated by the prismatic beam splitter and its appropriate colour filters.

42 Compass

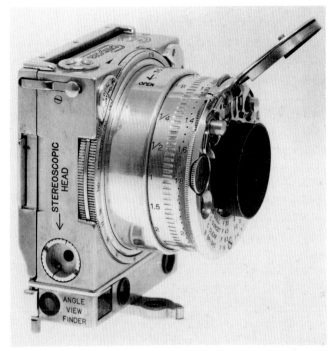

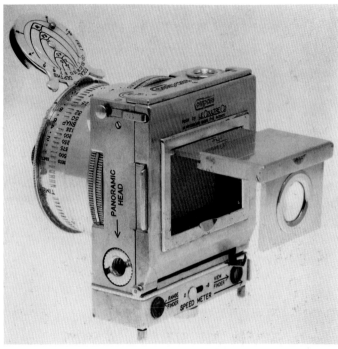

1938
SN 2776
Lens 35mm f3·5 Kern Anastigmat
Designed by Noel Pemberton-Billings,
England, and manufactured by
Jaeger Lecoultre, Le Sentier, Switzerland,
for Compass Cameras, 57 Berners Street,
London w1

See colour plate VII

The Compass camera is of a marvellous design in that it incorporates many features in a tiny space ($1\frac{1}{4} \times 2\frac{1}{8} \times 2\frac{3}{4}$in). One can well appreciate why its construction was contracted out to a famous Swiss watchmaker. The weight of the camera is less than 8oz.

The camera takes 24×36mm exposures on glass plates or six exposures on special roll film. The lens is of Tessar derived construction with the following apertures: f3.5, f4.5, f6.3 and f16. The rotating shutter offers twenty-two speeds from $4\frac{1}{2}$ secs to 1/500 sec and T. For the sake of compactness the lens and shutter unit unlocks and collapses into the main part of the body. Focusing is through an optical finder that also incorporates a coupled rangefinder and a right-angled viewfinder.

The camera also incorporates both a stereo and a panoramic head, three built-in filters, an extinction exposure meter, a spirit level, a built-in lens hood, a focusing screen magnifier, and finally a depth of field scale on the lens cap. Numerous accessories were available such as tiny tripod, a roll film back, an outfit case, a cable release, a contact printer and finally a complete enlarger. The film was produced in plate size and was also loaded in individual light-tight envelopes. Plates and roll film were produced by Ilford Ltd in black and white. A post-war London based company, A. Cubitt & Sons, manufactured a roll film back for the Compass that could take Kodak Bantam 828 size film which produced eight 24×36mm exposures; Kodak produced black and white and Kodachrome in 828 format.

There seem to be two variants of the Compass listed, I and II. Numerous advertisements in the photographic press of the day ensured that the malfunctioning I models have today completely disappeared: the offer advertised their exchange with free replacement II models. Differences in engraving exist and the lettering on the camera is mainly in English or German, rarely in French.

The Compass camera, of an outstanding design and manufacture, was unfortunately too far ahead of its time as regards film development. The results obtained were mediocre to say the least. World War II put an end to the development of the camera.

3 Roll Film Cameras

1888 onwards

The advent of roll film cameras in 1888 was a further step in the popularisation of photography and totally changed the design of cameras. This section starts with Eastman's first Kodak, one of the most important of all cameras, the '1888' [43]. This was the first point and shoot roll film camera, and the model that was to establish the Kodak empire all over the world. It was also the first camera that did not require the photographer to own his own dark room, and hence was the beginning of the photo-finishing industry, Eastman loading and unloading the camera and processing the film. Barely one year after this revolution, the first British roll film camera appeared, the Luzo [44]. In 1901 came the all-metal panoramic 360° Périphote by Lumière [48], hugely expensive, unlike the 1927 Kodak Panoramic 3A [51] that popularised panoramic photography. The 1927 Rolleidoscop [50] by the firm of Franke & Heidecke was a superb roll film stereo camera for the 127 format. The Rolleiflex Standard of 1932 [53] was one of the very earliest of Rolleiflex cameras and one of a long breed. Other Rolleis illustrated are the Rolleicord of 1934 [54], the Rolleiflex 4 × 4 of 1957 [67], the Rolleiflex T of 1958 [68] the Tele-Rolleiflex of 1959 [70], the Rollei Wide of 1961 [71] and finally the Rollei 2.8GX of 1987 [78].

The Kine Exakta I of 1936 [56] is the first 35mm single lens reflex camera, and the Kodak Super Six-20 of 1938 [59] the first camera to incorporate automatic exposure. The Purma Special of 1939 [62] is one of the few twentieth-century cameras to incorporate a gravity set shutter, and, furthermore, variable. The Hasselblad 500C of 1965 [75] is without doubt the workhorse of medium format photography and famous all over the world.

43 1888 Kodak

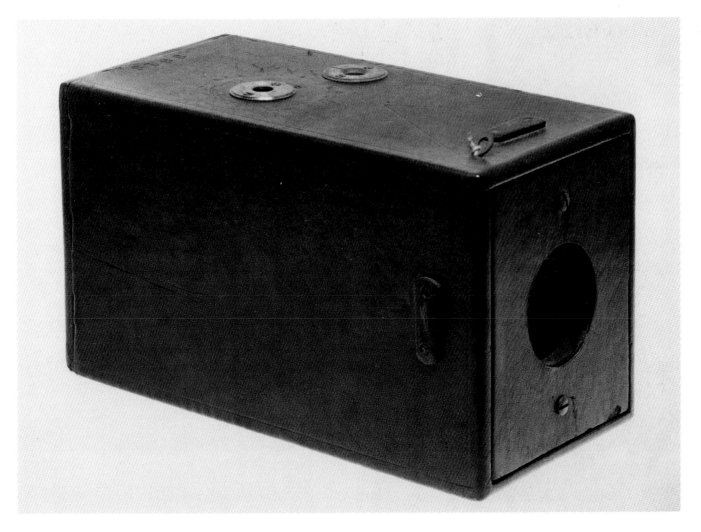

1888-89
SN 3146
Lens 57mm f9 Periscopic
Designed by Frank Brownell, Rochester,
for the Eastman Dry Plate and Film
Company, manufactured by George
Eastman, Rochester, New York State,
US Patent No.388850, 4 September 1888

The 1888 Kodak is a box camera for up to one hundred roll film exposures of 2 ½ in diameter. This camera was the first to combine the simplicity of a point and shoot roll film box with a developing and printing service that did away with the need for the user to have a dark room. Although by today's standards it was a primitive and expensive device it was the beginning of popular photography.

The camera was sold supplied with ready loaded 100 exposure film. When all the exposures had been made the camera was returned to Eastman for unloading, processing and re-loading. Hence there was no need for a dark room. There was a two dollar charge for re-loading the film or a ten dollar charge for re-loading and processing a hundred exposures or at least those that were decent enough to be printed. In this way Kodak were the pioneers of the photo-finishing industry.

The 1888 Kodak was launched as a light-weight detective camera at a not so light-weight price of US$25. The camera was promoted on the basis that it was simple to use: 'You press the button, we do the rest'. Pulling a string wind mechanism would cock the shutter and pushing the release button would complete the exposure.

The camera was built of wood covered with black smooth Morocco leather. The 57mm f9 Rapid Rectilinear lens was of fixed focus and was built into a cylindrical barrel shutter. There was no viewfinder but V-shaped sight lines were to be found on the camera's top surface. The film was advanced by a winding key.

In all it is estimated that only some 5,200 1888 Kodak cameras were produced. Furthermore, as the cameras were designed for the short-lived negative stripping process, few have survived as they soon became obsolete.

44 Luzo

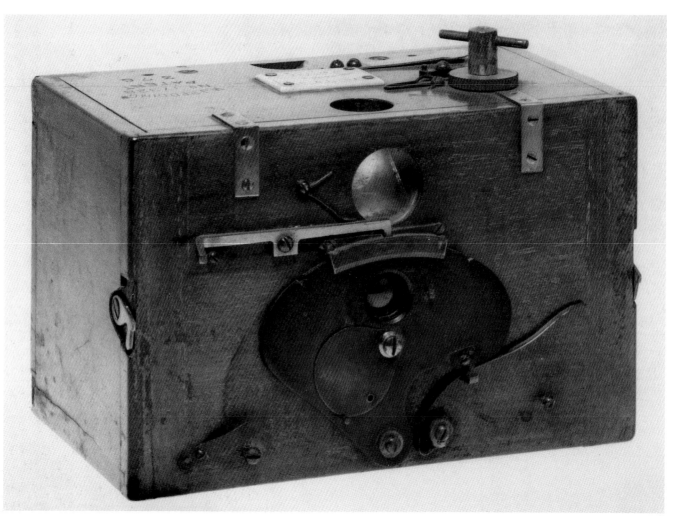

1889-99
SN 219
Lens 3in f8
Designed by H. J. Redding and
manufactured by J. Robinson & Sons,
172 Regent Street, London

See colour plate IV

H. J. Redding took out a patent for this camera, No.17328, on 28 November 1888, intended for the rolls of gelatine coated paper which were used in the first Kodak. The Luzo is therefore the first British roll film camera, an important camera in the development of photography and more advanced than the 1888 Kodak. The camera was produced over approximately ten years, and in very small numbers, probably under 1500. A great many varieties and different models were produced.

In Redding's original design the spools were housed in the front of the camera; this made it more compact in design than the Kodak. The film was fed across the back of the camera past a measuring roller which 'clicked' with each revolution. A pricker could be pressed to mark important exposures. The camera was made by Redding's employer, J. Robinson of 172a Regent Street, London. Later versions of the camera include quarter-plates, 5 × 4in and half-plate sizes. The illustrated example, No.219, was produced in 1889 and is one of the earliest known Luzos. It exposes negatives of 2 ⅜in diameter on 2 ⅞in wide film. It has a round aperture viewfinder, no film counter and a fixed focus lens.

The shutter on the first Luzos was an elastic band powered reciprocating plate, the anchor of the elastic band being moved from side to side after each exposure. The later models used a spring shutter tensioner.

A very unusual leather case which permitted operation from the outside was also available. This gave the Luzo the appearance of a detective camera.

45 **Kodak No.5 Folding Bellows**

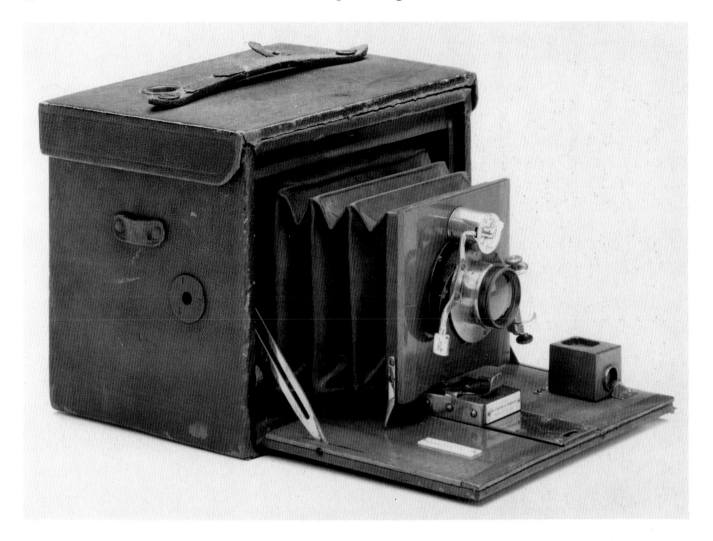

1890-97
Lens 165mm f11 Bosch & Lomb
Universal
Designed by Frank Brownell, Rochester,
New York State; manufactured by the
Eastman Company, Rochester

The No.5 Folding Kodak is a folding roll film camera for 5 × 7in exposures on Eastman's transparent roll fim. The removable Eastman Walker roll film contained the film for fifty-four exposures. The roll film holder had been developed prior to the launch of the camera and is duly inscribed 'Patented 5th May 1885'. Eastman bought rights to the Walker patents which were largely responsible for roll film as we know it.

The Bosch & Lomb Universal lens is set in a shutter by the same maker with speeds of T and ½ to 1/150 sec. Apertures are set by a wheel stop mechanism with markings from 1 to 5. The camera could either be focused using the removable ground glass screen at the rear of the camera or by using the small distance scale on the front of the baseboard. The camera could focus to 5ft. The small waist-level viewfinder could also be rotated for horizontal or vertical shots.

The camera was built of wood covered by leather with brass fittings.

46

1893
SN 14628
Lens fixed aperture meniscus
Designed and manufactured by
Alfred C. Kemper, Chicago; based on an
American patent issued on 20 December
1892 to William V. Esmond

Kombi

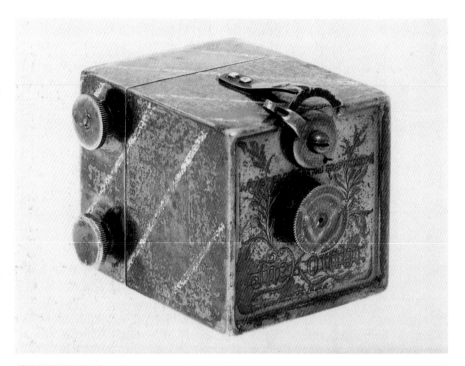

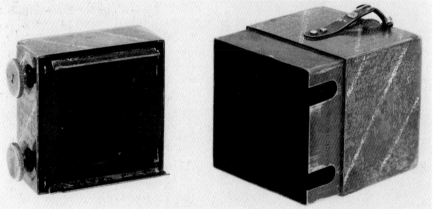

The Kombi is a miniature box camera for up to twenty-five 38mm diameter round exposures on 38mm wide roll film. It is the first miniature camera for roll film. The roll film was especially manufactured by Eastman Kodak of Rochester.

Three turns of the knob would wind the film to its correct position. There is a fixed focus lens and the lens cap is removable to adjust the aperture. There is a single speed sector shutter and no viewfinder.

The front and the back of the camera would separate. The back could be used as a viewer, hence the name of 'combined camera and graphoscope'. The camera was launched at the Colombian exhibition of 1893 at a price of $3. According to Kemper advertisements, some 50,000 were sold a year. The camera was constructed of brass with anodised silver finish.

47

Cyclographe panoramique à foyer variable

1896
SN 76
Lens 11cm f7.5 Darlot
Designed and manufactured by
Jules Damoizeau, 52 avenue Parmentier,
Paris

See colour plate V

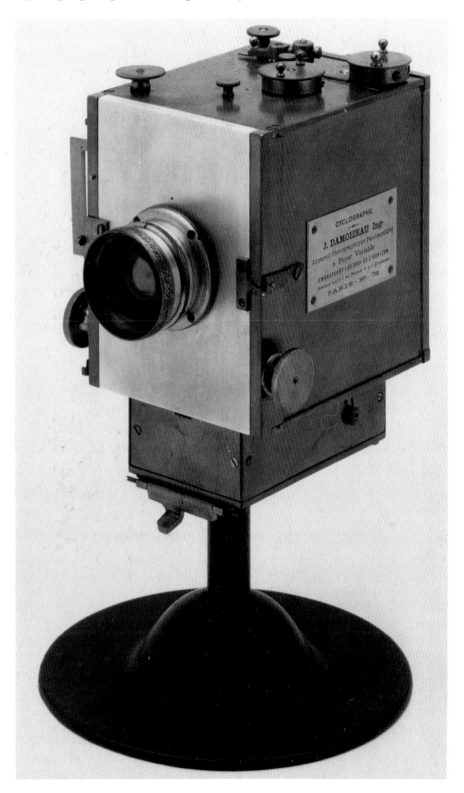

This camera is a typical product of the late nineteenth-century vogue for panoramic photographs. It produces a 360° panoramic image using 9cm wide film. It gives negatives 8.5cm wide up to 80cm long. The camera lens is on a rising front panel, and the aperture stops are marked 1 to 39.

A folding frame-finder determines the field of view and the camera is driven by a key-wind clockwork motor. Whereas the camera rotates on its axis, the film unwinds inside the camera but in the opposite direction past a narrow slit at the

Cyclographe panoramique à foyer variable *continued*

plane of focus. The exposure is in effect determined by the rotational speed at which the film goes past the slit and of course by the aperture of the lens. Small interchangeable pales of varying sizes help select the exact speed for the clockwork motor.

The camera is of a metal construction with a partially gilded finish. The small name plate bearing the details of its construction is slightly misleading. It indicates that the camera is a variable focus type ('foyer variable'), whereas this model is a fixed focus type. A variable focus Cyclographe constructed in wood was produced in smaller quantities and it may well be that the same name plate was used for this particular specimen.

It would appear that this all metal Cyclographe is unique, and it could be an experimental metal version of the wooden model. It was exhibited as item No.94 in the exhibition *La Photographie des origines à nos jours*, Passage 44, Brussels, April-June 1982.

48 Périphote

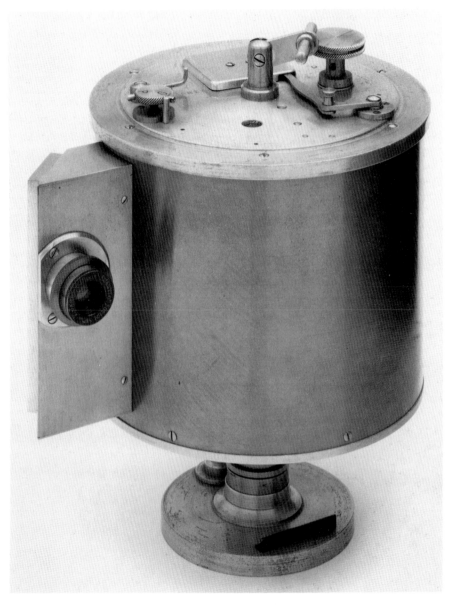

1901
SN 101
Lens 55mm f7.5 Jarret
Invented and manufactured by the
Lumière brothers of Lyon, France
Patented in Switzerland on 1 March
1901, and in England on 28 February
1901

See colour plate V

The Lumière Périphote is one of the earliest of the roll film panoramic cameras
and certainly the most attractive. It took six 7 × 38cm panoramic shots using
perforated film. The camera basically consists of two cylinders. The inner
cylinder is fixed to a foot to which the film is wound and the outer cylinder
rotates around the latter during exposure. The lens is at a tangent to the film
plane, hence the prism is behind the rear element. A lever enables the selection of
either 180° or 360° rotation.

 The camera is unique in having no viewfinder at all. It is constructed of both
aluminium and chromed brass, a most attractive combination. This particular
example of the Périphote, going by its serial number (101), was probably the first
or second produced. It comes complete with its only accessory, a carrying case.
Very few Lumière Périphotes were produced and it is interesting to note that the
Lumière brothers went on to produce a larger panoramic camera.

 The Lumière brothers were pioneer cinematographers and camera-makers.
They designed what is recognised as the first ciné camera in 1895, began
production as makers of both still and ciné cameras, and lastly manufactured
photographic materials, the most famous being the Autochrome.

49 Ticka watch face pocket camera

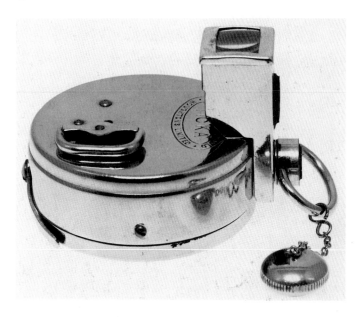 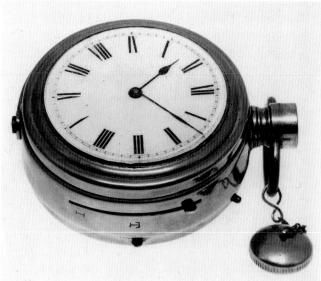

1907-16
Lens 30mm f16 Meniscus
Designed by Magnus Niell, Sweden and
manufactured by Houghton's, London
and Glasgow

The Ticka is a pocket watch camera for up to twenty-five 22 × 16mm exposures on
16mm film in special cassettes. It is typical of the craze of the early 1900s for spy
or detective cameras. It was manufactured in massive quantities and was more of
a toy than a serious camera. The Ticka was also available in hallmarked silver,
and another version incorporated a focal plane shutter.

The Meniscus lens is set in what would be the winding key of the watch. The
shutter is of the sector variety with either T or I at 1/60 sec. The cap on the chain
is used not only to protect the lens but also to cover the lens when arming the
shutter as the shutter is of the non-self-capping variety. A small optical
viewfinder would clip onto the winding key. However, with the watch face
Ticka the hands (set at 7 minutes past 10) indicated the field of view.

50 Rolleidoscop

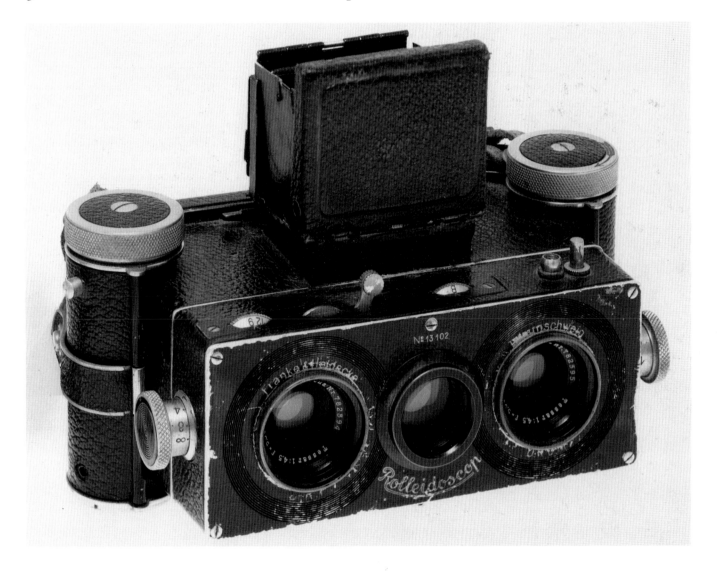

c.1927
SN 13102
Lenses: pair of 5.5cm f4.5 Tessars, SNs
782394 and 782395 by Carl Zeiss, Jena
Viewing lens Sucher Triplet 5.5cm f3.2,
SN 783123 by Carl Zeiss
Designed and manufactured by
Franke & Heidecke, Braunschweig

The Rolleidoscop is a stereo roll film camera producing up to six 4 × 4cm stereo pairs on 127 roll film.

The two Tessars are set in a shutter with speeds of B, T, and 1 to 1/300 sec. The lenses are in a rising front which could be used to correct the parallels. Viewing is achieved through the Sucher Triplet lens. The collapsible waist-level viewfinder is complete with a bubble and a magnifier to increase the accuracy of focusing.

The body is manufactured of metal and is covered in black leather complete with nickel fittings. The camera was a successful design and had been available earlier in 1926 in 120 format, producing two 6 × 6cm exposures. A plate version of both models of the Rolleidoscop, the Heidoscop, had first been available from 1925 with an interchangeable back for either plate or film. With the advance in popularity of roll film cameras a roll film back was first made available for the Heidoscop and finally the Rolleidoscop was introduced.

An advantage of the Rolleidoscop over the Heidoscop was the greater ease of loading the film. With the Rolleidoscop there was also no possibility of the film or plate jamming in the changing back mechanism. The Rolleidoscop was also much lighter and was substantially cheaper at £30 15s in 1931 as opposed to £38 15s. The Rolleidoscop was advertised in the 1931 *British Journal Almanac* as an all-round camera which was equally well adapted for stereoscopic and single photographs. It is highly unlikely that the Rolleidoscop would have been used for anything else other than stereo photographs.

Kodak Panoramic No.3A

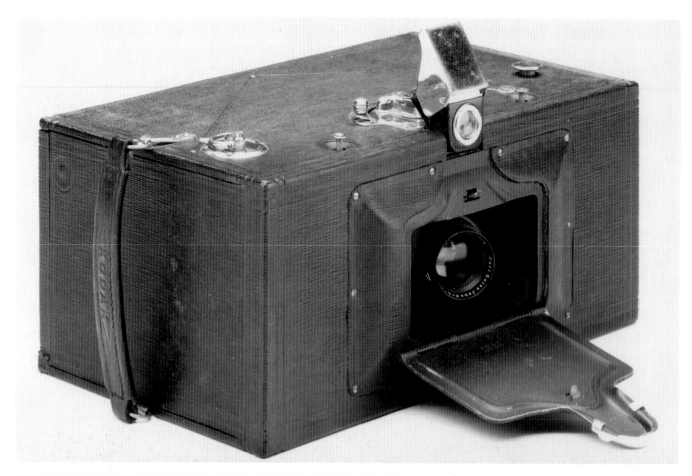

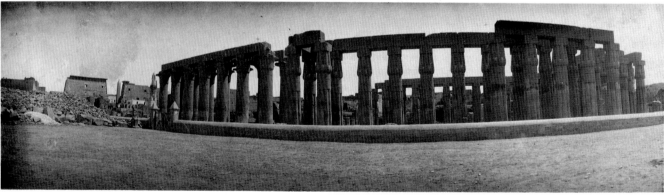

Panoramic photograph, c.1910, of Luxor, Egypt; a camera similar to the Kodak Panoramic No.3A was used.

1927-30
Lens Tessar 130mm f6.8 by Carl Zeiss, Jena
Designed and manufactured by the Eastman Company, Rochester, New York State

The Kodak Panoramic series of cameras were immensely successful and popularised panoramic photography for the amateur at the peak of its vogue. Previous Panoramic cameras such as the Damoizeau Cylindrographe and the Lumière Périphote had been for expert hands only. The model 3A has a swinging lens which covers a 120° angle producing 3 ¼ × 10 ⅜ in negatives on 122 roll film. The shutter has two speeds of either 1/10 or 1/50 sec. The camera has a small brilliant finder with a mirror for eye-level use. Additionally, in the top of the camera are V-sighting lights. The Kodak Panoramic 3A also incorporates a T-shaped spirit level.

The camera is constructed of wood covered with leather and was available with either the illustrated 130mm f6.8 Zeiss Tessar lens or a 133mm f6.3 Ross Homocentric lens.

52 Nagel Pupille

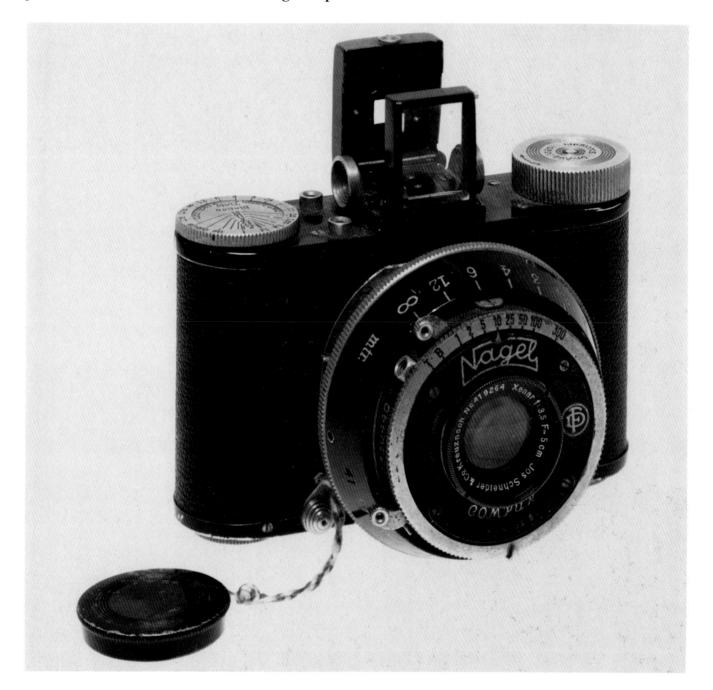

1931-35
Lens 5cm f3.5 Schneider Xenar,
SN 419264
Designed and manufactured by
Nagel Werke, Stuttgart

The Nagel Pupille is an extremely compact eye-level fixed camera for up to sixteen 3 × 4cm exposures on 127 film.

The Schneider Xenar lens is set in a Compur shutter with speeds of 1 to 1/300 sec, T and B. The lens is mounted on a beautifully designed helicoidal tube focusing right down to 13in. The camera has a small folding optical viewfinder and an accessory mirror reflex unit would aid close-up focusing.

The camera was first available with either a Schneider 4.5cm f2 Xenon, a Schneider 5cm f3.5 Xenar or a Leitz Elmar 5cm f3.5. From 1932 to 1935 the Pupille was marketed by Kodak AG and was offered with a 5cm f3.5 Zeiss Tessar or a 5cm f2.8 Zeiss Tessar. The Leitz long base rangefinder was also available and duly engraved 'N' (for Nagel) on the focusing wheel.

Nagel, after being bought out by Kodak, continued to design and manufacture Kodak's top cameras including the famous Retina, Duo and Regent series. When Retina ceased production after the war, Nagel made top-of-the-range Instamatics and lastly a 110.

53

1932-34
SN 217484
Lens 75mm f4.5, Tessar, SN 1358894 by
Carl Zeiss, Jena
Viewing lens 75mm f3.1 Heidoscop
Anastigmat
Designed and manufactured by Franke
& Heidecke, Braunschweig

Rolleiflex Standard

The Rolleiflex Standard (Type 2) is a twin lens reflex for up to twelve 6 × 6cm exposures on 120 film and is based on the most important 1929 Rolleiflex twin lens reflex. Although the Franke-Heidecke partnership had been in camera production since 1921 with the Heidoscop and Rolleidoscop stereo cameras, the most important camera produced was the 1929 Rolleiflex twin lens reflex. In the years that followed many a professional would abandon his plate camera and move over to the Rolleiflex and to the lower cost model, the Rolleicord. The current 1988 Rolleiflex 2.8GX is still based on the same concept as the Rolleiflex Standard.

The lens is set in a Compur shutter with speeds of T, B and 1 to 1/300 sec. The viewing lens is one stop brighter than the lens to give a better viewing image. The camera has a folding hood with a built-in magnifier and sports viewfinder. The film advance is by lever, unlike the original Rolleiflex of 1929.

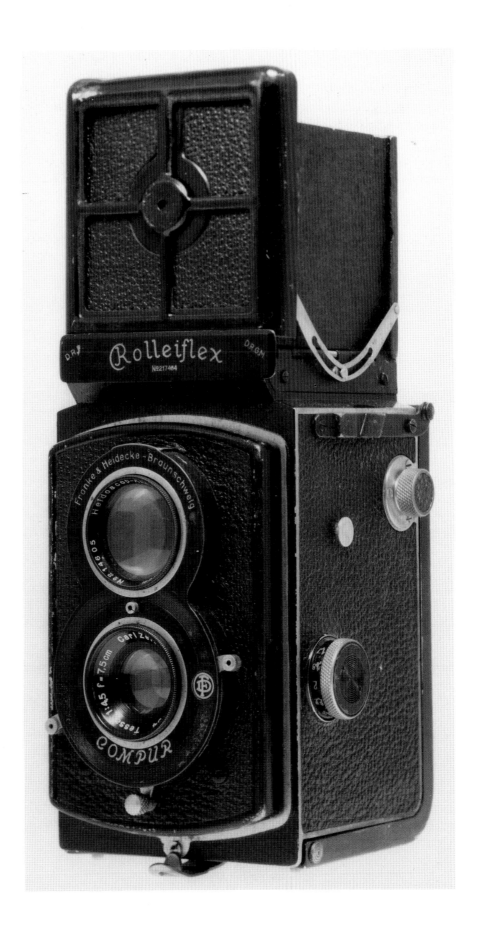

54

1934-36
SN 320
Lens 7.5cm f3.8, Triotar, SN.1622950 by
Carl Zeiss, Jena
Viewing lens 7.5cm f3.8 Heidoscop
Anastigmat
Designed and manufactured by Franke
& Heidecke, Braunschweig

Rolleicord I

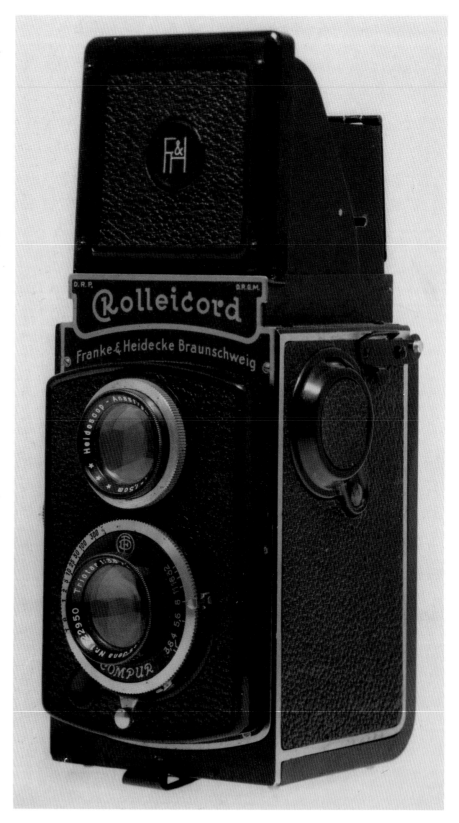

The first Rolleicord was introduced in 1933 as a more modestly priced
alternative to a Rolleiflex. The Rolleicord was very successful and some eighteen
different models were manufactured from 1933 to 1975.

The Rolleicord I, Type 2 is a twin lens reflex for up to twelve 6 × 6cm exposures
on 120 film. The three-element taking lens is set in a Compur shutter with speeds
of T, B and 1 to 1/300 sec. The viewing lens is a 7.5cm Heidoscop Anastigmat of
f3.8 aperture.

55 Night Exakta

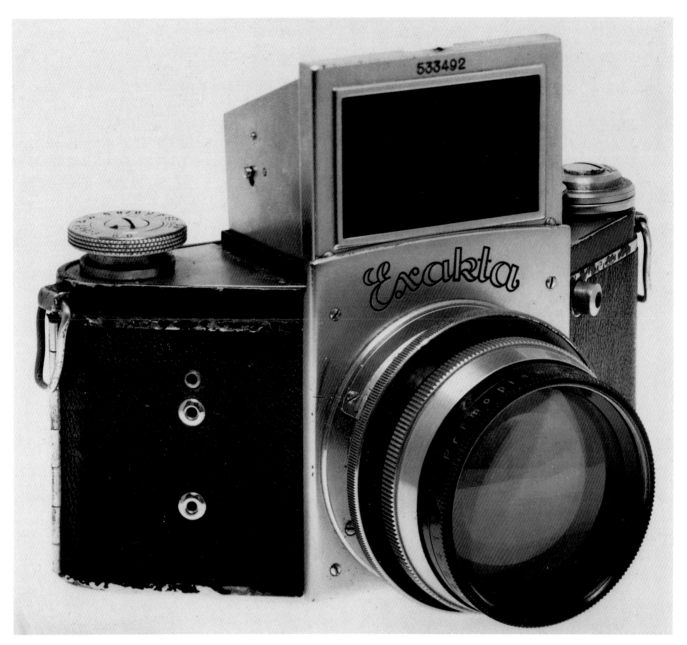

1935
Lens 80mm f2 Primoplan, SN 533492
Designed and manufactured by Ihagee,
Kamerawerk, Steenbergen & Co,
Dresden

The Night Exakta is a single lens reflex for up to eight 4 × 6.5cm exposures on 127 roll film. The camera is one of the earliest cameras with a very fast lens and owes its name to its 80mm f2 Primoplan lens. Alternative lenses available were the 80mm f2 Biotar, the 80mm f2 Xenon and the Super Six 8cm f1.9. The Dallmeyer Super Six lens was a UK only option. The Primoplan lens stops to f22 and focuses to 1m. The shutter is of the focal plane variety and consists of two cloth blinds travelling horizontally with speeds of 12 secs to 1/1000 sec. The camera also incorporates flash synchronisation sockets and a self-timer. The camera's folding hood, which also bears the serial number of the lens, has a built-in sports finder and magnifier. Because of the high aperture of the lens each lens has to be individually matched to a camera, hence the lens serial number on the body.

The camera is manufactured of brass with chromed finished metal parts. The remaining parts are covered with black leather. The Night Exakta was listed at £41 in 1935 and hence very few were sold.

56

1936
SN 485106
Lens 5cm f2.8 Tessar, SN 1913709 by
Carl Zeiss, Germany
Designed and manufactured by Ihagee
Kamerawerk, Steenbergen & Co,
Dresden

Kine Exakta I

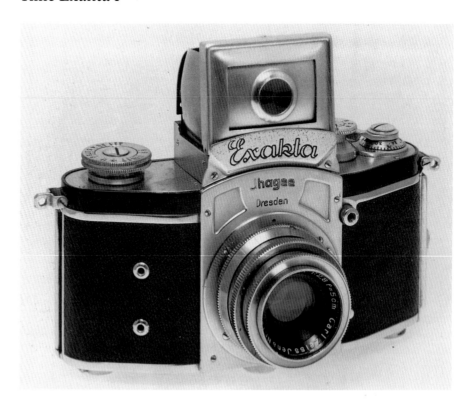

The Kine Exakta I is the world's first 35mm format single lens reflex camera system, producing up to thirty-six 24 × 36mm exposures on 35mm film. Ihagee Kamerawerk produced cameras from the early 1920s, in particular reflex 127 models from 1933, the first one being the Exacta A. The Kine Exakta I is very similar in design to the 127 model. The Kine, derived from the use of standard ciné film (*Kine* in German), was the first in a long line of 35mm single lens cameras bearing the name Exakta.

The bayonet-mounted interchangeable 5cm f2.8 Tessar lens stops down to f22 and focuses to 2ft 6in. The camera has a focal plane shutter consisting of two horizontally travelling cloth blinds with speeds from 12 secs to 1/1000 sec. The left-hand shutter speed control dial covers the speeds 1/25 to 1/1000 sec, B and Z. The right-hand shutter speed control dial covers the speeds of 1/10 to 12 secs. The delayed action setting can be used at any setting between 6 secs and 1/1000 sec. The camera also has a two-pin synchronisation socket for flash. The shutter release is operated by the left hand and is on the front face of the camera. This unusual location is probably due to the fact that a squeezing rather than plunging movement is less likely to result in camera shake. The folding metal viewfinder hood incorporates a round focusing magnifier. The viewing screen is not plain ground glass but a planoconvex condenser less with a matt ground lower surface. The focusing hood can also be converted to a sports finder, which was often used, as the reflex image was of necessity laterally reversed and when the lens was stopped down the image would be rather dim in all but the brightest conditions. Although the Kine Exakta I could be used with normal cassettes, a unique built-in cutting knife could be operated when using a cassette-to-cassette system.

The Kine Exakta I was also available with the Exakta 50mm f3.5, the Primotar 50mm f3.5, the Tessar 50mm f3.5, the Primoplan 50mm f1.9 and the Biotar 50mm f2. The camera was offered with a vast array of accessory focal length lenses by Ihagee, Zeiss, Schneider, Dallmeyer and Meyer.

57

c.1936
Lens 20mm f10
Designed and manufactured by the
Coronet Camera Company,
Birmingham

Coronet Midget

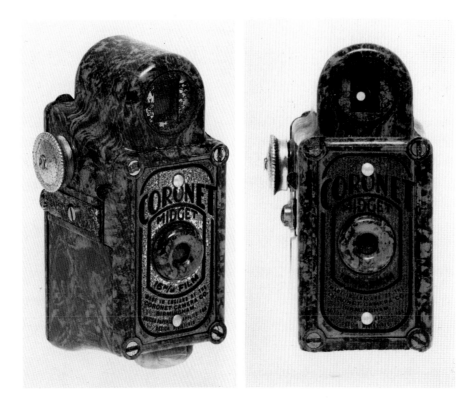

The Coronet Midget was a novelty camera often given away in cereal packets, a sub-miniature for up to six 13 × 18mm exposures on 16mm film wound in special spools. The lens is a focus fixed aperture f10 Meniscus by Taylor Hobson. The shutter is of the single speed 1/30 sec sector variety.

The Coronet was built of bakelite and was available in six different colours: green, black, blue, walnut, rose and olive.

58

c.1937
Lens 75mm f3.5 Radionar, SN 1081585
by Schneider, Kreuznach
Designed and manufactured by Paul Zeh
Kamerawerk, Dresden

Zeca-Flex

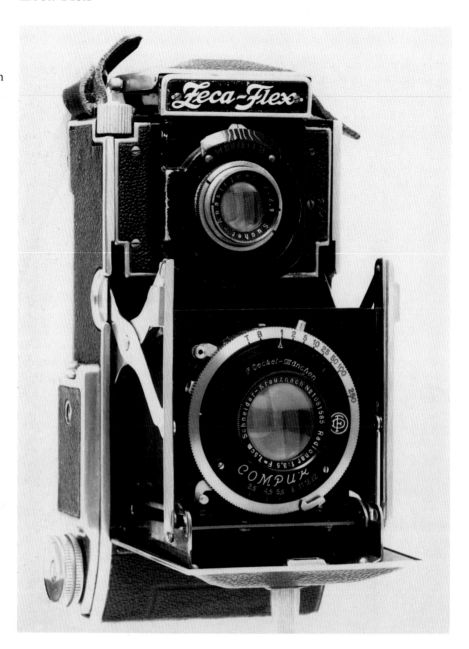

The Zeca-Flex is a twin lens reflex for up to twelve 6 × 6cm exposures on 120 film. The camera is unusual in that it incorporates a folding bellows unit for the taking lens. The three-element 75mm f3.5 Radionar is incorporated within a rim set Compur shutter with speeds of T, B, and 1 to 1/400 sec. The Zeca-Flex was also available later with four-element Xenar or Tessar lenses. The lens focuses to 1m and stops down to f22. The camera also has a folding hood and magnifier to assist viewing and focusing. The viewing lens is a f2.9 lens giving an extremely brilliant image on the screen. The body of the camera is made of light metal casting and is exceedingly strong in construction.

This particular folding 6 × 6cm twin lens reflex never became popular although it was much slimmer than its rival, the 6 × 6cm Rollei twin lens reflex.

59

1938-45
SN 2698
Lens 100mm f3.5 Kodak Anastigmat
Special No.144
Designed and manufactured by
Eastman Kodak Co, Rochester,
New York State

See colour plate VII

Kodak Super Six-20

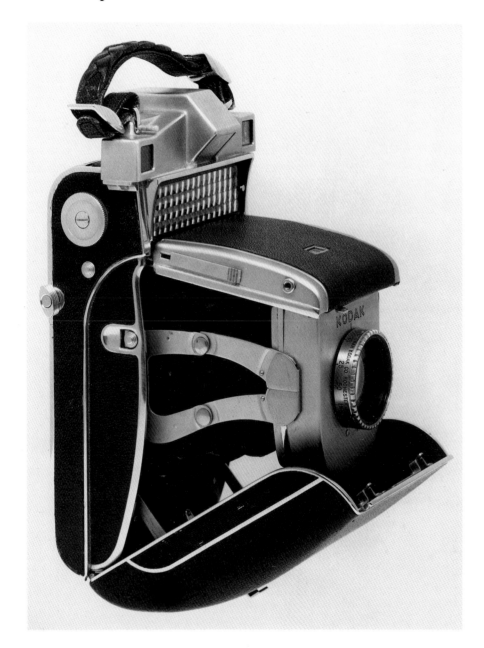

The Kodak Super Six-20 was a landmark in the technical development of cameras in that it was the first to incorporate automatic exposure. Probably less than a thousand were produced. The aperture blades of the lens would vary according to the quantity of light entering the selenium cell on the top of the camera. A set of special masks would reduce the light entering the cell according to the film speed rating, as no adjustment of the camera was possible.

The camera had a folding bellows type design with an optical viewfinder incorporating a rangefinder. Eight 2 ¼ × 3 ¼ in exposures on 620 film were possible using the Kodak Anastigmat Special 100mm f3.5 lens. The lens could stop down to f22 and the speeds were B and 1 sec through to 1/200 sec.

The film was advanced using a lever on the right of the camera which would also cock the shutter. The camera was finished to a high degree and was constructed mainly of aluminium covered by leatherette. The outside casing was designed by Walter Dorwin Teague.

60 Suprema

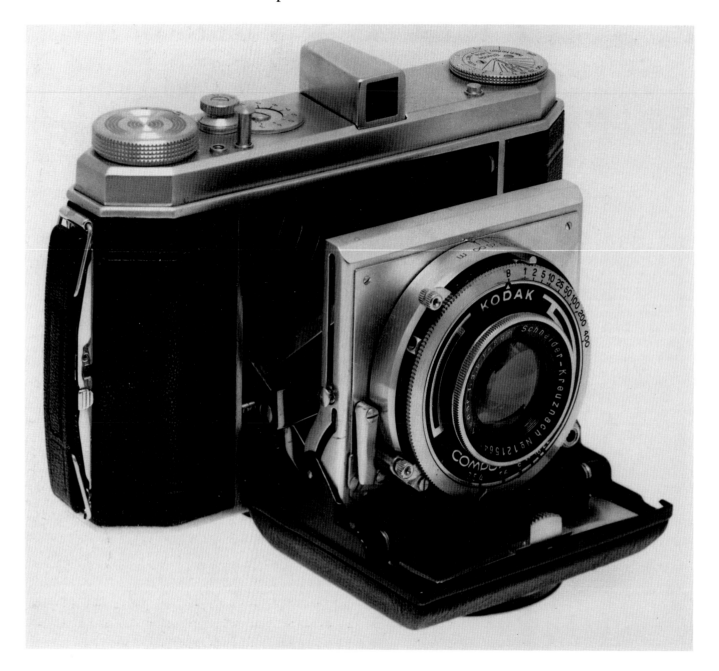

1938-39
Lens 80mm f3.5 Xenar, SN 1215641 by
Schneider, Kreuznach
Designed and manufactured by Kodak,
Germany

The Kodak Suprema is a self-erecting, folding roll-film camera for up to twelve
6 × 6cm exposures on 620 roll film. The 80mm f3.5 Xenar is set in a Compur rapid
shutter with speeds of B and 1 to 1/4000 sec. The lens stops down to f22 and the
nearest focusing distance is 1m. The camera does not have a rangefinder but has
a direct vision optical viewfinder and an automatic frame counter.

In design the Suprema owes a lot to the Retina. The Suprema looks like an
oversized Retina, which is not surprising since it was designed and made at the
Nagel works. Less than 2000 Supremas were manufactured and production was
halted owing to the war.

The camera is made of metal with matt chromed parts and is highly finished.

61

Regent II

1939
Lens 10.5cm f3.5 Xenar, SN 1412005 by
Schneider, Kreuznach
Designed and manufactured by Kodak,
Stuttgart

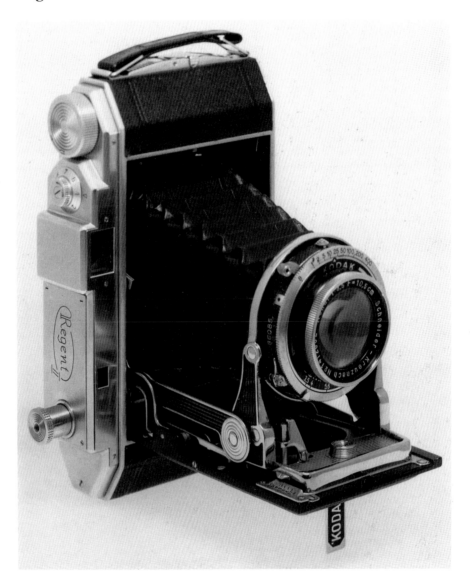

The Regent II is a coupled rangefinder camera for up to eight 6 × 9cm exposures
on 120 film, or, using a special mask, sixteen 4.5 × 6cm exposures could be
obtained.

The Xenar lens, set in a Compur rapid shutter with speeds of T and 1 to 1/400
sec, would stop down to f22 and focus to 1m. The camera has a combined
rangefinder-viewfinder unit and the top plate also contains the shutter release.
The camera has a self-erecting baseboard mechanism and the top plate is of
chrome-plated metal. The unusual streamlined shape is however very typical of
the late 1930s. Once again, owing to the outbreak of war, very few of these
cameras were produced.

62

1939
Lens 2 ¼in f6.3 Beck Anastigmat
Designed and manufactured by Purma;
marketed by R. F. Hunter, Gray's Inn
Road, London WC2

Purma Special

This miniature camera taking sixteen square pictures of 1 ¼in × 1 ¼in format on standard VP film, either number 27 or number 127, is one of the few twentieth-century cameras to have made use of a gravity set variable shutter speed mechanism. The three-element lens, of which all surfaces, with the exception of the outside of the front and the back elements, are bloomed to reduce internal reflection, has a fixed aperture of f6.3. The lens is of a fixed focus to give a sharp image of all objects from 20ft in front of the camera to the horizon. The lens barrel is spring-mounted and a screw-on lens cap holds the lens in a collapsed position.

The shutter has no means of external adjustment. Its speed is decided only by the manner in which the camera is held. There are three speeds: slow (1/25 sec), medium (1/150 sec) and fast (1/450 sec). When the camera is held level the shutter automatically sets itself to work at 1/150 sec. With the camera held on the left side the shutter speed becomes 1/450 sec, and when the camera is held on the right side the shutter speed is 1/25 sec. As the picture is square, the shape is not altered by turning the camera to set the shutter speed. The shutter itself is of the focal plane variety. Light is emitted to the negative through a slit which travels across the picture from right to left with the camera in the level position when the shutter release is pressed. The slit is in a curved metal plate, guiding a metal vein attached to this plate and linked with a pivoted brass weight. This narrows and widens the slit according to the position of the camera, varying the width from about 1/16in in the fast position to about ½in in the slow position. As the pivoted weight is attached to the main shutter plate it also helps to control the weight at which the shutter travels. In the slow position it backs against the shutter spring, in the medium position there is no effect, and in the fast position it acts with the spring.

A moulded plastic lever fitted flush with the upper surface of the camera to the right of the viewfinder window sets the shutter. It has a white arrow on top to show the direction in which it is to be set. The viewfinder is of the optical direct vision type, giving a reduced image of the field covered by the lens.

The body of the camera is made of two black plastic mouldings, one carrying the lens, the shutter assembly, the viewfinder and the film wind, and the other forming a detachable back and carrying the film pressure plate and exposure windows. The camera has a slightly curved film plane. Filters and close-up lenses were available.

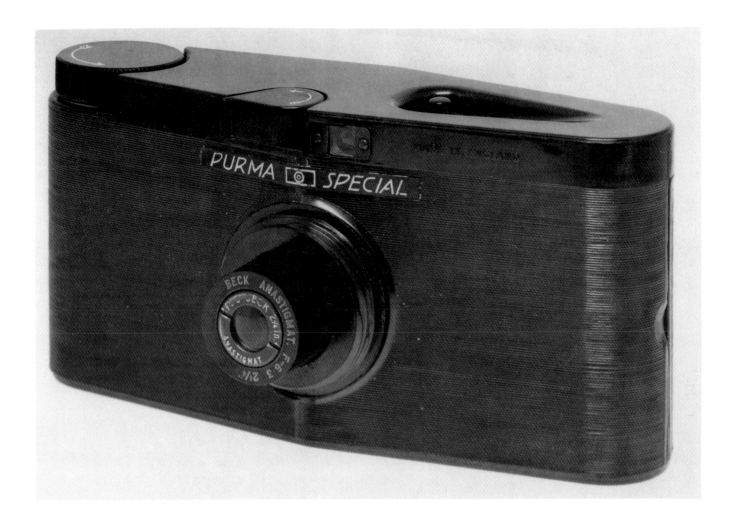

63

1947-53
Lens 100mm f11 Meniscus
Designed and manufactured by Kodak,
Harrow, Middlesex

Six-20 'Brownie' E

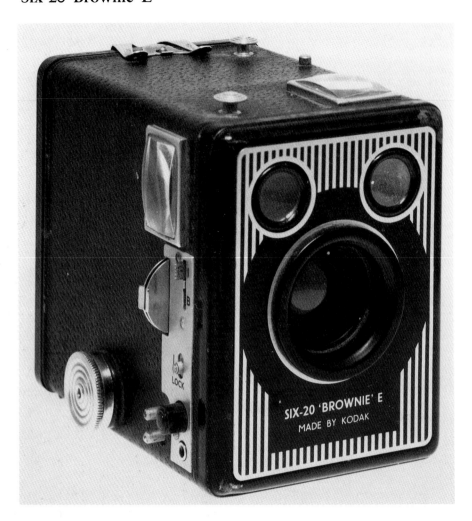

The Six-20 'Brownie' E, a box roll film camera for up to eight 2 ¼ × 3 ¼in exposures on 620 film, is one of a long line of over a hundred different Brownie cameras. In 1898 George Eastman decided to produce a simple and inexpensive camera yet capable of producing decent results. It was aimed at children, some of whom might later become serious photographers. Frank Brownell, the chief camera designer, came up with the Brownie. The Brownie was named after the little characters created by the Canadian author and illustrator Palmer Cox. The Brownies were reliable and were good value for money. They became synonymous with popular photography for over eighty years. Many children have spent wonderful hours playing with their Brownie cameras, and some of them have become great photographers.

The Meniscus lens with portrait attachment is set in a single blade shutter, with speeds of 1/100 sec to B. The lens has a built-in retractable yellow filter, and two brilliant optical viewfinders for horizontal and vertical shots are also to be found on the camera. There is a flash synchronisation with a two-pin flash contact. The camera has a socket for tripod use. The body is metal with imitation pigskin covering and a vertically striped front.

64

Ensign Selfix

c.1948
SN B20514
Lens 105mm f4.5 Ensar Anastigmat,
SN 20516
Designed and manufactured by Barnet
Ensign, Walthamstow, London E17

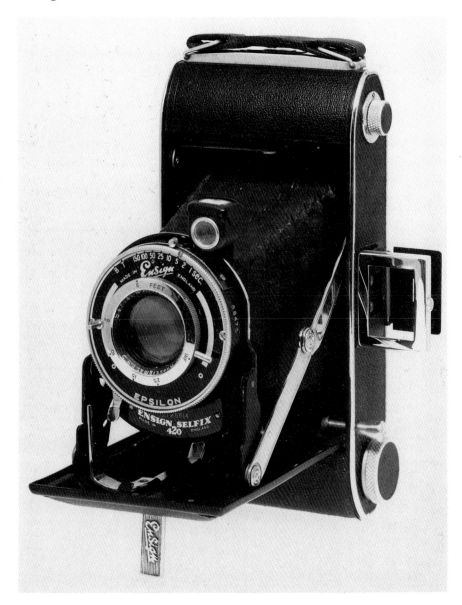

This camera is for up to eight 6 × 9cm exposures or sixteen 6 × 4.5cm exposures on
120 roll film .

The British-made 105mm f4.5 Ensar lens is set in an Epsilon shutter with
speeds of B, T and 1 to 1/150 sec. Two viewfinders are provided, a direct frame
finder for eye-level sighting and a waist-level reflecting finder which can be
turned into its fitting to take horizontal or vertical pictures. In the baseboard of
the camera a small screw may be removed, exposing a tripod socket. The Ensign
is of an all-metal sturdy construction with highly polished chrome fittings.

Later, more expensive 820 models were fitted with an f3.8 Ross Xpres,
an eight-speed shutter and an Albada viewfinder. The last 820s with uncoupled
or coupled rangefinder had performance and finish arguably superior to
German rivals.

65

*c.*1950
Lens 13mm f8
Designed and manufactured by Kamera
Werkstatten, Dresden

Jolly

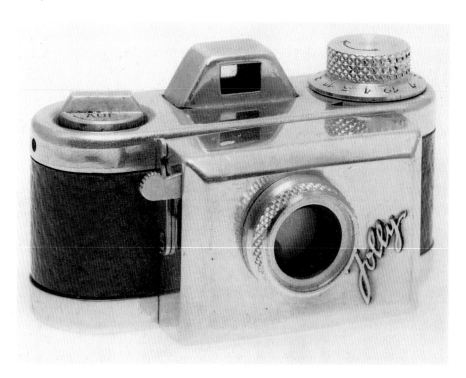

The Jolly is a small 16mm sub-miniature camera for up to twelve 10 × 15mm exposures on specially wound 16mm film cassettes. The camera has a small optical viewfinder and the single element lens is of fixed focus at infinity and fixed aperture at f8. The lens is set in a small sector shutter offering either T or M at a single speed of 1/60 sec.

The Jolly is constructed of aluminium which has been highly polished and has a red leather covering around the body.

66 Stecky IIIB

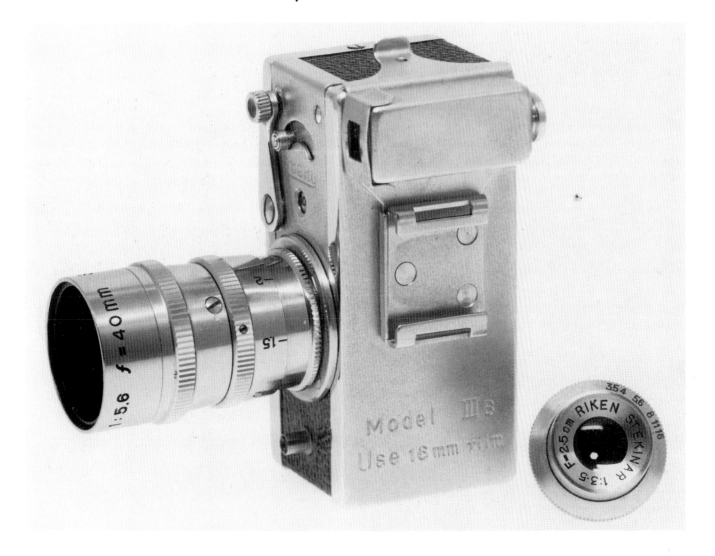

1950
SN S1730
Lens 25mm f3.5 Riken Stekinar
Accessory lens 40mm f5.6 Stecky-Tele
Designed and manufactured by Riken
Optical, Japan

The Stecky IIIB is one of the earliest Japanese sub-miniature cameras; it is for up to twenty-four 10 × 14mm exposures on 16mm film in special cassettes.

The camera has an interchangeable lens mount and the shutter is of the sector variety with speeds of B, 1/25, 1/50 and 1/100 sec. The standard lens stops down to f16 but is of the fixed focus variety, whereas the 40mm Stecky-Tele focuses down to 1m and also stops to f16. The camera has a built-in optical viewfinder and a separate mask for the 40mm lens. It has flash synchronisation and an accessory shoe usually found on 35mm cameras which dwarfs the rest of the Stecky. The Stecky was a successful 16mm sub-miniature camera and other models were available from as early as 1948.

67

1957
SN 2029930
Lens 60mm f3.5 Xenar, SN 5487173 by
Schneider-Kreuznach, Germany
Viewing Lens 60mm f2.8 Heidosmat
Designed and manufactured by Franke
& Heidecke, Braunschweig

Rolleiflex 4 × 4

This is the only 4 × 4 Rolleiflex produced after World War II. It is a twin lens reflex for up to twelve 4 × 4cm exposures on 127 film. It has a 60mm f3.5 Schneider in a Synchro-Compur exposure value shutter (1 to 1/150 sec, XM, with self-timer). The finder hood incorporates an eye-level frame finder and the shutter cannot be fired whilst the hood is folded. The film transport is effected by a winding knob on the right-hand side and the exposure counter is automatic. The camera has a grey finish with grey lens hood and case to match.

A small lens hood with a built-in meter was also available and was most useful. The Rolleilux exposure meter consisted of a miniature meter attached to a special lens hood fitting over the front of the taking lens; when not in use the meter could be swung inwards.

Before the war Frank & Heidecke manufactured two other versions of a 4 × 4 Rollei. The first model was launched in 1931 as the Babyflex and was later renamed the Sports Rolleiflex. It had a 60mm Tessar lens of either f2.8 or f3.5 maximum aperture set in a Compur shutter. The second model was introduced in 1937 and had a 60mm f2.8 Tessar in a Compur rapid shutter with an eye-level frame finder built into the collapsible hood.

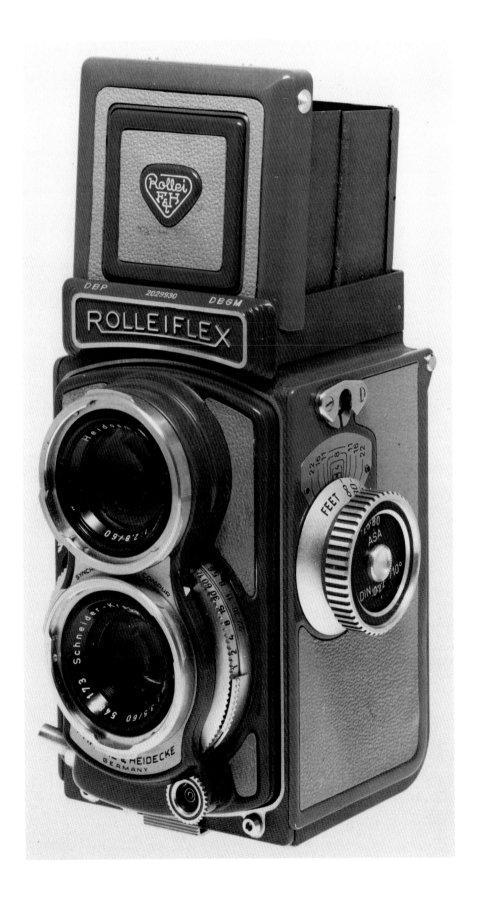

68

1958-70
SN 0002000
Lens 75mm f3.5 Tessar, SN 1403987 by
Carl Zeiss, Germany
Viewing lens 75mm f2.8 Heidosmat,
SN 2414033
Designed and manufactured by Franke
& Heidecke, Braunschweig

Rolleiflex T

The Rolleiflex T is a twin lens reflex camera with a non-interchangeable 75mm Tessar for up to twelve 6 × 6cm exposures on 120 film. The lens stops down to f22 and is set in a Synchro-Compur shutter with speeds of B and 1 to 1/500 sec. The camera was introduced as a market gap filler between the Rolleicord and the Rolleiflex E and F series with Planar or Xenotar lenses.

The Rolleiflex T was a successful camera and was easily recognisable by its grey leather fittings. It was introduced in 1958 and discontinued in 1976. From 1970 onwards it was finished in the traditional black leather and was available with a built-in exposure meter as an option.

The serial number of the illustrated specimen, 0002000, means that it is the second camera of the pilot production run. A matching grey case was planned but never produced.

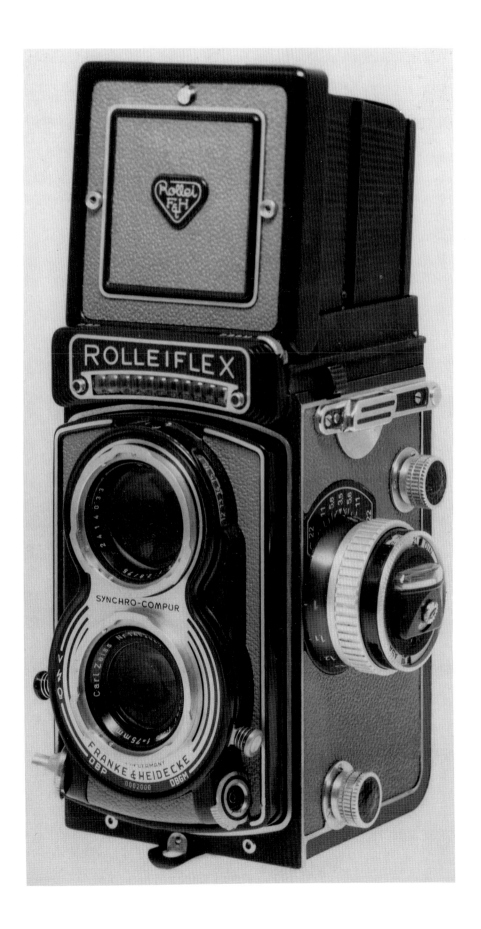

69 Minox B

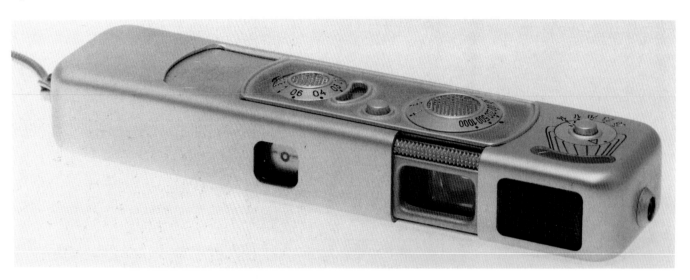

1958-71
SN 618632
Lens 15mm f3.5 Complan
Originally designed by Walter Zapp in
1937, Riga; manufactured by Minox,
Wetzlar

This tiny miniature has become a legendary spy camera much used in film if
nowhere else. That the Minox concept has survived for over fifty years is
something of a miracle. Its portrayal in films and television programmes as the
ultimate spy camera seems to relate more to marketing than to reality. Yet there
is no doubt that the Minox is a beautifully engineered precision instrument
capable of producing adequate results from negligible bulk, providing that the
photographer can apply a degree of scientific application in its use, particularly
as regards processing the tiny films.

The Minox produces up to fifty 11 × 8mm exposures on 9.5mm wide film
especially cassetted by Minox. The lens is a fixed aperture 15mm f3.5 Complan
which focuses down to 20cm. This was an essential feature of the Minox as it
was basically a camera used for photographing documents.

The shutter is of the guillotine type and offers speeds of ½ to 1/1000 sec plus
flash synchronisation. It has a built-in meter for films of 15 din to 27 din
sensitivity.

The Minox is built of anodysed steel and many interesting accessories were
available such as a tripod, a flash, a measuring chain, a developing tank, a
projector, a negative reader and an enlarger. The camera was available either in
chrome or in black finish although most were produced in chrome.

The very first Minox was designed by Walter Zapp and manufactured by
Valsts Electrotechniska Fabrika of Riga, Latvia. After the Soviet occupation a few
were assembled from spare parts and were accordingly marked 'USSR'. Post-war
refugees from Latvia opened a factory in Giessen, close to the Wetzlar Leitz
plant, where they are still being produced today.

70

Tele-Rolleiflex

1959-75
SN 52303464
Lens 135mm f4 Sonnar, SN 2718925 by
Carl Zeiss, Oberkochen
Viewing lens 135mm f4 Heidosmat,
SN 2693102
Designed and manufactured by Franke
& Heidecke, Braunschweig

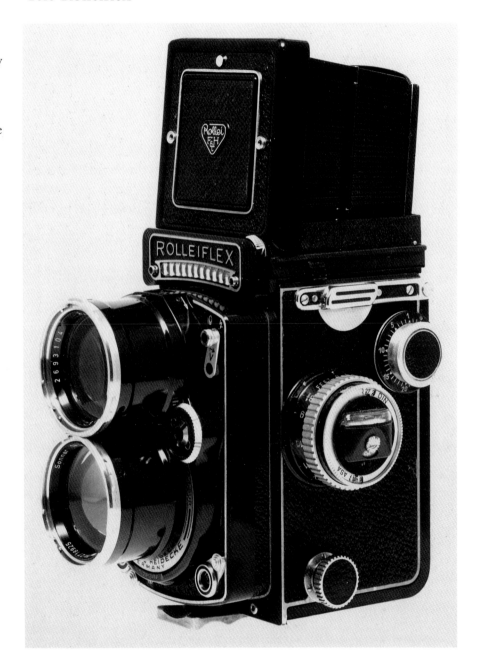

This twin lens reflex camera is the only Rollei with fixed telephoto lenses. It
produces twelve 6 × 6cm exposures on 120 film. Apart from the telephoto lenses, it
is similar to its fraternal contemporaries. The Sonnar taking lens is of the
well-known Zeiss design.

 The shutter is of the Synchro-Compur type offering B and 1 to 1/500 sec.
The minimum focusing distance is 8½ft and a set of specially designed
Rolleinar/close-up lenses was available. Also available was a glass pressure plate
which would improve the flatness of the film.

 The Tele-Rolleiflex was a successful camera much used by portrait
photographers, and over 5,000 were produced. It was available over a long period
of time and from 1970 onwards with a 220 film facility. The cheaper Mamiyaflex
twin lens reflex with interchangeable lenses hastened its demise.

71

Rollei-Wide

1961-67
SN W2491822
Lens 55mm f4 Distagon, SN 3506248 by
Carl Zeiss, Oberkochen
Viewing lens 55mm f4 Heidosmat
Designed and manufactured by Franke
& Heidecke, Braunschweig

The Rollei-Wide is the only twin lens reflex camera ever produced with a fixed wide-angle lens. It gives twelve 6 × 6cm exposures on 120 film. The taking lens is of the well-known Zeiss Distagon design. The shutter is of the Synchro-Compur type offering B and 1 to 1/500 sec, and later models had a glass pressure plate in the film plane.

The Rollei-Wide was launched in 1961 as a companion to the Tele-Rolleiflex, which had been launched in 1959, giving Rollei photographers a choice between a wide-angle, a tele or a normal Rollei lens or, if wealthy enough, a set.

The Rollei-Wide had a much shorter life than the Tele-Rolleiflex and was discontinued in 1967. It is estimated that no more than 4,000 could have been produced. Both the Tele-Rollei and the Rollei-Wide suffered excessively from the competition of the 6 × 6cm single lens reflex with interchangeable lenses, though they both had advantages in cost, weight and lack of camera shake when hand-held.

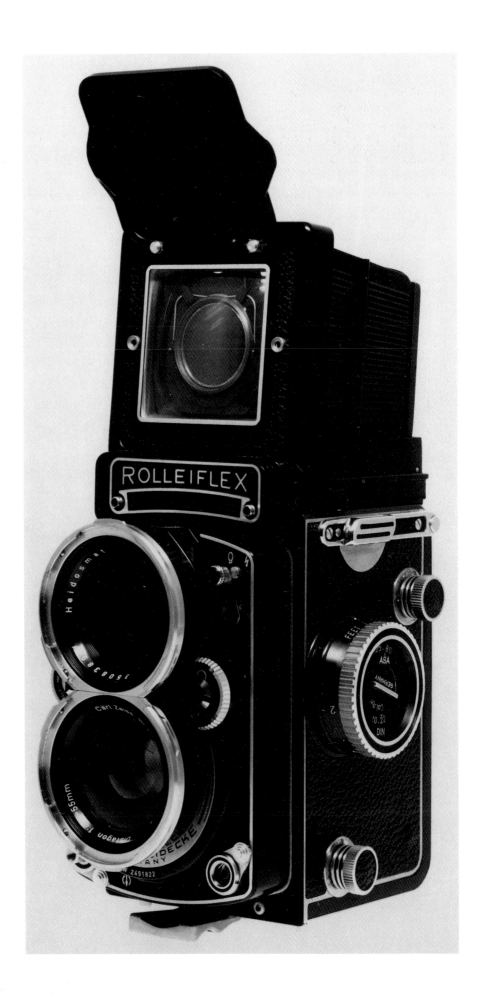

72

Bessa II

1962
Lens 105mm f3.5 Color Heliar by
Voigtländer, Braunschweig
Designed and manufactured by
Voigtländer

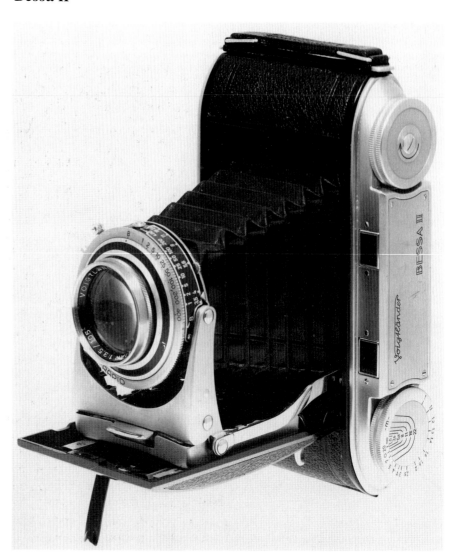

The Bessa II is a coupled rangefinder folding camera for either eight 6 × 9cm
exposures or sixteen 6 × 4.5cm exposures on 120 film. The five-element
Voigtländer Color Heliar lens is set in a Compur Rapid Shutter with speeds of B
and 1 to 1/400 sec. The lens stops down to f22 and focuses to 1m. The viewfinder
is of the optical variety with a round circle for the rangefinder. The Bessa II was
also available with a cheaper four-element Colour Skopar or an expensive
six-element Apo-Lanthar. In the erected position the camera was given rigidity by
a couple of lazy tongs. The Bessa II has a complicated joint linkage between the
shutter and the body of the camera where the release could be conveniently placed.
The body release mechanism of the Bessa was patented as early as 1934. Of a
delicate but nonetheless beautiful construction and one of the most compact of
the 6 × 9cm cameras, the Bessa II is capable of taking excellent photographs and is
hence a much sought-after instrument.

The Voigtländer factory is Germany's oldest optical concern, whose founder
designed the famous Daguerreotype Petzval f3.4 lens. Voigtländer never achieved
the fame of Zeiss, although the firm arguably produced lenses of equal
performance and certainly better finished cameras. Voigtländer is now part of the
Zeiss group and Voigtländer is still used as a brand name.

73

1963-66
Designed and manufactured by Kodak,
England

Instamatic 100

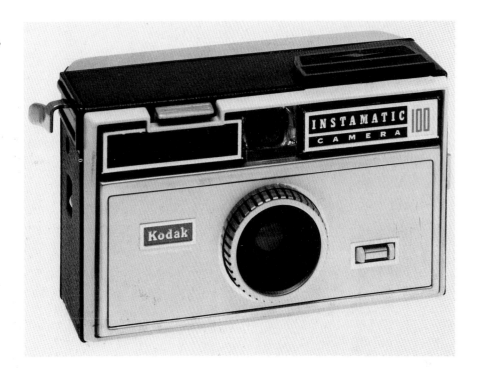

The Instamatic series were the first cameras to incorporate a foolproof film cassette, and were immensely successful. The Instamatic 100 took up to twenty-four 28 × 28mm exposures using a Kodapak 126 cartridge. The fixed focus plastic lens was of f11 aperture built into a 1/90 sec single shutter speed system. The film was wound by a lever and the camera incorporated a pop-up flash for AG1 bulbs. Although the negative was 28 × 28mm the cartridge nevertheless used a 35mm wide film but with only a single registration perforation for each frame, hence the increased width from 24mm to 28mm. The instamatic film was a direct descendant of the pre-war 828 'Bantam' format, except that a cassette rather than a spool was used. The film was equipped with a black backing paper on which the exposure numbers were printed. When the cartridge was inserted into the camera the exposure number was visible through a clear rectangular slot in the camera back.

Loading the film had always been a hazardous operation for all but the very experienced or dexterous. Kodak had been involved in facilitating this process since its inception. The 1888 Kodak was a breakthrough in that film was loaded in the factory and unloaded there as well. The Eastman Kodak camera of 1891 used a light-tight cardboard container for supplying and taking up film, but these were not successful. Many an amateur photographer left the camera loading and unloading to the camera shop. It was the advance in the precision moulding of plastics that led to Kodak developing a cartridge. The cartridge was pre-loaded and could be inserted into the camera in only one way, which was the only correct way. The Kodapak 126 cartridge system was launched in 1963 and remained in operation until 1973. Nearly 70 million Kodak cameras of the Instamatic variety, *ie* accepting Kodapak, were sold. Most of these were basic fixed lens exposure models. However, in 1967 Kodak AG, Germany, produced the Instamatic Reflex camera, albeit only for three years. The Instamatic Reflex very much resembled a Kodak Retina and was available with a choice of interchangeable lenses from 28mm to 200mm.

74

Narciss

1964
SN 6411061
Lens 35mm f2.8 Vega M1, SN 7133
Designed and manufactured by
Mashpriborintorg, Moscow

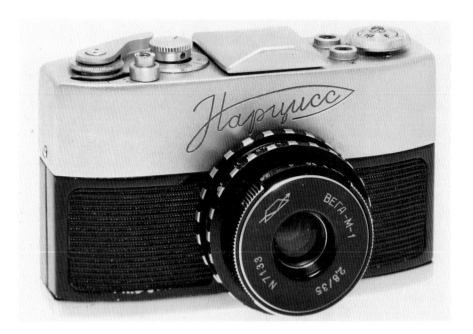

This camera is typical of the inventiveness of Soviet camera design which blossomed in the 1960s. It is a single lens reflex camera for up to twenty-four 14 × 21mm exposures on 16mm unperforated film in specially wound cassettes. The focal plane shutter consists of two cloth blinds travelling horizontally with speeds of B and ½ to 1/500 sec. The camera allows for screw-mount interchangeable lenses but it does not have an instant return mirror. The camera accepted within an adaptor the full range of Zenith lenses from 37mm to 1000mm. There is a reflex viewing system and the prism is removable although no other viewing system is offered with the camera. The film is advanced with a lever and also has X and M flash synchronisation. The camera is built of chromed metal and the body is covered with a plastic covering. The Narciss was introduced as a complete outfit with four special cassettes, an ever ready case and an enlarger flange for £29 19s 6d.

75 Hasselblad 500C

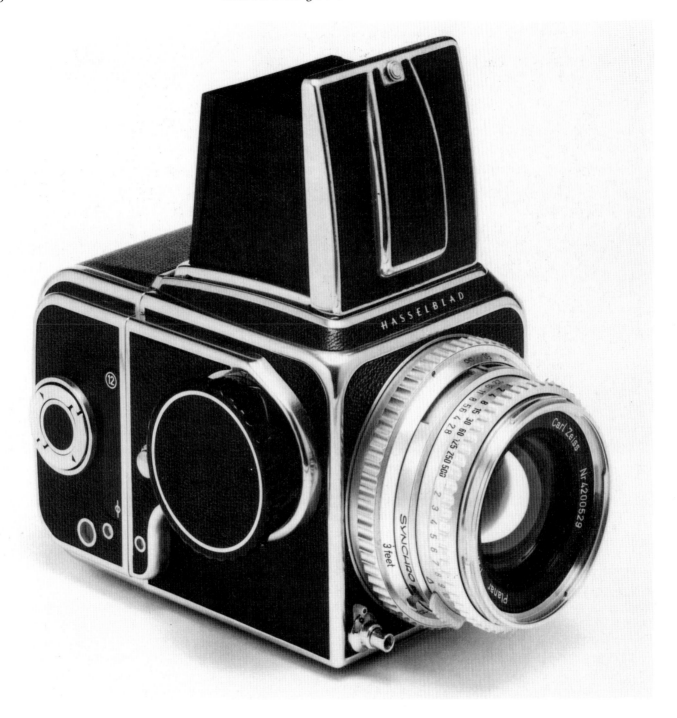

1965-66
SN TC 91771
Lens 80mm f2.8 Planar, SN 4200529 by
Carl Zeiss, Oberkochen
Designed and manufactured by Victor
Hasselblad, Göteborg

The Hasselblad 500C, a precision single lens reflex camera of advanced design
for either 6 × 6cm or 4.5 × 6cm exposures on either 120 or 220 film, is an
outstanding piece of workmanship, built for a long life. The Hasselblad 500C
was available from 1957 although the illustrated specimen dates from 1965-66.

The camera consists essentially of four parts: main body unit, finder hood, lens
and film magazine. The Synchro Compur shutter of the Hasselblad is built into
the lens and is changed with it. The shutter speeds are B and 1 to 1/500 sec.
There is an auxiliary shutter in the rear of the camera. The Planar lens is of
six-element symmetrical construction, is mounted in a helical unit, and focuses
to 3ft. The viewfinder has a screen with a built-in magnifier. Film transport is via

Hasselblad 500C *continued*

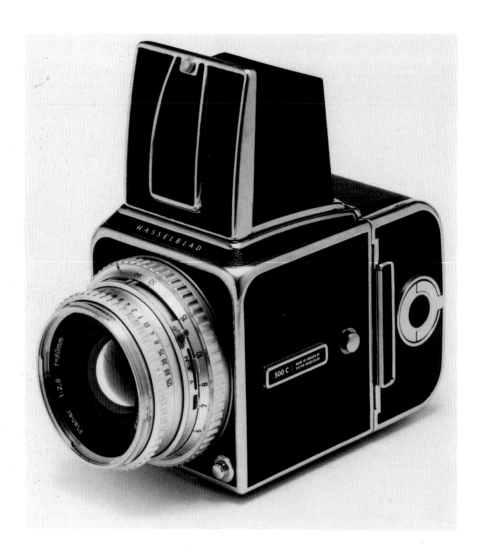

a knob wind and the camera has interchangeable magazines for 120, 220, 4.5 × 6cm or 4 × 4cm formats. The 80mm Planar is of exceptional definition and flatness of field.

The early 500C accessory lenses available from 1957 were in chrome finish as follows:

60mm f5.6 Distagon
150mm f4 Sonnar
250mm f4 Sonnar
A 50mm f4 Distagon and a 500mm f8 Tele-Tessar were soon to follow.

The camera shown here was bought new in 1966 by a travel photographer, who ten years later replaced it with 500cm and sold it to his brother. He used it for several years and then sold it to a fashion and glamour photographer. It has just passed into the hands of an advertising photographer who happens to be the assistant of the original owner! In twenty-two years the camera has been serviced three times and is still in perfect order.

The original 'professional' package consisted of a camera body, an 80mm lens, two backs, a magnifying hood and a 80mm lens hood.

76 Panophic

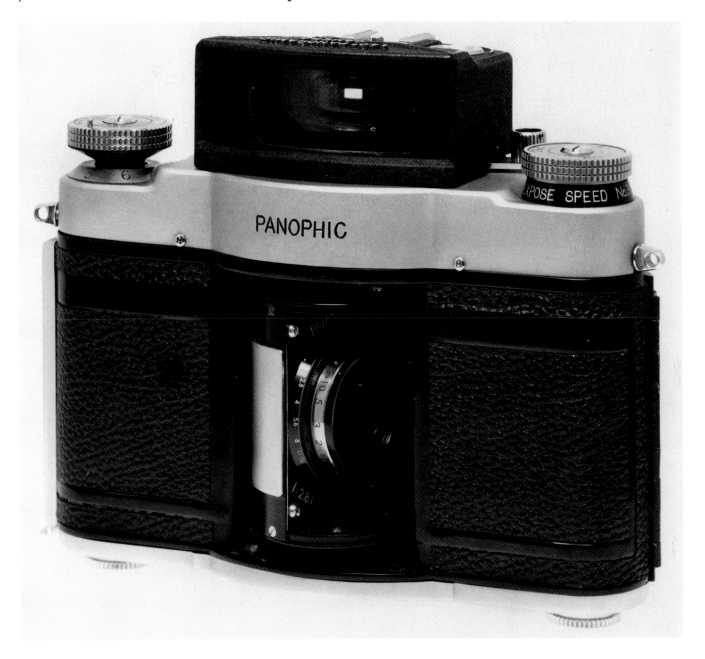

c.1968
Lens 50mm f2.8, SN 37436
Designed and manufactured by Panox, Japan

See colour plate VII

The Panophic is a 140° panoramic camera producing six 50 × 120mm exposures on 120 roll film. The film plane is curved and the lens rotates in front of the curved film. The lens is a coated 50mm f2.8 which focuses from infinity down to 1.5m. The shutter speeds are 1/8, 1/60 and 1/250 sec. The camera has a built-in optical viewfinder with a case level. This camera was produced some years after the Panon, and is a refined and somewhat lighter version. The main difference between the Panon and the Panophic is the latter's optical viewfinder, whereas the former had a folding framefinder.

77

1969-80
SN 2263043
Lens 75mm f3.5 Planar, SN 3270528 by
Carl Zeiss, Oberkochen
Viewing lens 75mm f2.8 Heidosmat,
SN 3046779
Designed and manufactured by Franke
& Heidecke, Braunschweig

Rolleiflex 3.5F, Type 4

The Rolleiflex replaced the Speed Graphic as the press reporters' favourite camera in the 1950s before being replaced by 35mm cameras. Cecil Beaton used only Rolleiflexes from their inception until the end of his career. Other celebrated users of the Rolleiflex have been Richard Avedon, John French and Fritz Henle.

The Rolleiflex 3.5F is a twin lens reflex camera fitted with a non-interchangeable 75mm f3.5 Planar. The viewing lens is the 75mm f2.8 Heidosmat. The shutter is a Synchro-Compur for B and 1 to 1/500 sec. The 3.5F could produce either twelve 6 × 6cm exposures on 120 film or twenty-four 6 × 6cm exposures on 220 film. In all other respects the 3.5F is a descendent of the 1939 Automat Rolleiflex.

The 3.5F is one of the most sought-after Rolleiflex cameras. The planar lens is of outstanding quality, surpassing even the 80mm F2.8 Planar as fitted to the Hasselblad camera. The 3.5F had a huge range of accessories including underwater housings, motor drives, stereo and panoramic heads, pentaprism and viewfinder, close up lenses (with parallax correction), 35mm and plate backs and an exotic 4 × Tele-Magnar telephoto attachment.

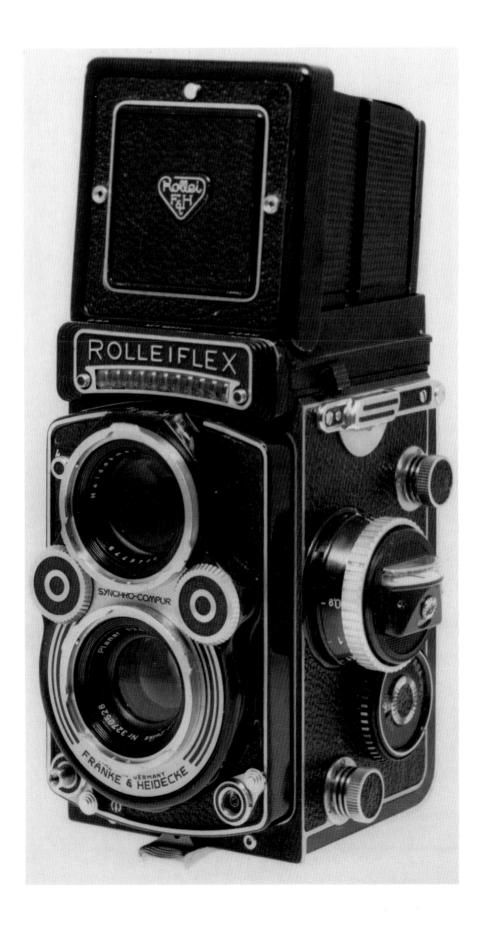

78

1987 onwards
SN 3013006
Lens 80mm f2.8 Planar HFT by Rollei,
SN 8101500
Viewing lens 80mm f2.8 Heidosmat
Designed and manufactured by Rollei
Fototechnic, Braunschweig

Rollei 2.8GX

The 2.8GX is an old classic brought back to life. The last Rolleiflex, the 2.8F, was in production from 1962 to 1981. When discontinued it was much missed, and the 2.8GX was produced to fill the demand which its absence created. Mention should be made of the production of a gold-plated model, the Aurum, in 1983 to commemorate the 60th Anniversary of the Rollei.

This twin lens reflex produces twelve 6 × 6cm exposures on 120 roll film. It is a direct descendant of the original Rolleiflex of 1929. The 2.8GX has had two major improvements built into it; a through-the-lens exposure meter and a through-the-lens automatic flash capacity.

The centre-weighted integral exposure metering has two photo elements. Five light-emitting diodes of different colours help adjust for perfect exposure. The TTL flash measurement on the film surface is via an additional photo element. The shutter is of the synchro Compur variety for B and 1 to 1/500 sec. Now that Rollei Fototechnic has passed under the control of Schneider, it is possible that Zeiss lenses may be discontinued in favour of the Schneider lenses.

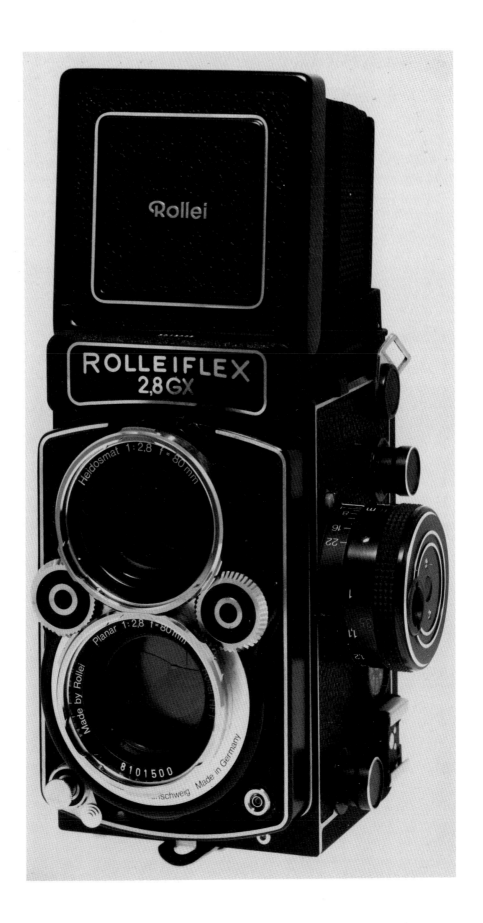

4 35mm Roll Film Cameras

1913 onwards

The 35mm roll film camera is now the most widely used and accepted of all formats. The single lens reflex dominates the upper market and the autofocus snapshot is taking over the lower part of the market. Yet that 35mm should become the accepted standard was not so evident in the early part of the century.

This section begins with the first commercially available camera using 35mm film, the Touriste Multiple [79]. Manufactured in 1913, this camera could produce up to 750 18 × 24mm exposures, a totally unmanageable number of photographs. The favoured format of 24 × 36mm came only much later. The French Homeos [80] was the first stereo 35mm camera and the Swiss Sico [83] was the only wooden-bodied 35mm camera. The all-important prototype Leica of 1923 is examined in detail. All 35mm cameras, even those of today, owe much in design to this model. The Leica I, or model A as it has been called in the USA [85], was first produced in 1925 and was certainly not the first full-frame 35mm camera; it was without doubt, however, the first successful one. Lower shutter speeds came along with the Leica Compur of 1926 [87], fully interchangeable lenses were introduced with the Leica I of 1930 (Model C) [88], and interchangeable coupled rangefinder lenses were introduced with the Leica II of 1932 [90].

From then on the history of the 35mm camera progresses more slowly, though on a sure footing. In 1932 Zeiss Ikon entered the fray with their most complicated Contax I [91] with its innovative bayonet-mounted lens. The year 1934 saw the first Japanese coupled rangefinder camera in the form of the Canon Hansa [95], and 1948 a composite of both the Leica and the Contax, the Nikon I [108]. Czechoslovakia is represented in the first ever 35mm tri-colour camera, the Spektaretta, and Italy in the pocket-sized 35mm Ducati. Special lenses were also produced before and in the early years of World War II, such as the Thambar soft-focus lens of 1935 [98], the Olympic 180 f2.8 Sonnar of 1937 [100] and the Contax Stereotar C of 1941 [105]. After the war, when the format established itself as 24 × 36mm, the struggle developed between rangefinder and single lens reflex models. The immensely successful M3 of 1954 [113] was followed by a newly designed Nikon rangefinder, the S2 [116]. The famous SP [119] was introduced in 1957, the same year as the wide-angled Leica M, the M2 [120]. The Leningrad, of Russian manufacture [121], was the first 35mm with a built-in clockwork motor.

The year 1959 saw the entry of a camera onto the market which would eventually destroy the massive sales of the Leica coupled rangefinder: the Nikon F [127]. In the same year Zeiss Ikon brought onto the market the most elaborately and beautifully engineered reflex ever made, the Contarex I [126]. The Contarex I was soon followed by more advanced models, including one with a fixed, distortion-free, 15mm f8 lens, the Hologon [143]. In 1967 Olympus had a last stab at the half-frame market with an exciting half-frame reflex camera, the Pen FT [138]. Jacques Cousteau developed the first ever camera for underwater use that does not require a special housing, naming it after his favourite boat, the Calypso [132]. In 1965 Leitz finally produced their first single lens reflex camera, the Leicaflex [133]. This was followed in 1971 by the Leica M5 [145], the first coupled rangefinder camera with through-the-lens metering.

The book closes with the 1985 Leica M6 [150], a direct descendant of the 1925 Leica and certainly the most important classic 35mm camera still in production.

79

Touriste Multiple

1913
SN 1816
Lens 5cm f3.5 Tessar, by Carl Zeiss, Jena
Designed by Paul-Dietz, patented by him
on 31 March 1914, nearly one year after
initial production commenced
Manufactured by New Ideas
Manufacturing, New York

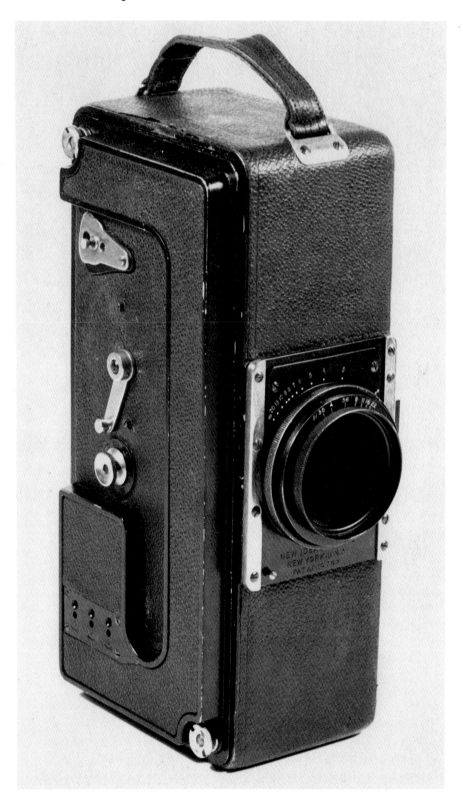

The Touriste Multiple is the first 35mm camera to be commercially produced
and is for up to 750 18 × 24mm exposures on standard 35mm wide ciné film. The
highly recessed 5cm f3.5 Tessar stops to f22 and focuses to 3ft. The film winding
mechanism is linked to the shutter cocking. The guillotine type shutter has
speeds of 1/40 to 1/200 sec. The camera incorporates a three-digit film counter.
When advertised at the price of $175 the camera was described as the ideal
companion for an American undertaking a complete European tour.

Technically interesting and an obvious landmark, the Tourist Multiple met an
early demise owing to the outbreak of World War I.

80 Homeos

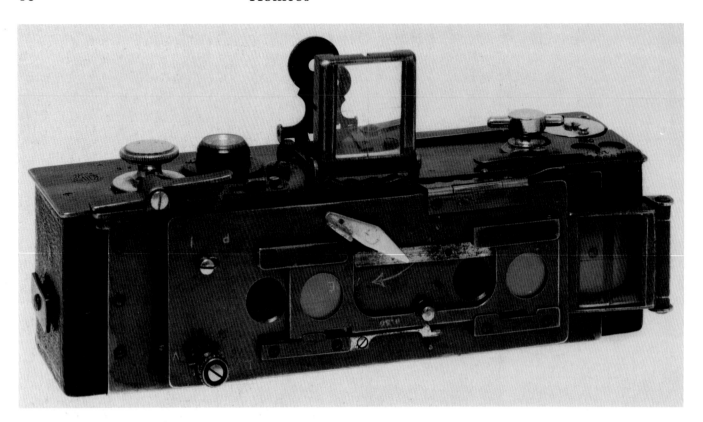

1914
SN 235
Lenses: pair of 28mm f4.5 Krauss
Tessars
Designed and manufactured by Jules
Richard, Paris

The Homeos is the first 35mm stereo camera to be produced. It would produce up to twenty-five pairs of 17 × 24mm exposures. Results could be viewed (in suitable mounts) in any of the maker's 45 × 107mm viewers.

The lenses are set in a shutter of the guillotine variety and the speeds are 1/10 to 1/150 sec and B. The camera has two eye-level optical viewfinders, one on top of the camera and one on the side. An unusual feature is a sliding set of close-up lenses. The camera is constructed of metal covered with black leather and the small brass fittings are blued.

The Homeos was listed at 1,550 francs and by the time it was finally discontinued in the early 1920s, less than 1,500 had been sold.

81 Minigraph

1915
SN 2128
Lens 54mm f3.5 Anastigmat
Designed and manufactured by Levy-
Roth, Berlin

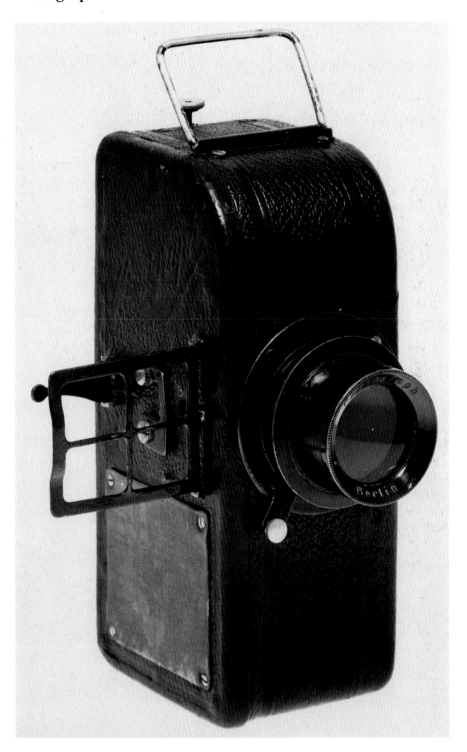

The Minigraph is important not only in that it is a pre-Leica 35mm camera, but also in being the first German pre-Leica 35mm camera. It could also be used as a contact printer or an enlarger.

This camera took 35mm perforated film and produced fifty 18 × 24mm exposures. The Anastigmat lens stopped down to f36. The shutter speeds were T, B and 1 to 1/100 sec. The shutter of a sector variety was cross-coupled to the film advance lever. The camera was constructed of wood covered with leatherette. An extensive plate below the viewfinder gave details of the shutter/aperture and film speed combinations.

82

1923
SN 111
Lens 50mm f3.5 Anastigmat,
by Ernst Leitz, Wetzlar
Designed by Oskar Barnack and
manufactured by Ernst Leitz

The Leitz 'O' Series

The 'O' series of cameras is without doubt the most important 35mm camera, and no major photographic museum would be complete without an 'O' series camera. The 'O' series takes up to thirty-six 24 × 36mm exposures.

The shutter is of a non-self-capping variable slit focal plane type consisting of two cloth blinds travelling horizontally. The slit between the two blinds can be adjusted to give exposures 1/25, 1/50, 1/100, 1/200 and 1/500 sec. As the shutter is of the non-self-capping variety, the lens has to be capped prior to advancing the film and tensioning the shutter, otherwise the film will be fogged. A leather cap (missing on SN 111) is secured to the body of the camera with a cord.

The viewfinder is of a small Newtonian construction. The finder of SN 111 is not the original one supplied with the camera. The original would have been complete with a folding-down negative lens and a pivoting foresight.

The Anastigmat lens stops down to f16. It was designed by Dr Max Berek and is of a five-element triplet construction with the rear three elements cemented together.

Less than twenty-two of these cameras were produced and most seem to have found a way either to public collections or museums. The 'O' model is the cornerstone upon which the design of all 35mm cameras is based.

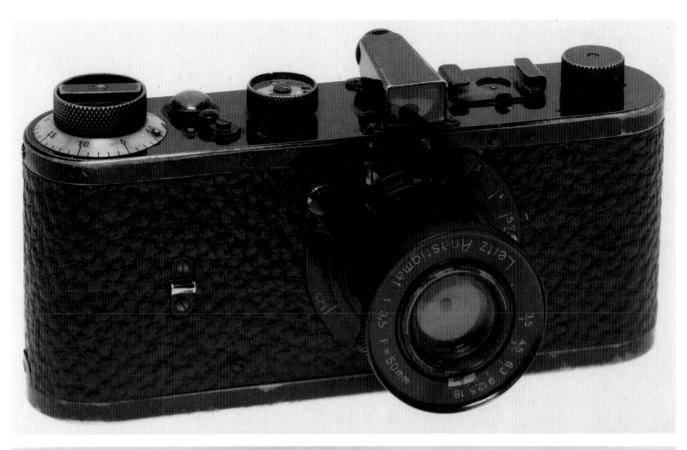

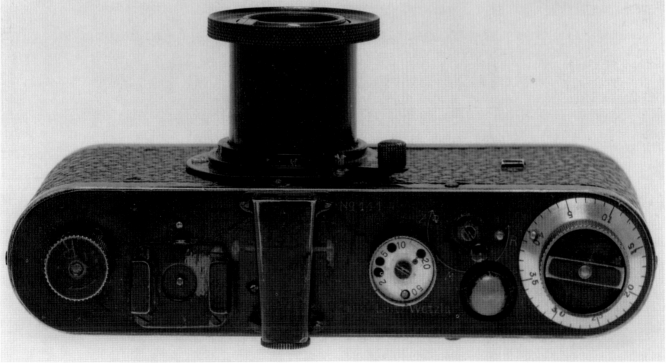

83

1923
SN 17
Lens 50mm f3.5 Rüdersdorf
Anastigmat
Designed and manufactured by
Wolfgang Simons, Bern

See colour plate VII

Sico

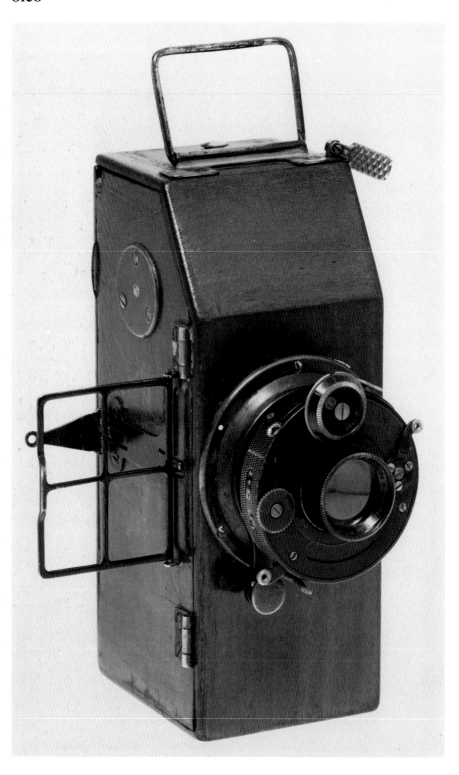

The Sico is the only pre-Leica brass-bound wooden 35mm camera and is the most beautiful in this category.

Using special paper-backed, unperforated film, the Sico produced twenty-four 30 × 40mm exposures. The Rüdersdorf Anastigmat lens in a dial-set Compur shutter could stop down to f22 and the shutter speeds could be adjusted to T, B and 1 to 1/300 sec. The lens/shutter was mounted on a lens barrel which retracted into the body of the camera. A folding framefinder was screwed onto

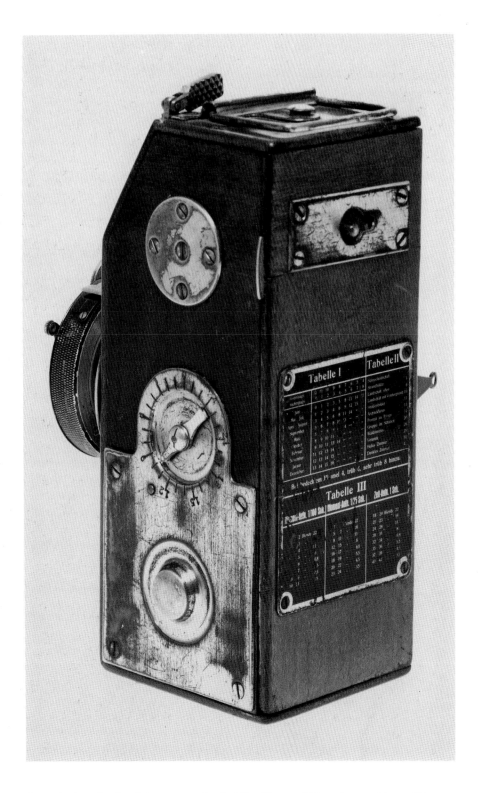

the right-hand side of the camera body. The film could be advanced by pulling on a brass rod on the top of the camera. The numbering on the rear of the paper-backed film corresponded to the number of exposures. The exact location of the film could be read through the orange window at the rear of the camera.

Each camera was individually numbered on the outside and stamped on the inside on various parts. Probably less than two hundred were produced, making it one of the rarest pre-Leica 35mm cameras.

84 Eka

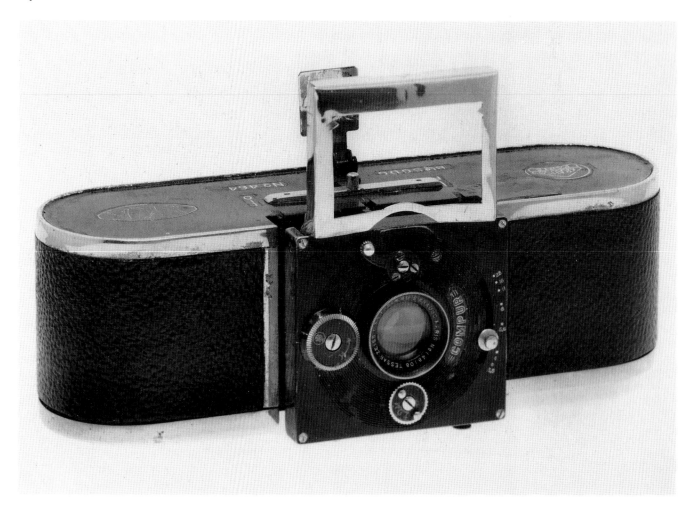

1924
SN 424
Lens 5cm f3.5 Krauss-Tessar, SN 148108
Designed and manufactured by
M.E. Krauss, 18 rue de Naples, Paris

See colour plate VII

The Eka, a small all-metal camera of outstanding quality, taking unperforated film, produced up to one hundred 30 × 44mm negatives. The Krauss-Tessar lens was in a dial-set Compur shutter with speeds from 1 to 1/300 sec, T and B. Krauss, like Ross of England or Bausch & Lomb of the USA and others, were Zeiss licensees for the Tessar formula. The lens would stop down to f23 and viewing would be through a folding framefinder. The lens/shutter assembly was set in a beautifully designed helicoidal mount. When the lens was retracted the finder folded itself into the top plate. A sliding, swivelling, angled bar containing a tripod bush enabled the taking of both horizontal and vertical photographs.

The sides of the camera were covered in black leather and from the serial number run it would seem that no more than one thousand were produced.

85 Leica I

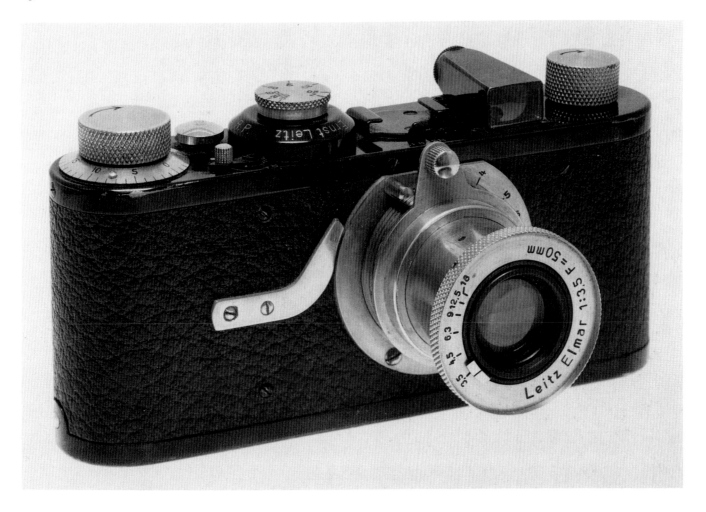

(Model A in USA)

1925
SN 7932
Lens 50mm f3.5 Elmar, manufactured by
Ernst Leitz, Wetzlar
Designed and manufactured by Ernst
Leitz

See colour plate VIII

The Leica I, designed by Oskar Barnack, is the first commercially available Leica. It is a fixed lens camera for up to thirty-six 24 × 36mm exposures. It incorporates features which are still to be found in the latest M cameras, such as the basic shutter design and location of the accessory shoe. The Leica I was first shown in public at the Leipzig Spring Fair of 1925.

The camera had a focal plane shutter consisting of two cloth blinds travelling horizontally offering speeds of Z and 1/20 to 1/500 sec. The film advance would also wind on the shutter, hence no double exposures were possible. It would also adjust the film counter accordingly.

The camera has no built-in rangefinder, although an accessory long base rangefinder was introduced. The height of the rangefinder was 10.5cm and the base was 8cm in length. It is interesting to note that the rangefinder was available in 1924, one year before the introduction of the Model I.

With over 50,000 produced in a period of six to seven years, the Leica I was an immensely successful camera, the first 35mm camera to sell to more than 1,000-2,000 aficionados as compared to other early 35mm cameras.

Constructional variations exist such as improvements in the height of the knob, threaded shutter release, depth of field scale for the lens and improved speed increments. The Leica I was supplied with four different lenses. Body numbers 130 to approximately 300 had the five-element 50mm f3.5 Anastigmat, the three rear elements of which were cemented together. Bodies with serial numbers from approximately 300 to 1300 had the 50mm f3.5 Elmax, which is optically similar to the 50mm f3.5 Anastigmat. Cameras with serial numbers

Leica I *continued*

above approximately 1300 had the 50mm f3.5 Elmar which was of four-element construction, the two rear elements being cemented together. The four-element 50mm f3.5 Elmar lens is permanently fixed to the body and is in a collapsible mount. It was upon this lens, designed by Dr Max Berek, that the world-famous reputation of Leitz was built. Unlike most Elmar lenses which focus down to 1m or 3ft only, this example, for export only, focused to 1.5ft. This model is commonly known as the near-focus model.

A few Leica I cameras had the fast 50mm f2.5 Hektor lens which was of a six-element triplet construction. A handful of Leica I cameras were produced finished in gold, with the code-name Luxus.

86 Esco

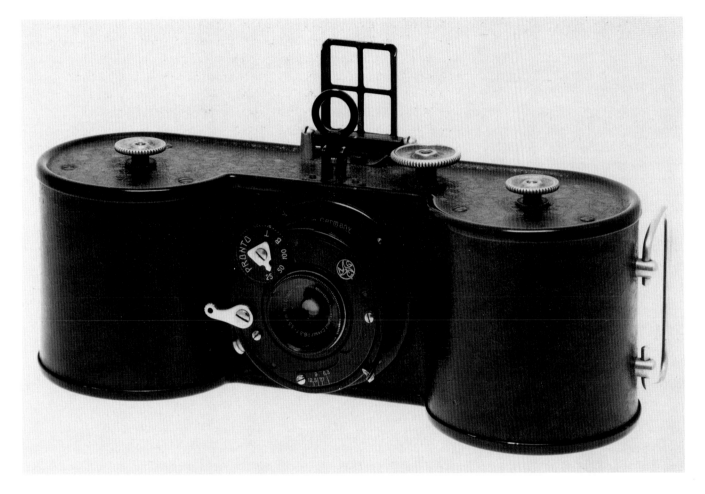

1926
Lens 35mm f6.3 Cassar Anastigmat,
SN 163320 by Steinheil, Munich
Designed and manufactured by Otto
Seischab, Nuremberg

The Esco is a small camera for up to four hundred 18 × 24mm exposures; it could
be said to have pre-empted the Leica 250. The Steinheil Cassar set in a Derval
Pronto shutter has speeds of T, B, 1/25, 1/50 and 1/100 sec; it stops down to f22
and focuses to 1m. A more expensive 35mm f3.5 Cassar was also available set in
a Compur shutter.

The film advance is by knob wind and there is also a small folding frame
viewfinder on top of the camera. The body is lined with black felt as the film
spools have to be loaded and unloaded in the dark. The camera is constructed of
metal with a black crackle finish.

87 Leica Compur

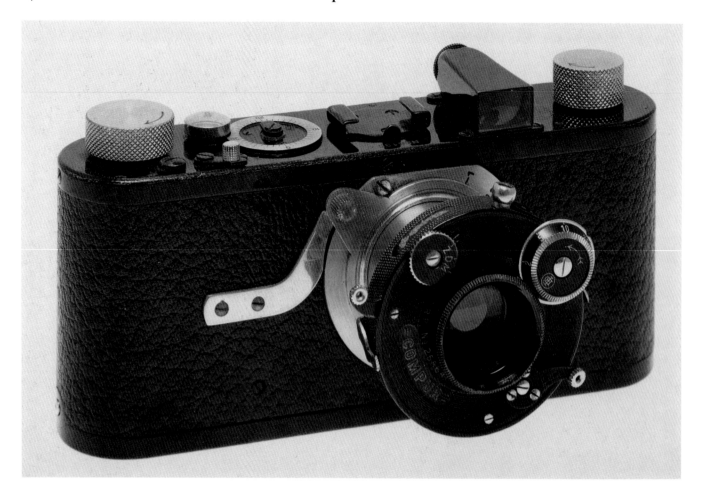

(Model B in USA)

1926
SN 6135
Lens 50mm f3.5 Elmar by Ernst Leitz,
Wetzlar
Designed and manufactured by Ernst
Leitz

See colour plate VIII

The Leica Compur is Ernst Leitz's second 35mm camera model, and the first
to include slow speeds. It is a fixed lens camera for up to thirty-six 24 × 36mm
exposures. In 1926, one year after the introduction of the Leica I, when demand
for the sophisticated model I was still growing, Leitz nevertheless introduced a
simpler, cheaper camera, the Leica Compur. Unlike the Leica I, which had a focal
plane shutter, the Leica Compur was fitted with a Compur shutter set in the lens
with the speeds of B, T and 1 to 1/300 sec. This camera had the advantage of
slow speeds which were unavailable with the model I, and it was useful for the
slow films of the period. The winding mechanism is not coupled to the shutter
cocking, hence double exposures are possible. The lens is the four-element Elmar
lens with the rear elements cemented together. Special filters and close-up lenses
were available.

At around £15 sterling in 1926, the Leica Compur compared favourably with
the model I at £22. With a total production of little less than 600, the Leica
Compur dial set is a classic camera indeed.

88 Leica I Interchangeable

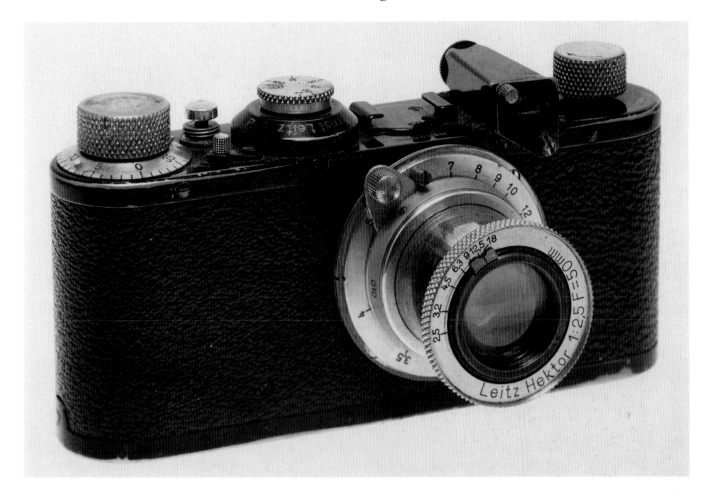

(Model C in the USA)

1930
SN 52010
Lens 50mm f2.5 Hektor SN 010 by
Ernst Leitz, Wetzlar
Designed and manufactured by Ernst
Leitz

See colour plate VIII

The Leica I Interchangeable was the first 35mm camera to offer lens interchangeability and later full standardisation. Taking up to thirty-six 24 × 36mm exposures, it had a focal plane shutter consisting of two cloth blinds travelling horizontally with the speeds of B and 1/20 to 1/500 sec.

The Leica I had an interchangeable lens facility with a 39.5mm thread which became known as the Leica flange. Initially each lens had to be individually matched for infinity register to a particular body and the following lenses were offered: 50mm f3.5 Elmar, 50mm f2.5 Hektor, 35mm f3.5 Elmar and 135mm f4.5 Elmar. Consequently, each matched lens was engraved with the last three digits from the serial number of its correct camera body.

Fewer than 3000 non-standardised Leica I interchangeable cameras were produced. By December 1930 the problem of lens interchangeability had been resolved by having the front of the flange at 28.8mm from the film plane. With this fixed distance between film plane and flange, all lenses could be used without individual adaptation. All such totally standardised cameras had the camera body lens flange marked with an 'O'.

89

Factory code Stereoly

1931
SN 1162
Designed by Professor Lihotsky;
manufactured by Ernst Leitz, Wetzlar

Leitz Beam Splitter

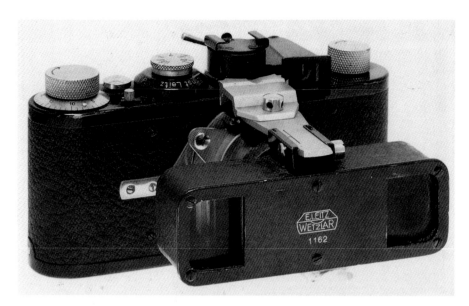

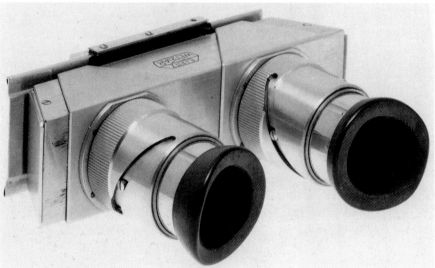

At the Leipzig Spring Fair of 1931 Leitz introduced a Stereo beam splitter device designed by the outstanding optical engineer Professor Lihotsky. The Stereoly consists basically of a unit which incorporates two separate prisms 7mm apart. Each prism is fitted with a bracket which makes it adaptable to any 5cm lens and the 24 × 36mm image is consequently divided into two 18 × 24mm frames. The Stereoly can be used for instantaneous photography. However, its main drawback is that the 5cm lens, used with an 18 × 24mm portion film, produces a telephoto effect which is excellent for portraits but totally unsatisfactory for landscapes.

The Stereoly, which continued to be in production until 1939, was initially available only for the Leica models I and I Interchangeable. Later, with the introduction of the Leica II, a special bracket with an optical finder was introduced. Lastly a special bracket was made available for the Leica IIIC.

A stereo viewer (factory code Votra) was offered in conjunction with the Stereoly. This beautifully machined device has individually adjustable eyepieces and the interpupillary distance is adjustable. The viewer can either be held in the hand or fixed to a sturdy table stand. Finished in nickel and sold in a coffret lined in velvet, this is probably one of the most attractive Leitz accessories.

90 Leica II

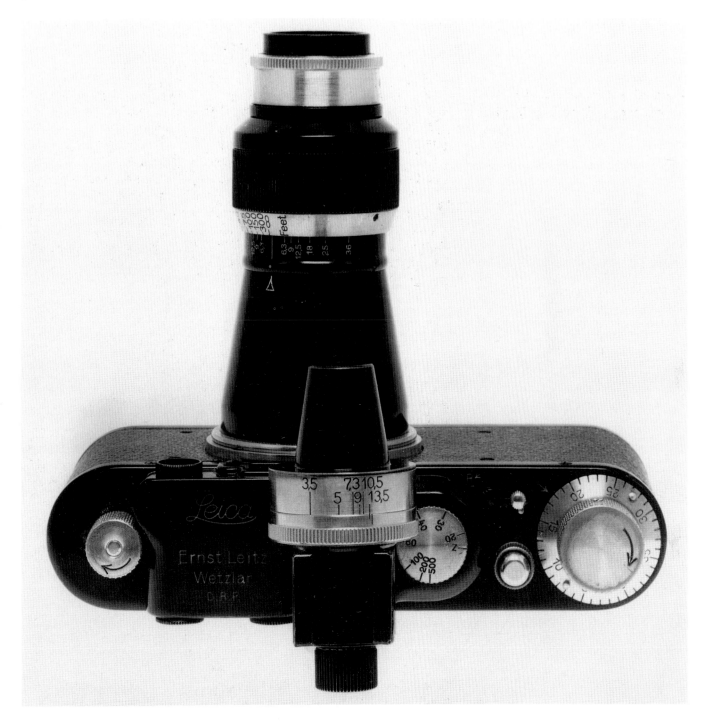

Model D in USA
Model Couplex in France

1932
SN 97228
Lens 10.5cm f6.3 Elmar, SN 136407 by
Ernst Leitz, Wetzlar
Designed and manufactured by Ernst
Leitz, Wetzlar

The Leica II was the first Leica to be fitted with a coupled rangefinder, to which
lenses from 35mm to 135mm could be coupled. The Leica II became the basis of
the interchangeable lens system and met with great success when it was first
shown at the Leipzig Spring Fair of 1932. Soon after the Fair, on 1 February, mass
production of the Leica II was begun under the direction of August Bauer, the
first serial number being 71,200.

The Leica II is similar to the Leica I in construction, with the addition of the
rangefinder housing. On the top plate the only difference is the increased height
of the re-wind knob which was made extendable to make re-winding easier. It
was said that Barnack placed a ruler across the wind knob and decided that this
was to be the maximum height of the rangefinder housing. It was therefore

Leica II *continued*

logical to extend the re-wind knob to the same height as the wind knob and it had to be extendable for it to be possible to use it.

The rangefinder of the Leica II is similar in design to the accessory rangefinder, except that the optical base is much shorter. Since operation is by a coupled cam, instead of transference of readings from rangefinder scale to lens scale, this reduction in base length is accurate enough for lenses of up to 135mm focal length. It is the movement of the cam that determines the range.

Initially the Leica II was produced in black with nickel fittings, later in chrome, the early examples having the brighter finish. The illustrated specimen is an export model in that it has 'Germany' engraved on the accessory shoe. This is confirmed by the engraving of both owner's name and supplier's name on the baseplate: 'V. W. G. RANGER' and 'Sold by JAMES A. SINCLAIR and Co Ltd, 3 WHITEHALL, LONDON, SW1'.

The 10.5cm f6.3 Elmar lens is often described as the 'lightweight' or 'mountain' Elmar as it was designed as an accessory lens for the traveller or mountaineer. It is of a standard four-glass construction and the two rear elements are cemented together. The optical design is by Dr Max Berek and the lens was supplied with a reversible lens hood and cap. It is one of the neatest and most graceful of all the Leitz lenses and although it is of fine optical design, light and inexpensive, it met with only limited success. Its low weight was achieved at the expense of maximum aperture, hence results were poor on account of camera shake, which in turn was caused by the use of low shutter speeds. The lens stops down to f36 and focuses to 10ft.

91 Contax I

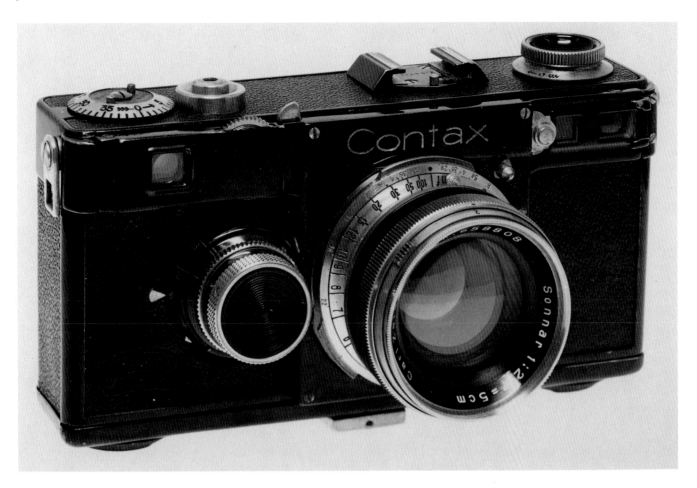

1932-36
SN Y63166
Lens 50mm f1.5, SN 1459449 by Carl
Zeiss, Jena
Designed by Heinz Kuppenbender;
manufactured by Zeiss Ikon, Dresden

See colour plate VII

50mm f1.5 Sonnar
50mm f2 Sonnar
50mm f2.8 Tessar
50mm f3.5 Tessar
28mm f8 Tessar (uncoupled)
40mm f2 Biotar
85mm f4 Triotar
85mm f2 Sonnar
135mm f4 Sonnar
180mm f2.8 Sonnar
300mm f8 Tele-Tessar K (uncoupled)
500mm f8 Fern lens (uncoupled)

The Contax was Zeiss Ikon's rival to Ernst Leitz's Leica. Its introduction to the market was much delayed as Leitz had patented many vital parts of the shutter.

The Contax took perforated film and produced up to thirty-six 24 × 36mm exposures. The shutter speeds on this specimen, the first version of the Contax I, are B and 1/25 to 1/1000 sec. Later versions of the Contax I incorporated the slower shutter speeds of ½, 1/5 and 1/10 sec. The lenses (listed on the left), which had many types of viewfinder to match, were offered with the Contax I. All of them were in black enamel and nickel-plated finish. Later Contax pre-war lenses would also fit.

The optical finder of the Contax I was initially only for 50mm lenses, though a slide in the viewfinder for 85mm or 135mm lenses soon became a built-in feature. The combined viewfinder and rangefinder covered virtually the entire base of the Contax, and this therefore enabled accurate coupling, especially when using long lenses up to the 180mm f8 Tele-Tessar K. The camera has two bayonet mounts, an inner and an outer mount. Heavier (and usually longer) lenses used the outer bayonet whereas the inner bayonet mount was used mainly for the standard lighter lenses.

The film advance and shutter winder were cross-coupled but the advance wind knob was located in a rather unusual position on the front of the camera, to the left of the lens. The shutter was made of metal slats and travelled vertically, in contrast to other 35mm shutters. The shutter was of great mechanical complexity, owing to the fact that Leitz of Wetzlar held many vital shutter patents. The whole of the camera back was removable for easy loading.

The camera body was made of die-cast metal; the top and bottom were enamelled and the sides were covered with leather. A whole array of unusual accessories were offered in conjunction with the Contax I, making it a true system camera to rival the Leica.

92

1934
SN A46962
Lens 50mm f2.8 Tessar, SN 1533848 by
Carl Zeiss, Jena
Designed and manufactured by Zeiss
Ikon, Dresden

Contaflex twin lens reflex

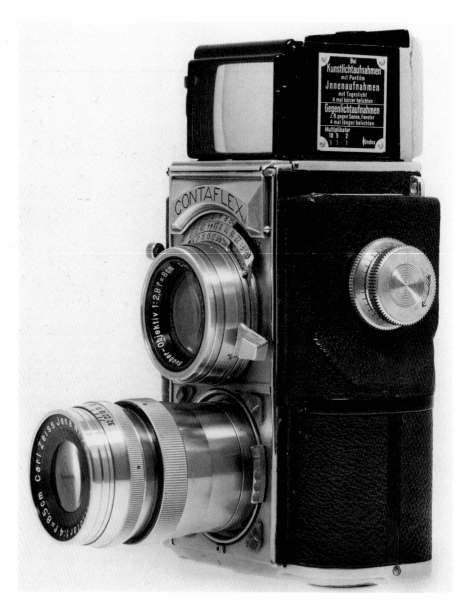

The Contaflex, the first camera to have a built-in exposure meter (although this
was not coupled to the camera), was undoubtedly a landmark. It was a camera of
great complexity and its design was a triumph amongst its contemporaries.
Many of the accessories available for the Contax were adapted or modified for
use with the Contaflex, such as the interchangeable back for single exposure.
The Contaflex used 35mm perforated film, taking up to thirty-six 24 × 36mm
exposures. The upper lens of the camera, the 8cm f2.8 Sucher Objektiv, was used
for viewing and focusing, whereas the lower lens, the 50mm f1.5 Sonnar, was
used for taking the pictures. The latter lenses were interchangeable and the
following were available:

50mm f3.5 Tessar	35mm f4 Biogon
50mm f2.8 Tessar	85mm f4 Triotar
50mm f2 Sonnar	85mm Sonnar
50mm f1.5 Sonnar	135mm f4 Sonnar

The 8cm f2.8 Sucher Objektiv reflex viewing lens was complemented by an
Albada suspended frame viewfinder.

The shutter was similar in design to that of the Contax and had metallic slats
descending vertically to a range of speeds from 2 secs to 1/1000 sec and B.

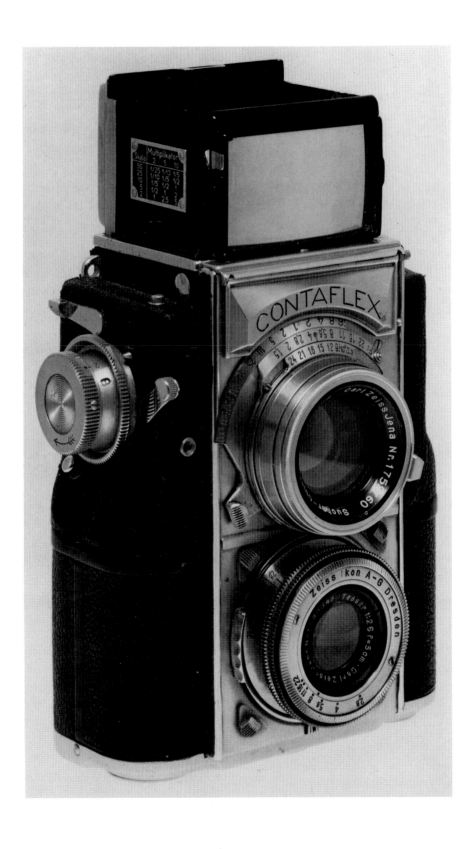

93 Leica 250

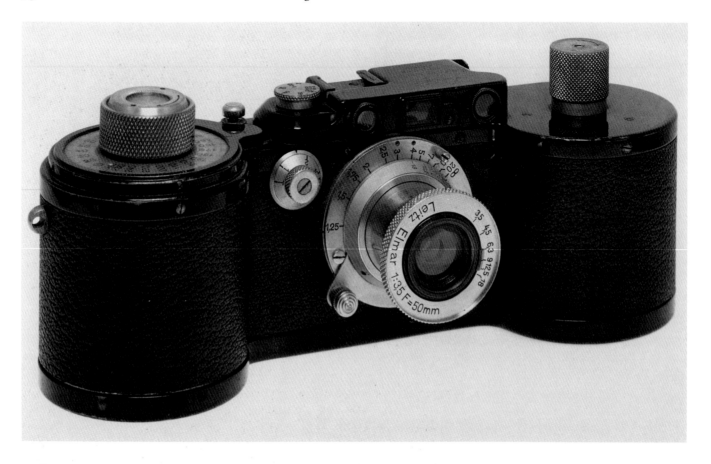

Also named the Leica Reporter or 'FF' in the USA

Introduced 1934
SN 135626
Lens 5cm f3.5 Elmar, no SN, by Ernst Leitz, Wetzlar
Designed and manufactured by Ernst Leitz

See colour plate VIII

The Leica 250 is a coupled rangefinder camera for up to 250 24 × 36mm exposures. Its design was initially based on that of a normal production model Leica III with the end sections doubled in order to take the 10m film load. The 250 is the only Leica for more than thirty-six exposures of the full 24 × 36mm format and was also the last camera designed by Oskar Barnack, the father of the Leica.

To ease loading the film was passed from one cassette to another. Cassettes obviously had to be loaded in the dark but could also be installed in the camera in daylight. The 250 could also be used with spools in which case loading had to take place in the dark. The cassette to cassette facility did have the advantage of speeding up re-loading as it was not necessary to have to re-wind the film back into the other cassette. In other respects the 250 was identical to a Leica III. The shutter consisted of two cloth blinds travelling horizontally with speeds of T, B and 1 to 1/500 sec. Later models of the 250 were based on a IIIA with a top speed of 1/1000 sec and were appropriately called 'GG'. In all, less than 1,000 Leica 250 cameras were produced.

94

1934-38
SN 16242
Lens 3cm f2.8 Tessar by Carl Zeiss, Jena
Designed and manufactured by Otto
Berning, Schwelm-Westfalen

Robot I

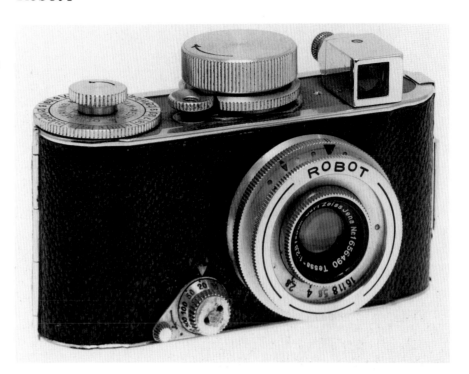

The Robot I was the first in a long line of Robot cameras. Robot cameras are still in production today and may be used for surveillance purposes with built-in electric motors and other specifically designed accessories.

The Robot I took up to fifty 24 × 24mm exposures on 35mm film in special Robot cassettes. The camera accepted special dark-room-loaded cassettes and operation was from cassette to cassette. It was possible to obtain up to fifty exposures per load but only ten to twelve exposures per spring wind at a maximum of two frames per second when new. The film counter reads 1-25 and then repeats itself for a full load. The spring wind knob is located on the top of the camera, as is the optical viewfinder. The direct vision optical viewfinder swivels through 90° to give a lower level but inverted image further degraded by the introduction of a blue monochromatic filter for tone evaluation – a singularly useless feature.

The camera has a rotary metal shutter with speeds of 1 and 1/500 sec and T. The camera accepts screw-mounted lenses with special colour-coded depth of field indicators. When introduced in 1934 the Robot I was available with the following lenses:

3cm f3.5 Meyer Primotar
3cm f2.8 Zeiss Tessar
5cm f5.5 Schneider Tele Xenar with box-type viewfinder mask.

No accessory viewfinders were available as the Robot I had no accessory shoe.

95 Canon Hansa

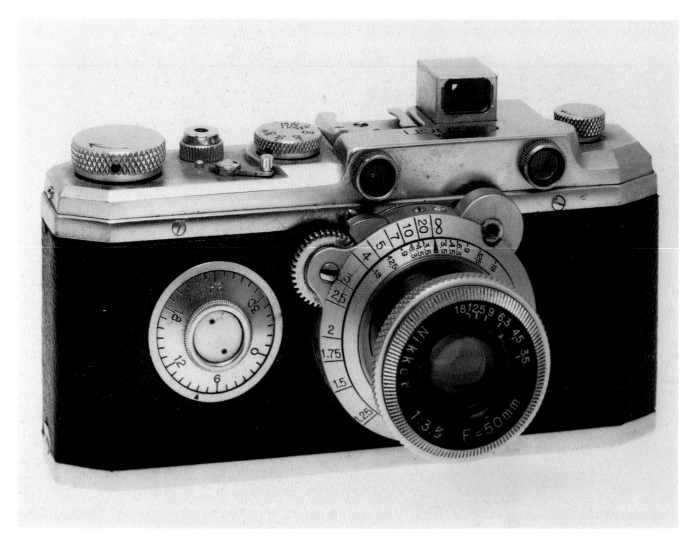

1934-40
SN 457
Lens 50mm f3.5 Nikkor by Nippon
Kogaku, Tokyo
Designed and manufactured by Seiki
Kogaku, Japan

The Canon Hansa is Seiki Kogaku's first available coupled rangefinder camera, producing up to thirty-six 24 × 36mm exposures. It is also the first camera to have Nikkor lenses. The lens manufacturer Nippon Kogaku were later to produce the Nikon rangefinder, followed by the lengendary Nikon F.

The 50mm viewfinder retracts into the top plate and the eyepiece is solely used for focusing the rangefinder. The lens mount is of the Contax bayonet type (an inner mount only) and the Hansa was usually supplied with the 50mm f3.5 Nikkor lens. A small wheel to the left of the lens would focus the rangefinder. It would appear that the lens mount was also produced by Nippon Kogaku and it is engraved to this effect.

The shutter consists of two horizontally travelling cloth blinds and the shutter speeds are Z and 1/20 to 1/500 sec. The camera has no slow speeds and the Canon Seiki available from 1938 onwards was designed to alleviate this problem.

The wind-on knob, re-wind knob and reverse lever are all on the top plate in the locations normally associated with 35mm cameras. However, the frame counter, so often part of the lower portion of the wind-on knob, is situated on the front of the camera to the left of the lens. Its location, so close to the focusing wheel, caused many problems.

The Canon Hansa was only available in a chrome finish and probably only about 1,000 were produced.

96 Super Nettel I

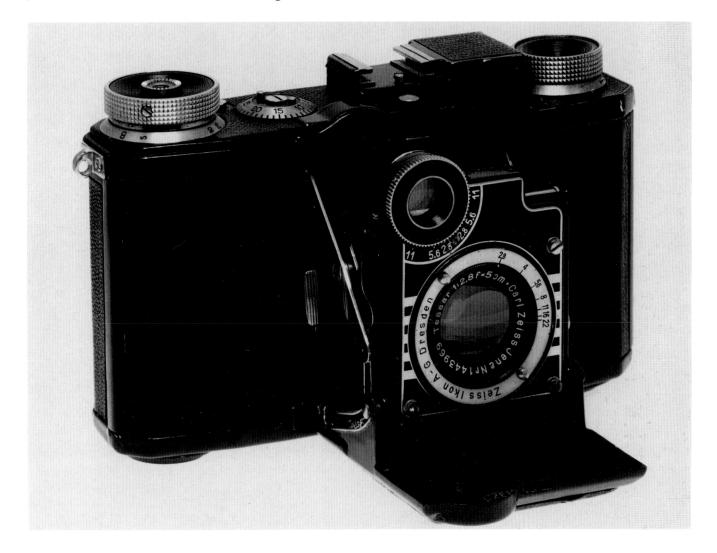

1934-38
SN B22547
Lens 5cm f2.8 Tessar by Carl Zeiss, Jena
Designed and manufactured by
Zeiss Ikon, Dresden

The Super Nettel I was a triumph of design and enabled many enthusiasts to be introduced to Contax photography at a reasonable cost.

This camera, a coupled 35mm rangefinder for up to thirty-six 24 × 36mm exposures, had a fixed 50mm lens which could be either the f2.8 Tessar, the f3.5 Tessar or the f3.5 Triotar. The camera had a similar shutter to the Contax II with vertically travelling metallic slats. The shutter offered speeds of T and 1/5 to 1/1000 sec. The camera had a built-in optical 50mm viewfinder and a rotating wedge-type rangefinder.

The most interesting feature of the Super Nettel I is that it incorporated a folding bellows unit held rigid by lazy tongs and by the collapsible front cover of the camera. The camera was therefore much more compact than the Contax II and also much lighter. The Super Nettel was the ideal camera for the enthusiast who wanted the precision of the Contax but did not require interchangeable lenses or extremely slow speeds.

The camera was finished in black enamel paint with nickel fittings (later chrome) and the main part of the body was covered in black leather. The usual accessories such as a case, lens hoods, filters, waist-lever finder, oblique finder and Albada finder were offered; a special cut-sheet plate back adaptor and a close-up device called the Contameter were also available, enabling close focusing at 20in, 14in or 8in, when the camera was fitted with one of the supplementary lenses provided. The Contameter acted both as a special distance meter for near subjects and as a finder with compensation for parallax.

97

Sport

1935
Lens 5cm f3.5 Industar, SN 13737
Designed and manufactured by Gomz,
Leningrad

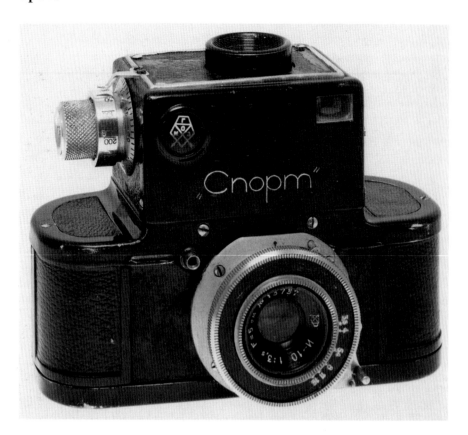

The Sport is one of the earliest single lens reflex cameras produced. It takes up to fifty 24 × 36mm exposures on 35mm film in special cartridges. The camera is of cartridge to cartridge operation, hence there is no re-wind knob. The shutter consists of vertical metal blades with speeds of 1/25 to 1/500 sec and B. The lens of Tessar-derived four-element construction stops down to f16. A focusing mount is permanently attached to the camera and the lens bayonet mount is very much in the Contax-Exakta fashion. The reflex housing does not have an instant return mirror and there is also a small optical viewfinder.

The knob on the top plate serves three separate functions. It winds the film, cocks the shutter and incorporates an exposure counter. The finish of the camera, leather covering with nickel plated fittings, as well as its mechanical quality, bear more resemblance to German cameras than to the abysmal finish given to most Russian cameras of the period. It is a widely held view amongst photo-historians that the Sport was actually manufactured in Dresden and assembled in Leningrad, although it might possibly have been designed in Russia.

98

Factory code Toody

1935
Lens 9cm f2.2 Thambar, SN 283495
Designed and manufactured by Ernst
Leitz, Wetzlar

Thambar soft focus lens

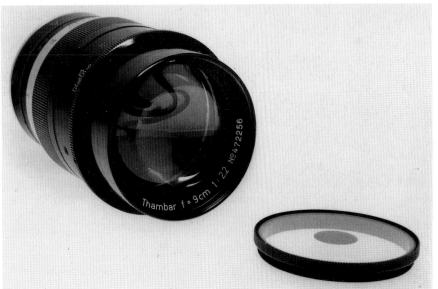

The rare Thambar, one of the legendary Leica lenses much sought-after by
collectors. It was the first lens for a 35mm camera especially designed for taking
soft focus portraits. Of a simple four-element construction, it is designed to
retain a certain amount of spherical aberration at full aperture. It is this inherent
lack of sharpness combined with the use of a central diffusion spot that led to the
production of a very soft image. At apertures below f6.3, and with the spot
removed, the Thambar can be used as a normal long-focus lens. The lens has two
aperture scales: a red one and a white one. The red one is used in conjunction
with the spot and has marking from f2.3 to f6.3. The white scale is for use
without a spot and has marking from f2.2 to f25. The lens is coupled to the
rangefinder of a Leica and focuses to 3.5ft.

99 Nettax

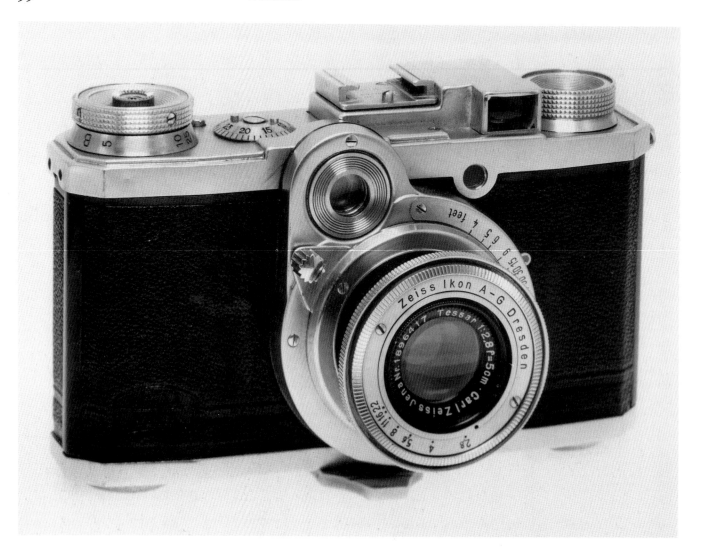

1936-39
SN A 48280
Lens 50mm f2.8 Tessar, SN 1896417 by
Carl Zeiss, Jena
Designed and manufactured by Zeiss
Ikon, Dresden

The Nettax, a coupled rangefinder 35mm camera for up to thirty-six 24 × 36mm exposures and in many ways a rigid version of the Super Nettel, was offered as a cheaper alternative to the Contax II. Unfortunately even in England the price differential of only two pounds was nominal, hence the Nettax did not compete favourably with the Contax II. The Nettax, moreover, was nearly as heavy as the Contax II. The Nettax 35mm camera was brilliantly designed but its design and specifications were too close to those of the Contax II, hence few were sold.

The lens is interchangeable and a choice of either a 50mm f3.5 or a 50mm f2.8 Tessar was available. The only two non-standard lenses were the 105mm f5.6 Zeiss Triotar and the 28mm f8 Zeiss Tessar. The lenses were supplied in kidney-shaped mounts and each incorporated a rotating wedge. Contax lenses, particularly the 85mm f4 Triotar, could be used with an adaptor ring but there was no rangefinder coupling. A separate viewfinder for both accessory lenses was required as the camera incorporated only a 50mm field of view. The shutter consisted of vertically travelling metal slots and the speeds were T and 1/5 to 1/1000 sec.

The Nettax was finished in chrome and the body was covered in black leather. Many accessories were available, such as lens hood, filters, accessory viewfinders, a close-up Contameter unit and a single exposure plate back unit.

Olympic Sonnar 18cm f2.8 for the Contax

Introduced 1937

SN 1844950
Designed by Ludwig Bertele and
manufactured by Carl Zeiss, Jena

The 18cm f2.8 Sonnar was first introduced for the Winter Olympics of 1936 at
Garmisch-Partenkirchen, in a prototype form to selected photographers. At the
1936 Summer Olympics in Berlin the lens was also available to a greater number
of photographers including Leni Riefenstahl, who used it widely for her famous
film of the event. The 18cm f2.8 Sonnar is an outstanding lens. It is still in
production, albeit in a mechanically different form, at Carl Zeiss, as a lens for the
Contax RTS single lens reflex camera.

 The resolution and contrast are surprisingly good. The lens focuses down to
approximately 5ft and also improves considerably on stopping down. The lens
consists of four elements in four groups and was designed by Ludwig Bertele.
Once the lens had been discontinued for the Contax it was later reintroduced in a
new mount for the Contarex single lens reflex camera. In its Contax version the
18cm f2.8 Sonnar appeared in two different mounts. The first version was direct
coupled, *ie* the 18cm lens would be coupled directly to the rangefinder of the
Contax and an accessory optical viewfinder was used. Unfortunately the base of

Olympic Sonnar 18cm f2.8 *continued*

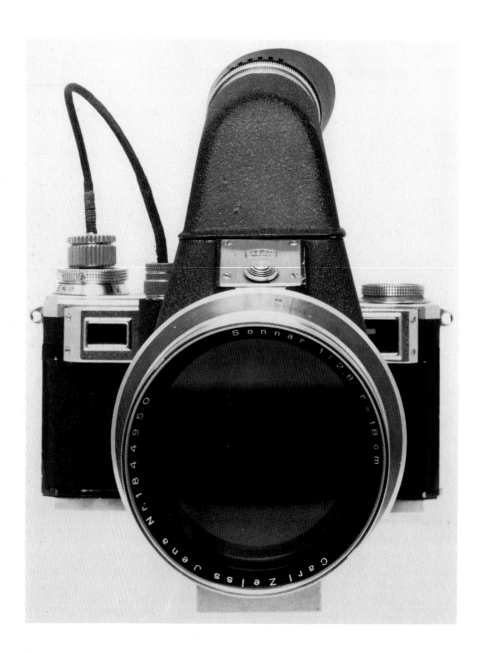

the rangefinder was not sufficiently long to ensure accurate focusing, hence the reflex mirror housing, namely the Flektoskop, was introduced. This gave a real though inverted image. The lens would stop down to f22 and focus to 2m.

The 18cm Sonnar was much used in conjunction with a special Zeiss gun stop and pre-war photographers were very fond of this outfit. When introduced in 1937, the lens, at £64, was immensely expensive. It nevertheless sold well. Its outstanding design ensured it a long life, first for the Contax, then for the Contarex and finally for the Contax RTS, although the optical specification did alter to allow for new glasses.

In the prototype and the patent drawings the lens consists of four elements in three groups. The early production, ie pre-war and war-time versions, consist of five elements in three groups, whereas the Contarex configuration consists of four elements in three groups once again, owing to the use of new rare earth glasses. The East German Zeiss plant has continued production of this lens but with multi-coating for the Praktica/Pentacon. The lens is also used in Exakta and other mounts up to the present day. The 18cm f2.8 Sonnar will also cover 6 × 6cm and was intended to be an option for the 1939 6 × 6cm Exakta and Primaflex. The Pentacon 6 × 6cm version is still an excellent performer by modern standards.

101 Canon Seiki

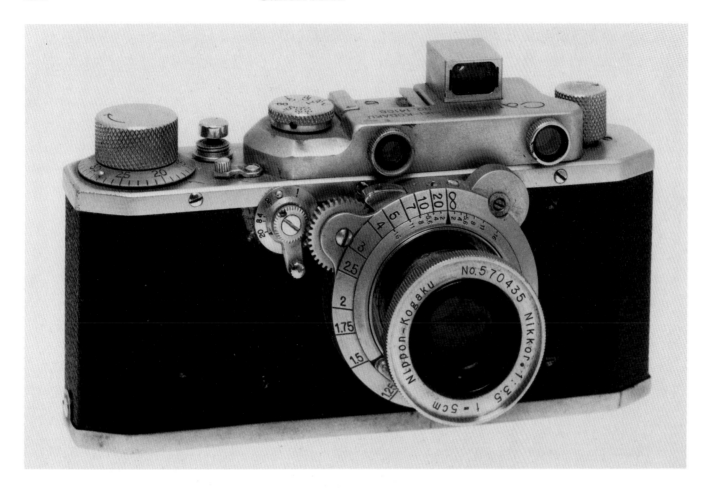

1938-45
Body No. 14108
Lens 5cm f3.5 Nikkor, SN 570435 by
Canon Kogaku, Japan
Designed and manufactured by
Canon Kogaku

The Canon Seiki is a 35mm coupled rangefinder camera for up to thirty-six 24 × 36mm exposures and, after the Hansa, was basically Canon's second model.

The 50mm viewfinder retracts into the top plate and the eyepiece is used merely for focusing the rangefinder. The lenses are interchangeable and bayonet-mount themselves into the front flange. A small wheel to the left of the lens is used for focusing. The following range was offered:

50mm f3.5 Nikkor
50mm f2.8 Nikkor
50mm f2 Nikkor
and perhaps a 35mm f3.5 Nikkor.

The shutter consists of two horizontally travelling cloth blinds and two separate speed dials to regulate its operation. The slow dial (on the front of the camera) covers the speeds 1 sec to 1/20 sec, whereas the dial on the top plate covers Z and 1/20 to 1/500 sec.

The Canon Seiki was available only in chrome. Over 1,500 were produced.

102

Ducati

1938
SN 07597
Lens 35mm f3.5 Vitor, SN 31325 by
Ducati, Italy
Designed and manufactured by Società
Scientifico Radio Brevetti Ducati, Milan

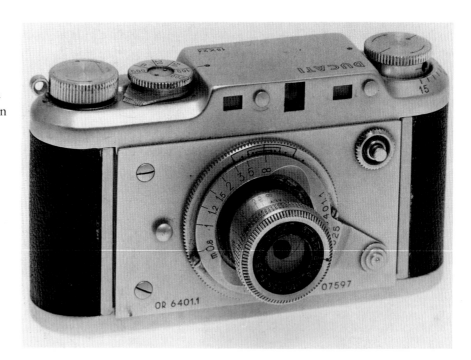

The Ducati is the only Italian half-frame camera. It is a miniature 35mm coupled rangefinder camera for up to fifteen 18 × 24mm exposures on 35mm film in special cassettes.

The Vitor lens stops down to f16 and focuses to 0.8m. The lens is in an interchangeable bayonet mount and the alternative standard lenses also available for the Ducati were the 35mm f2.8 Vitor and the 35mm f3.5 Etar. The lens mount is collapsible. The shutter is of the focal plane variety consisting of two cloth blinds travelling horizontally with speeds of B and 1/20 to 1/500 sec. The camera also has an inner double flap shutter as the main shutter is not of the self-capping variety. There are two eyepieces; one for the viewfinder and another for the rangefinder.

The camera is well built of chromed brass and the body is covered with leather. Many and various Ducati models were produced, the main variant being fixed or interchangeable lens or rangefinder or non-rangefinder.

103 Spektaretta

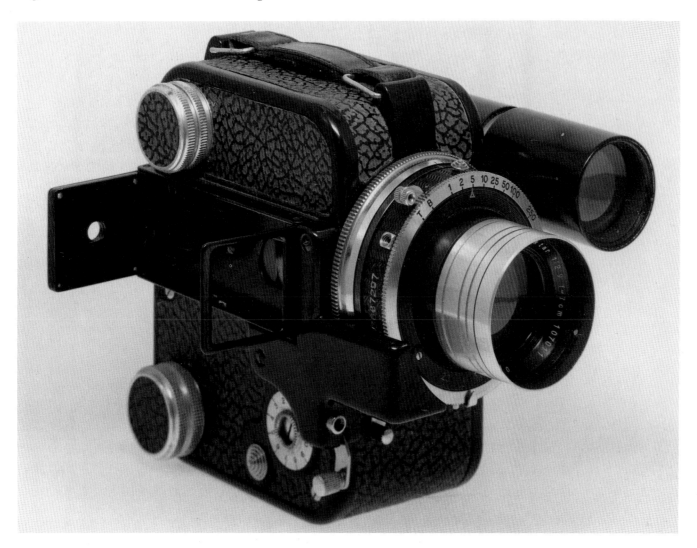

1939
SN 2920
Lens 7cm f2.9 Spektar, SN 107011 by
Optikotechnika, Prerau/Prerov,
Czechoslovakia
Designed and manufactured by
Optikotechnika, Prerau

The Spektaretta is a tri-colour camera for three simultaneous exposures and is unique in that it is the only 35mm tri-colour camera ever made.

A complicated prism splits the single image from the lens into three separate images through three different colour filters of red, green and blue. The camera would therefore enable the user to expose twelve tri-colour exposures, each consisting of three 24 × 36mm negatives. The Spektar lens is built into a Compur shutter with speeds of T, B and 1 sec to 1/250 sec. The lens stops down to f22 and focuses to 1m; it is reputedly made by Meopta in Prague. For viewing there is a folding framefinder and a telescope magnifier which assists focusing. The telescope finder has a ground glass screen and a scale. Readings can be transferred on to the main lens mount.

The Spektaretta was covered by the Deutsche Reichspatent No.705918.

104 Leica IIIC grey

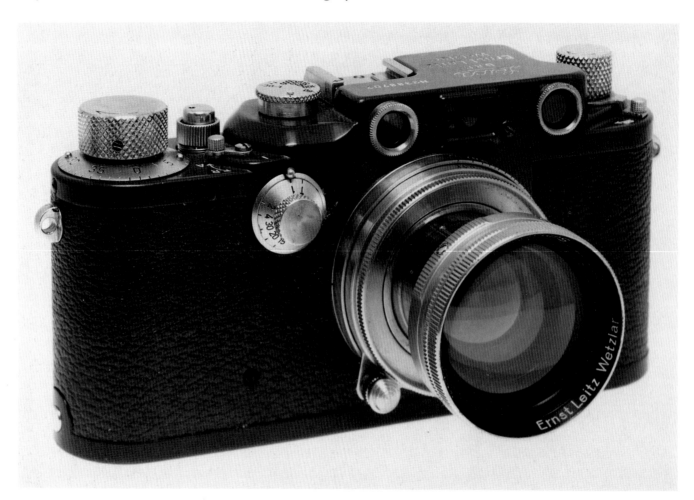

1941
SN 387 702
Lens 5cm f2 Summitar SN 585426
by Ernst Leitz Wetzlar
Designed and manufactured by Ernst
Leitz

See colour plate VIII

A coupled rangefinder camera for up to thirty-six 24 × 36mm exposures. With nearly 140,000 Leica IIIC cameras produced, albeit in various finishes and specifications, the Leica IIIC was one of the most successful models produced by Ernst Leitz.

The IIIC heralds a complete departure from previous models. This is the first Leica to have a die-cast body and the cover of the rangefinder housing is an integral part of the top plate. The rigid alloy casting which replaces the earlier brass shutter crate not only increases rigidity but also ensures greater film planeity. The die-cast alloy interior also made possible a stepping-up of production since die-cast components can be quickly machined. The camera has two oculars: one for the 5cm parallax corrected optical viewfinder and the other for the coupled rangefinder. The shutter consists of two cloth blinds travelling horizontally with speeds of T, B and 1 sec to 1/1000 sec. By 1941, as a result of the war, the Leitz company had exhausted its stock of Kodak blind material and German parachute cloth was used instead. By the same token this IIIC is finished in grey-blue enamel as there was a severe shortage of chrome.

Stereotar C stereo lens for the Contax

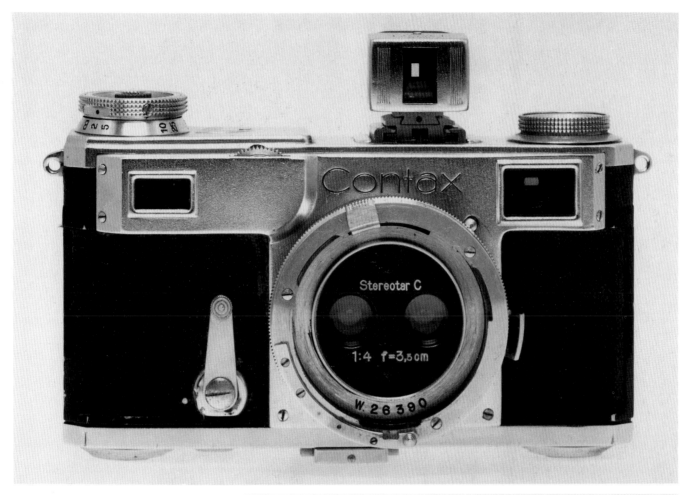

1941-42
Lenses 35mm f4 twin matched,
SN W26390, Zeiss Code 543/70
Designed and manufactured by Zeiss
Ikon, Germany

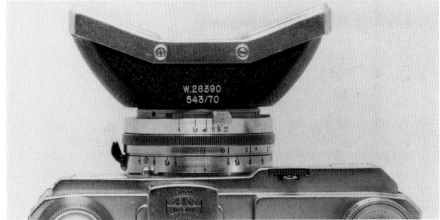

Introduced at the 1949 Leipzig Fair, the Stereotar C lens unit was produced in very small quantities during World War II; it had a military application for aerial photography. A modified, more advanced version of the Stereotar C was offered post-war for the amateur market.

The Stereotar C fits the outer bayonet of the Contax 35mm camera, transforming it into a stereo camera. The unit was not coupled to the rangefinder and the focus had to be set by hand. Beyond a 3m field a special prism would have to be fitted to the lens, thereby increasing the effective separation. Two types of viewfinders were offered; one was a small optical viewfinder and the other consisted of a small mask that fitted over the viewfinder of the existing Contax.

106 Reid

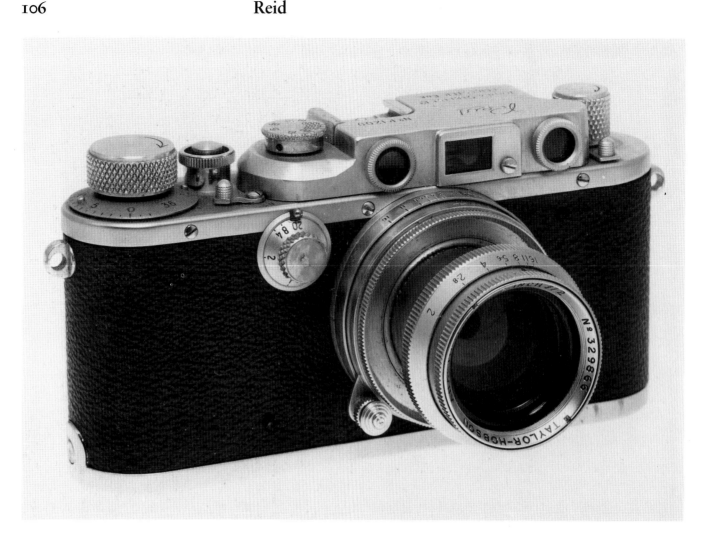

c.1947
SN P1200
Lens 2in f2 Anastigmat, SN 329866 by
Taylor-Hobson
Manufactured by Reid & Sigrist,
Leicester

The Reid is a precise and well-built British copy of the Leica IIIB, the last pre-war Leica model. It is a coupled rangefinder camera for up to thirty-six 24 × 36mm exposures. The camera has a focal plane shutter with speeds of T, B and 1 to 1/1000 sec. It has a coupled rangefinder system that will accept all Leica screw-type lenses.

The Reid cameras were produced in various forms. The illustrated model is the original Reid III. Later IIIs were flash-synchronised. A model II appeared without slow speeds (similar to the Leica II), a model I without a rangefinder (similar to the Leica Standard), and a model IA with neither rangefinder nor viewfinder (similar to the Leica IF).

The Reid cameras were produced at the instigation of the Ministry of Defence as German cameras were not imported into the UK until 1955. Many Reid cameras of all models were to be found with British military markings consisting of a big arrow and a patt number which is in effect a contract number. This arrow and the patt number are stamped on the rear vulcanite. The Reid is to all intents and purposes a British Leica and is certainly the best produced of all the Leica copies.

Starting to collect in the early 1960s, I recall seeing many Reids for sale not only in camera shops but also in military surplus shops and in military surplus auctions. One military surplus camera specialist, Marston & Heard, acquired many Reid parts and assembled them in the late 1960s. A small Wray universal viewfinder similar to the Leitz Viooh was also produced, as were Dallmeyer accessory lenses for the Reid.

107 Duflex

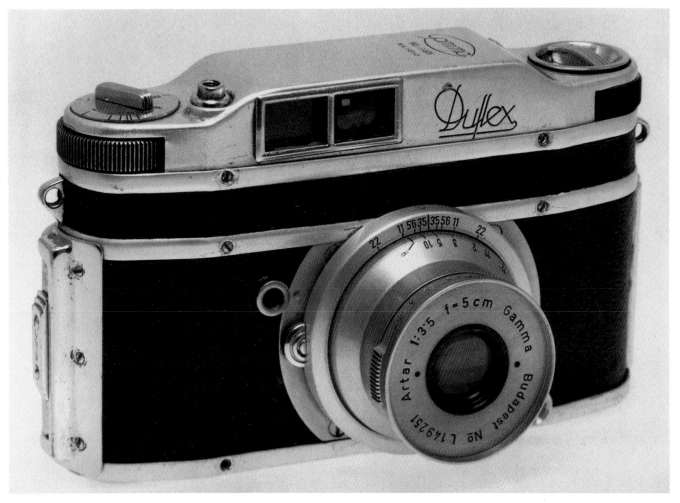

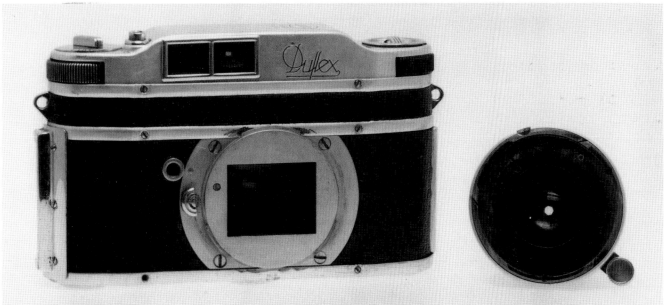

c.1947
SN 3429
Lens 50mm f3.5 Artar, SN L149251 by
Gamma, Budapest
Designed and manufactured by Gamma

The Duflex is a little-known but important camera, incorporating many
remarkable features, the most notable being the instant return mirror, the first in
a 35mm camera. It took up to thirty-six 24 × 36mm exposures. It had an off-set
mirror reflex housing and an impressive eye-level right-way-up and right-way-
round viewing system via mirrors. The Artar lens was bayonet-mounted and had

Duflex *continued*

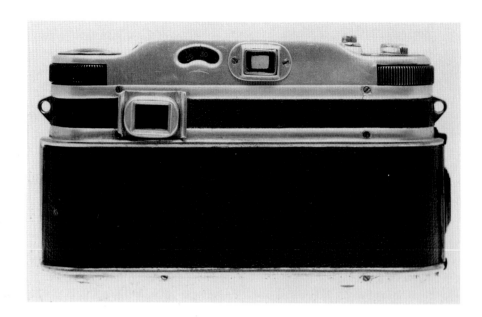

an automatic diaphragm activated by a pin. The Duflex was the first camera to have such a mechanism.

The Duflex had an internally activated fully automatic diaphragm coupled to the shutter release. When the shutter was pressed the diaphragm closed just before the shutter opened, to reopen after the exposure was completed. The mirror of the camera was of the self-return variety. The focal plane shutter consisted of two thin metal blinds travelling horizontally with speeds of 1 to 1/1000 sec. The camera was made of chromed parts with a leather-covered body.

The Duflex was way ahead of its time, and a pentaprism prototype is also said to have been planned. Many camera designers were inspired by this model.

108 Nikon I

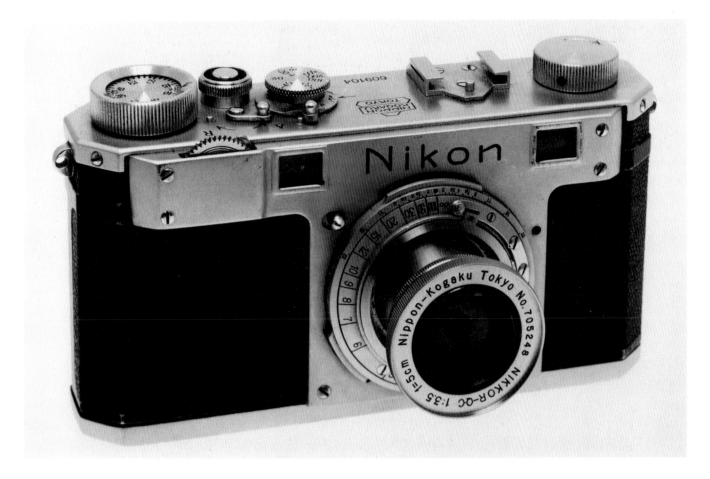

1948-49
SN 609104
Lens 50mm f3.5 Nikkor, SN 705248
Designed and manufactured by Nippon
Kogaku, Japan

The Nikon I is historically important in being the first Nippon Kogaku camera, a coupled rangefinder producing up to thirty-six 24 × 32mm exposures.

Nippon Kogaku KK had been in optical manufacturing since 1917, producing mainly microscopes, binoculars, telescopes and optical measuring instruments for industry. By the early 1930s the company had a range of plate camera lenses of various focal lengths called Nikkor lenses. When Canon launched the Canon Hansa in 1935 they therefore turned to Nippon Kogaku for lenses and the 50mm f2, 50mm f3.5 and 50mm f4.5 Nikkor were produced. Later Nikkor lenses were also produced in Leica screw-mount to meet unexpected demand. It was therefore logical that Nippon Kogaku would eventually produce a camera as a vehicle for selling their own lenses. Around 1946 design work was started on a 35mm camera and by 1948 the first Nippon Kogaku camera, the Nikon I, appeared.

The Nikon I owed much in design to the Contax and Leica, combining the best features of both cameras. The shutter, consisting of cloth blinds travelling horizontally, and the rangefinder unit came from the Leica. The body shape, removable back, focusing mechanism, inner and outer bayonets and the location of the knobs all took their inspiration from the Contax. The shutter speeds were B, T and 1 to 1/500 sec, and the camera had no provision for flash. Although the lens mount was interchangeable it would seem that only 50mm lenses were available: the 50mm f3.5 Nikkor H and the 50mm f2 Nikkor H. Widely available Contax accessory lenses would of course fit the Nikon I.

The only important aspect in which the Nikon I varied from the Contax and

Nikon I *continued*

Leica was the film gate size, and this proved the reason for its demise. The negative size was 24 × 32mm and was hence different from the Leica format of 24 × 36mm. What prompted Nippon Kogaku to adopt this negative size is difficult to explain. Perhaps they felt that in time the 24 × 32mm format could become the Nikon format in the same way that the 24 × 36mm had become the Leica format. Opposition also came from the film processors who were geared to 24 × 36mm sized negatives.

The Nikon I, faultless in all respects except in format, was withdrawn less than a year after its appearance and only some 750 were produced.

109 **Nikon M**

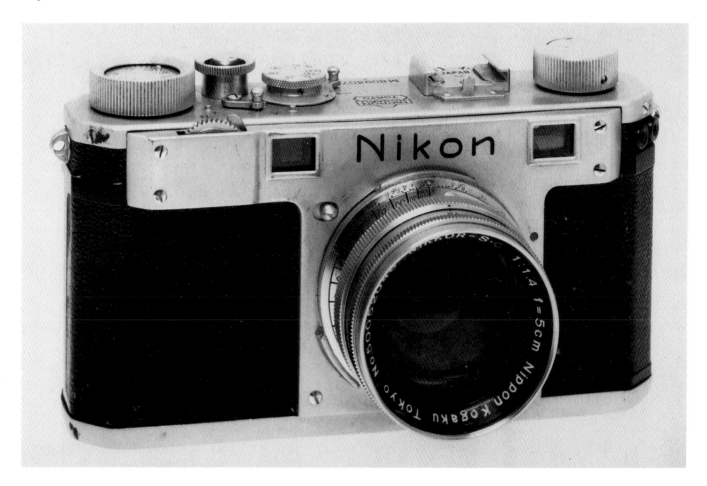

1949-51
SN M6093071
Lens 5cm f1.4 Nikkor-S-C,
SN 50052048 by Nippon Kogaku, Tokyo
Designed and manufactured by Nippon
Kogaku, Tokyo

The Nikon M is Nippon Kogaku's first coupled rangefinder camera producing up to thirty-six 24 × 34mm exposures. Whereas the Nikon I had a 24 × 32mm format, the M went half-way to the full 35mm format of 24 × 36mm. The Nikon M is therefore an intermediate model, a stepping stone to the full 35mm format.

The M is the easiest Nikon to identify in that its body serial number is preceded by an M. Apart from the increased film size gate the M is virtually identical to the I. Basically it is still a cross between a Leica and a Contax. Within the span of production of the M, many cameras with small variations exist. The most important variation is that the late batches of M had flash synchronisation with outlets marked F and S for either bulb or electronic flash.

The M was a successful camera, but as in the case of the Nikon I its format was its downfall, hence it was produced for only three years with a total production of only slightly over 3,000 cameras.

110 **Wrayflex**

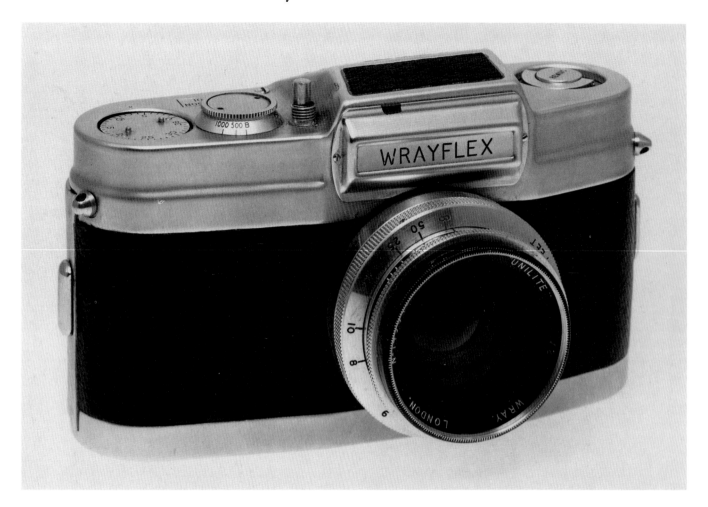

1950
SN 2701
Lens 5cm f2 Unilite, SN 149547, by Wray,
London
Designed and manufactured by Wray
(Optical Works), Bromley, Kent

The Wrayflex is a 35mm single lens reflex camera for up to forty-two 24 × 32mm
exposures. When it was initially launched its designers assumed that the 3:4 ratio
of the negative was more pleasing than the 2:3 ratio of the standard 24 × 36mm
frame. However, owing to popular demand a 24 × 36mm model was later
introduced. The Wrayflex is one of the first cameras designed exclusively for
eye-level viewing of the screen image. The focusing screen is set into the top of
the body and carries a small magnification lens cemented directly onto the
screen. This enlarges a small centre position of the image approximately eight
times for critical focusing.

The screen is observed via two mirrors through the eye-piece at the back of the
camera. With the camera held horizontally the image appears upright but
laterally reversed. If the camera is held vertically for upright pictures the image
on the screen appears upside down but the right way round.

The body of the Wrayflex is streamlined and designed with operating controls
recessed as far as possible. The only significant projections on the top (apart
from the finder housing) are the shutter speed and release button. The shutter is
of the focal plane variety offering speeds of B and ½ to 1/1000 sec. The film
transport and shutter wind mechanism are operated by turning a folding key set
into the baseplate of the camera.

All the lenses had pre-set iris diaphragms and the earliest available were:

35mm f4.5 wide angle Lustrar
50mm f2.8 or f2 Unilite
90mm f4 Lustrar.

The camera was manufactured in a light alloy casting.

111 Nikon S

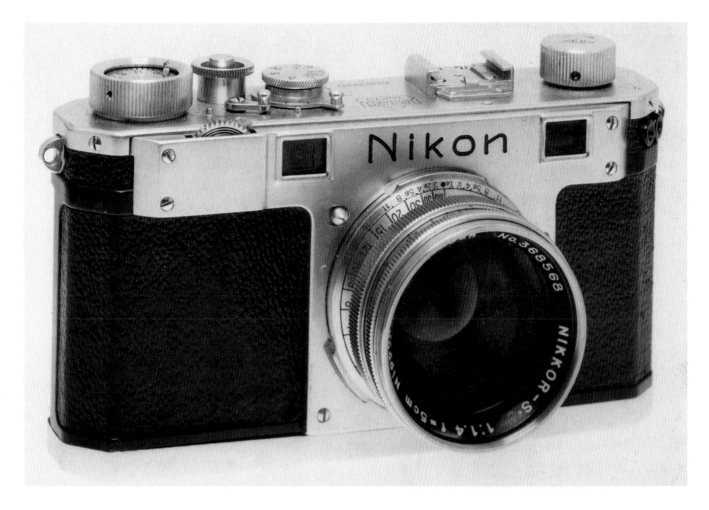

1952-54
SN 6120925
Lens 50mm f1.4 Nikkor S-C, SN 368568
by Nippon Kogaku, Tokyo
Designed and manufactured by Nippon
Kogaku

The Nikon S is the first Nikon coupled rangefinder 35mm camera using the
24 × 36mm format, unlike the Nikon I or the Nikon M.

The viewfinder covers the 50mm lens and incorporates a long-base rangefinder.
The lens is in focus when the double image disappears after rotating the focusing
wheel on the front of the camera body. The body has an inner bayonet mount for
the lighter lenses and an outer bayonet for the heavier lenses, i.e. normally for
those with a longer focal length.

The following range of lenses were available for the Nikon S:

25mm f4 Nikkor	50mm f2 Nikkor
35mm f3.5 Nikkor	85mm f2 Nikkor
35mm f2.5 Nikkor	135mm f3.5 Nikkor
50mm f1.4 Nikkor	

All these lenses, with the exception of the 50mm, would require accessory
viewfinders of the single or multiple focal length varieties.

There are two shutter speed dials on the top plate and the range is B and 1 to
1/500 sec. The shutter blinds are made of cloth and the blinds travel horizontally.
Like its predecessor, the Nikon S has a wind-on knob and the film setting counter
is manual. Internal synchronisation is provided for several types of flashbulbs and
for electronic flash, hence the F and S synchronisation spots on the side of the
camera.

The Nikon S was the first stepping stone to the immensely successful later
lever-wind cameras, the S2, SP, S3, S4 and S3M.

Stereotar C stereo lens unit for the Contax

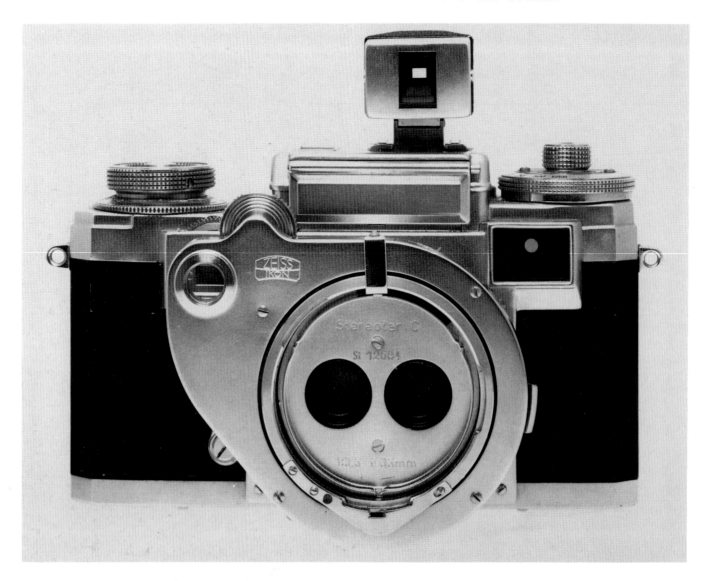

1952
Lenses 35mm f3.5 twin matched,
SN ST12684, by Zeiss Ikon, Stuttgart
Designed and manufactured by Zeiss
Ikon

A post-war version of the Stereotar C lens unit introduced to capitalise on the revival of interest in stereo photography. The Stereotar C has a pair of 35mm f3.5 instead of f4 twin matched lenses. The stereo lens unit fits the outer bayonet of the Contax, transforming the camera into a stereo camera. The resulting transparency could either be viewed in a Zeiss Ikon cream-coloured stereo hand viewer, code 00/1428, or projected through the Stereo Ikolux 500.

Unlike the wartime Stereotar C, the post-war version couples to the rangefinder of the camera with its own focusing wheel. The rear elements of the Stereotar C protrude right into the camera. The lens, viewer and projector all have a 'oo' marking. This indicates that this equipment is for use with the twin lens stereo unit and should not be confused with the beam splitters (indicated by 'o'), such as those for the Contaflex series.

As the 50mm viewfinder for the Contax could not be used, a special 18 × 24mm optical viewfinder slipped into the accessory shoe of the camera. For effective stereo photography of subjects further than 3m away a special 62mm wide prism locked into the front of the lens, thereby increasing the effective separation of the lenses. The Stereotar C unit would focus from infinity right down to 1m.

For close-up photography a special Contameter was available. The Contameter was supplied with three different Proxars for different close-up

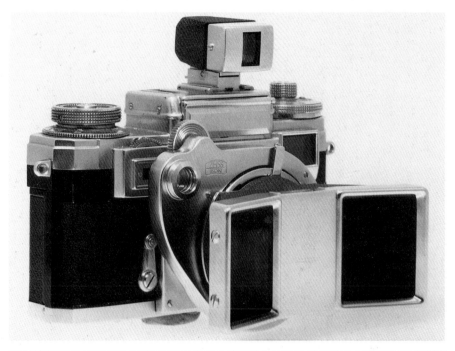

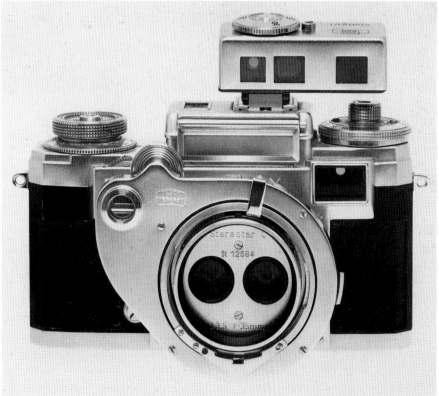

distances, different in optical specification from those used with the Contax 50mm lenses. Also available was a fixed distance document copying unit. This device had built-in Proxars and was much used for fingerprint photography. In the close-up field the Stereotar C was far more advanced than the Stemar, which lacked any close-up facilities.

The Stereotar C, viewfinder, prism and filters all fitted neatly into a beautifully designed leather case.

113

1954-69
SN 700059
Lens 5cm f2.8 Elmar, No.0000232 by
Ernst Leitz, Wetzlar
Designed and manufactured by
Ernst Leitz

Leica M3

The Leica M3 is a coupled rangefinder camera for up to thirty-six 24 × 36mm exposures. It differs radically in design from the Leica I of 1925, yet the heart of the camera, the shutter design, remains virtually the same.

The M3 has a built-in parallax compensated framefinder and a rangefinder for lenses of 50mm, 90mm and 135mm focal lengths. The camera has a bayonet as opposed to a screw mount. The Leitz screw mounts were not obsolete as a special screw mount to M adaptor was available. Upon inserting a lens of either 50mm, 90mm or 135mm focal length, the appropriate frame would appear in the finder.

The shutter consists of two cloth blinds travelling horizontally and the speeds are all on one dial. This is the first Leica to have all the speeds on one dial, B and 1 to 1/1000 sec. On the speed dial there is a small notch which can be coupled to the cam of a specially designed accessory exposure meter, the Leicameter MC. The M3 was the first Leica to have an exposure meter coupled to the shutter speeds: the aperture is read off the meter and transferred to the lens. The film advance and the shutter cocking are done with a lever. Early models require two strokes to advance the film and cock the shutter fully, whereas later models require only one stroke.

The Leica M3 was a world-wide success, in which the most important factor must have been the parallax corrected frames and viewfinders of 50mm, 90mm and 135mm focal lengths. As over 250,000 M3s were produced over a long period from 1954 to 1969 many small mechanical modifications exist such as glass pressure plates, later replaced by metal pressure plates.

Most models were produced in chrome and a few in black enamel finish with matching black paint lenses. A military version of the M3 finished in olive green with a matching olive green vulcanite was made to order for the German army. The M3 was an outstandingly important Leica and its massive success may to some extent have contributed to Leitz's slowness to engage in single lens reflex development.

The 5cm f2.8 Elmar lens was launched as a replacement for the legendary 5cm f3.5 Elmar. Owing to the availability of a rare new earth the recomputation of the 5cm f3.5 yielded an extra stop to f2.8.

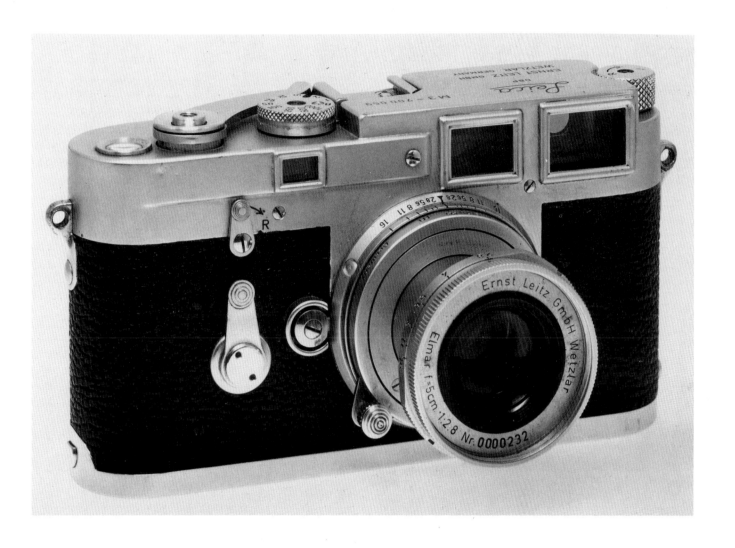

114

1954
SN 2507
Lens 50mm f3.5 Lumar, SN 2356 by
Corfield, Wolverhampton
Designed and manufactured by Corfield

Periflex I

In the early post-war years, Leica, Contax and Exakta cameras could not enter the UK in quantity, requiring special import licenses. A market opened up for reasonably priced alternatives. The Reid was produced as a virtual copy of the Leica IIIB and the Wrayflex was an attempt at a single lens reflex. The Periflex I was much more popular than both the Reid and the Wrayflex as it was cheaper. It was also much used as a second Leica body. It took up to thirty-six 24 × 36mm exposures.

The Periflex I met with great success, to the extent that production could not meet home, let alone international demand. Nevertheless, more sophisticated models followed, the Periflex 2 in 1958, the Periflex 3 in 1957, the Periflex 3A in 1959, the Periflex 3B in 1961, and the Gold Star and the Interplan body in 1961. All these models followed the basic design of the Periflex I with the periscope viewer. In 1961 a single lens 6 × 6cm reflex was launched as the Corfield 66. In the early 1960s the Periflex I came into competition with Japanese single lens reflex cameras. The family firm, by then based in Northern Ireland, faced with stiff competition, decided to abandon production.

The most unusual feature of the Periflex I is its unique periscope-type focusing system. Reflex focusing (not viewing) is achieved by manually placing a mirror and ground glass screen behind the lens which is viewed through a periscope on top of the camera. The viewing area is 4mm wide with the mirror positioned 8mm above the central axis of the 24 × 36mm frame, the eyepiece giving 10x magnification. Viewing is by means of a small optical viewfinder which slips into the accessory shoe. The camera was supplied with a 50mm optical viewfinder but viewfinders from 28mm to 150mm were also available. The 50mm f3.5 Lumar is a three-element lens based on a Cooke triplet; it was designed by Kenneth Corfield and Frederick Archenhold. The optical elements were manufactured by the British Optical Lens Company of Walsall. The lens would focus to 3ft and stop down to f16. The iris was of the manual variety. The camera had a Leica screw thread.

The focal plane shutter consisted of two horizontally travelling rubberised cloth blinds with speeds of B and 1/30 to 1/1000 sec. The shutter also had facilities for flash. The camera was made of light alloy and brass with a black enamel and the centre part had a rubberised leather covering. Later models were of chrome as opposed to a black enamel finish.

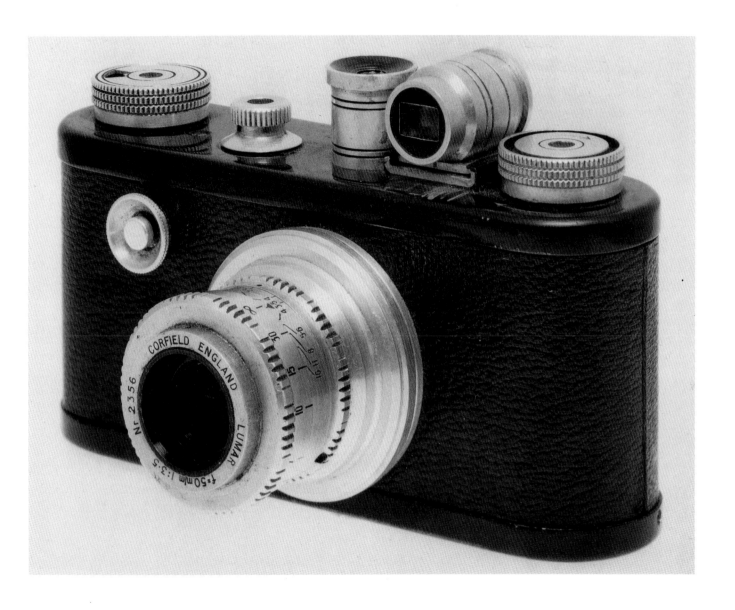

115 Leitz Stemar stereo unit for the Leica

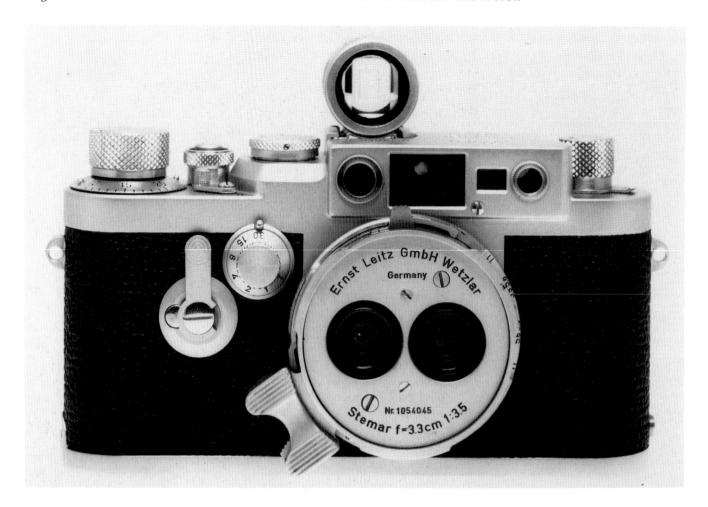

1954
Lens 3.3cm f3.5 Stemar, SN 1054045 by
Ernst Leitz, Wetzlar
Designed and manufactured by Ernst
Leitz

By far the most original and effective contribution of Leitz towards Stereo photography resulted from their evolution of a combination of two lenses based on a design by Albert, dated 28 June 1937. Two wide-angle lenses were incorporated on one mount with a partition reaching far back and splitting the 24 × 36mm frame into two 18 × 24mm frames. The inclusion of two wide-angle lenses in one unit was a highly original conception which averted the problems of the telephoto effect which had been encountered with the Stereoly. The Stemar, incorporating a couple of 3.3cm f3.5 lenses, was manufactured from 1954 to 1957 at the Midland, Ontario Leitz plant, although a few, probably the first batch, were manufactured in Wetzlar. The Stemar had an accessory prism to increase the interlens distance to a 72mm separation. A small brilliant optical viewfinder with an 18 × 24mm frame was available as was a special lens hood. The lens unit was used with prisms for infinity shots and without prisms (but with the lens hood closed) for portraits.

The Stemar met with some success and was produced for both the screw and bayonet-mounted Leicas. A small plastic stereo viewer with a battery housing was also available as was a Prado projector with stereo lenses of different focal lengths.

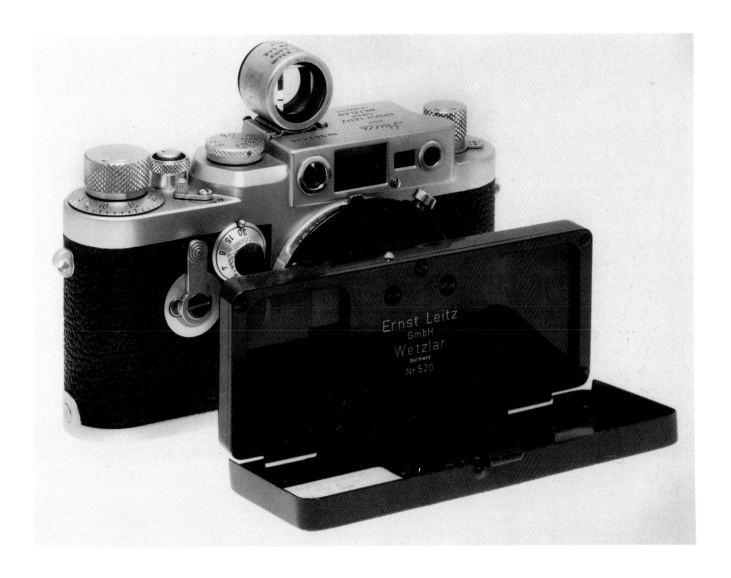

116

1955-58
SN 6170953
Lens 28mm f3.5 W. Nikkor, SN 714238
Designed and manufactured by Nippon
Kogaku, Tokyo

See colour plate VII

Nikon S2

The S2 was a highly successful coupled rangefinder camera, the first of the second and final generation of Nikon rangefinder cameras.

The viewfinder window, which covers only the 50mm field, includes a centred light-coloured rectangle. This shows a double image until it has been brought into focus by rotating the focusing wheel on the Nikon body.

The body has an inner bayonet mount for the light lens and also an outer bayonet for the heavier lenses. The following lenses were available for the S2:

25mm f4 Nikkor	85mm f1.5 Nikkor
28mm f3.5 Nikkor	85mm f2 Nikkor
35mm f2.5 Nikkor	105mm f2.5 Nikkor
35mm f3.5 Nikkor	135mm f3.5 Nikkor
50mm f1.4 Nikkor	180mm f2.5 Nikkor
50mm f2 Nikkor	250mm f4 Nikkor
50mm f3.5 micro-Nikkor	500mm f5 Nikkor

With the exception of the 50mm lens, all lenses require accessory viewfinders of either a single or a multiple focal variety. The 180/2500mm lenses would require the use of the Nikon reflex housing.

The film is advanced using a rapid wind lever; the S2 is the first Nikon to have such an advance system. The two shutter speeds on the top-plate of the S2 are linear, from 1 to 1/1000 sec, also with B and X. The S2 has a flash synchronisation selector on the top plate to provide the proper (millisecond) interval between the start of the shutter release and the ignition of the bulb so that the light is at its maximum when the shutter is open.

The S2 was available with a wide range of accessories other than lens hoods and filters, such as the Nikon Repro-Copy Outfit, close-up adaptors and all-metal under-water housing, which could be used at a depth of 165ft.

A few S2s were also motorised. It has always been assumed that the SP of 1957 was the first motorised Nikon rangefinder but this was not so. The Nikon electric motor drive could either be used for up to three frames per second or on an exposure by exposure basis.

The S2 was discontinued in 1958 and at least two variants are known; one with a white distance scale and a later model with a black dial distance scale. Although most S2s were finished in leather and chrome-plated brass, a professional all black model was also available. The external portions were black nickel-plated and then laquered to eliminate all reflections.

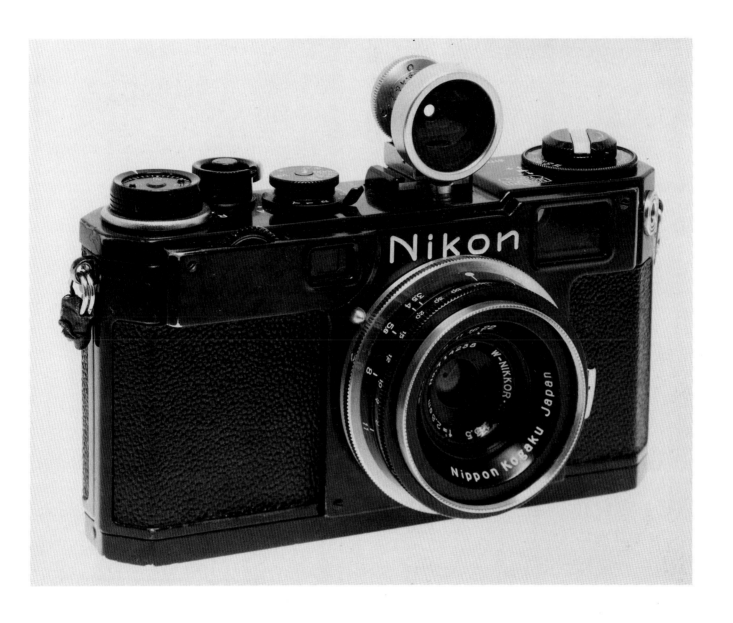

117 Leica MP

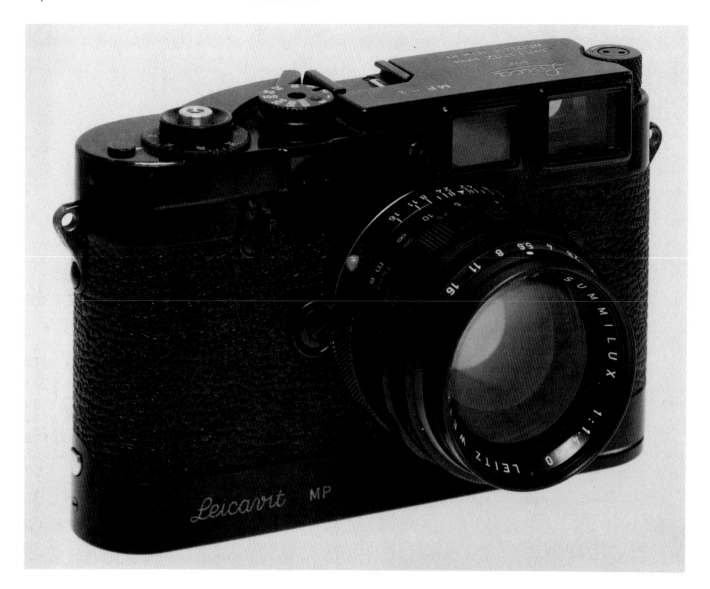

1956-58
SN 2
Lens 50mm f1.4 Summilux, SN 2039932,
designed and manufactured by Ernst
Leitz, Wetzlar
Designed and manufactured by Ernst
Leitz

See colour plate VIII

The Leica MP, a coupled rangefinder camera for up to thirty-six 24 × 36mm
exposures, is basically a Leica M3 body modified to accept a rapid trigger wind
base, the Leicavit MP. Further, the MP has no delayed action and a non-
automatic frame counter. The MP stands for M for Press. The Leica MP
resulted from a series of M3 cameras with Leicavits presented to Albert Einstein,
David Douglas Duncan, and Alfred Einsenstadt. These cameras were
respectively engraved 'MPE' ('E' for Einstein), 'M3D' ('D' for David Douglas
Duncan) and 'M3E' ('E' for Eisenstadt).

Only 402 MPs were manufactured. The MP1 to the MP12 were either black or
chrome. MP1 remains in the factory and MP2 was given to Bob Schwalberg, a
noted photo-journalist and a former Leitz employee. Leicas MP13 to MP150

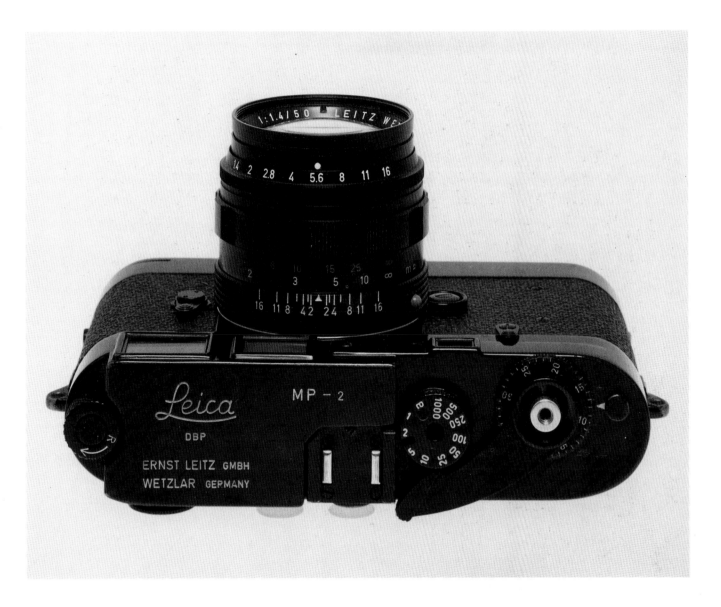

were black and Leicas MP151 to MP402 were in chrome finish. The Leica MP is an historic camera and highly regarded in collectors' circles.

The Summilux lens is of a seven-glass element construction using Lanthanium glass which reduces flare at maximum apertures. This particular version is in black paint, a special order item to match normally either black M2s, M3s or sometimes MPs.

It was an article by Bob Schwalberg about his collection published in the 1960 *Good Photography Handbook* that first aroused my interest in cameras. I soon began to hunt all over the world for other examples of cameras described and illustrated in the article. I did not then imagine that the MP2 itself would one day pass via another collection into mine.

118 Leica IIIG

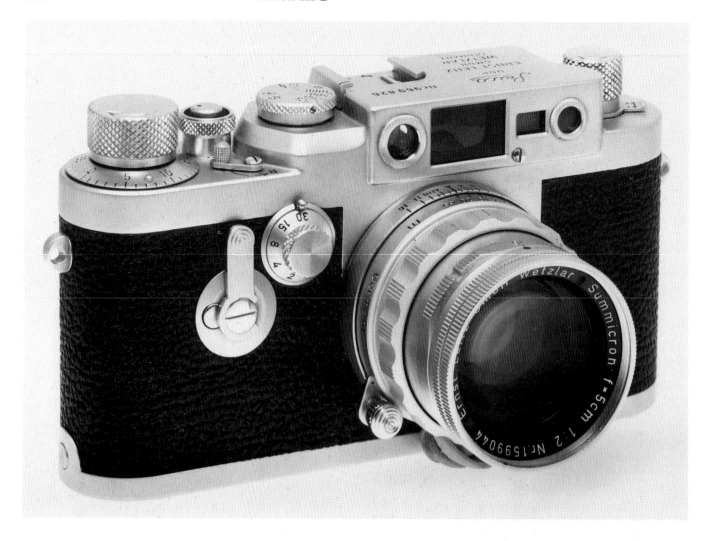

1957-67
SN 969826
Lens 50mm f2, Summicron,
SN 1599044 by Ernst Leitz, Wetzlar
Designed and manufactured by Ernst
Leitz

The Leica IIIG, a coupled rangefinder camera for up to thirty-six exposures, 24 × 36mm, is the last screw-mount Leica and is an acknowledged and beloved classic amongst collectors. Many have been introduced to camera-collecting and, more precisely, to Leica-collecting through the acquisition of a Leica IIIG.

The shutter is of the focal plane variety with two cloth blinds travelling horizontally. The shutter speeds are B, T and 1 to 1/1000 sec. The camera has a built-in rangefinder with both 50mm and 90mm parallax corrected bright-line frames. This is the only screw-mount Leica to have the frames for other than a 50mm lens. The Leica IIIG is also fully synchronised for flash, both electronic and bulb. The camera was available in chrome finish although 125 were produced in black enamel for the Swedish army.

The 50mm f2 Summicron is of a seven-glass Gauss computation and a lens of such outstanding quality that others are judged by it.

119 Nikon SP

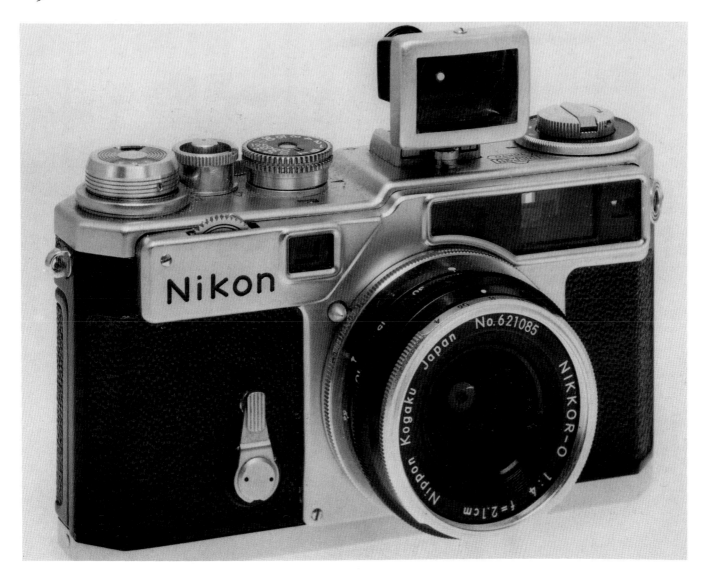

Introduced 1957
SN 6210857
Lens 21mm f4 Nikkor O, SN 621085 by
Nippon Kogaku, Japan
Designed and manufactured by Nippon
Kogaku

The SP was the most famous and innovative of the Nikon rangefinder cameras,
highly praised by the professionals. Subsequent models, such as the S3, S4 and
S3M, were either lesser models or were special application cameras.

The Nikon SP ('P' is for 'Professional') was the first Nikon 35mm coupled
rangefinder camera for up to thirty-six 24 × 36mm exposures to incorporate a
built-in multi-focal viewfinder. Produced in no small quantity, this legendary
camera paved the way for the immense success the Nikon was to have. Many
features of the SP would later find their way into the Nikon F.

The rear eyepiece is divided into two windows. The left-hand one combines
the rangefinder and the frames for the 50, 85, 105 and 135 focal lengths. A field
selector dial determines the projected frame lines which appear in the window.
The left window outlines the areas of both the 35mm and 28mm lenses.

As with previous models, focusing is achieved using the small wheel on the
front of the camera. Further to the lenses offered for the S2, the 21mm f4 Nikkor
and 50mm f1.1 Nikkor too are offered for use with the SP. The SP also has an
inner and an outer bayonet mount.

For the first time the speeds are to be found on one dial; they are T, B and 1 to
1/1000 sec. The SP is also the first Nikon to have a built-in self-timer.

Most of the accessories for the S2 could also be used with the SP, the electric

Nikon SP *continued*

motor drive in particular. Although announced in conjunction with the S2, the motor has always been closely associated with the SP. Films could be taken in bursts of two or more exposures per second or as single manually controlled shots.

The SP had its own small, specially designed exposure meter, which would slip onto the accessory shoe and couple to the accessory speed dial. To increase the sensitivity of the meter a small amplifier plate was available.

The SP was available in either chrome or black finish and either with cloth or foil shutter blinds as from 1959.

The 21mm f4 Nikkor O is the widest of all the Nikon rangefinder lenses. The lens consists of eight elements in four groups. The angle of view is 92°, the lens stops down to f16 and the minimum distance is 3ft. The lens requires a special accessory 21mm viewfinder but couples to the rangefinder of the camera. Less than 500 were produced.

120 Leica M2

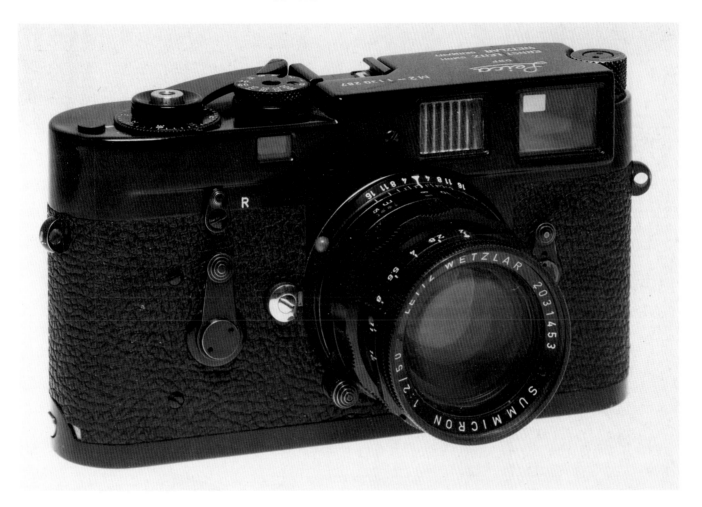

1957-69
SN 1130287
Lens 50mm f2 Summicron, SN 2031453
by Ernst Leitz, Wetzlar
Designed and manufactured by Ernst
Leitz

The Leica M2, a coupled rangefinder camera for up to thirty-six exposures of 24 × 36mm, was very similar in design to the M3, the main difference being in the viewfinder; the M2 covers the field of 35mm, 50mm and 90mm lenses, whereas the M3 covers the field of 50mm, 90mm and 135mm lenses. Further, Leitz did away with the automatic frame counter of the M3 and replaced it with a manually re-set counter in order to reduce the price of the camera. The camera was first available in chrome and later a few were manufactured in black enamel. A special batch of twenty were also available in a grey finish with matching grey vulcanite; these were supplied to the West German government.

The Leica M2 was the first Leica M to be motorised, in 1966. The detachable motor to replace the baseplate could achieve up to three to four frames per second. Early cameras had no special engravings but in 1966 one batch was produced engraved 'M2-M'.

The Summicron lens of a seven-glass Gauss computation was available from 1953 onwards. The example shown here is in black paint finish and was only available to special order to match black M cameras.

The Leica M2 followed in the trail of the immensely successful M3 and was itself very successful. It became a much used camera especially with the 35mm lenses.

121 Leningrad

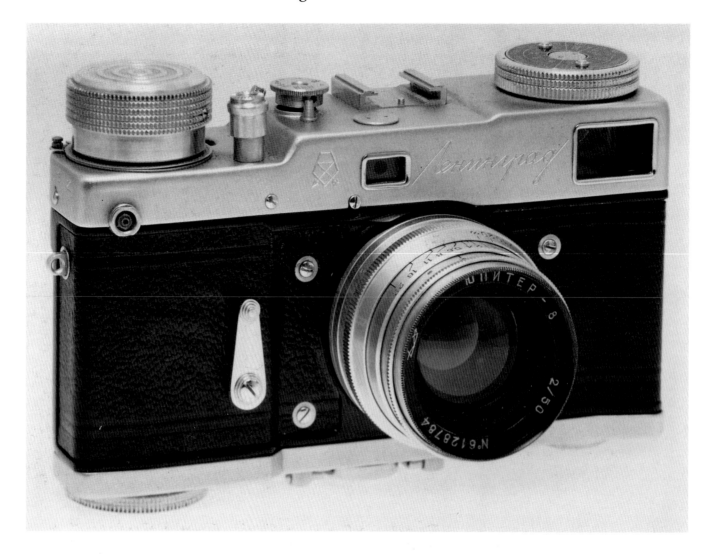

1958
SN 614454
Lens 50mm f2 Jupiter 8, SN 6128784
Designed and manufactured by
Leningrad Combinat

This coupled rangefinder for up to thirty-six 24 × 36mm exposures is a prestige production. Beautifully engineered, the Leningrad has aluminium fittings and is built of chromed brass, and some of the features, such as glass pressure plates, are rarely found on 35mm cameras. The camera handles very well; the front curvatures of the body provide for a good grip. The Leningrad is typical of Soviet post-war inventiveness.

The Leningrad has a spring motor drive for up to two frames per second. The large knob on the top of the camera winds on the motor and the lever below the knob selects the number of burst shots: 0 to 20.

The focal plane shutter consists of two cloth blinds travelling horizontally with speeds of B and 1 to 1/1000 sec. The coupled rangefinder will accept Leica screw lenses. The Jupiter 8, of a six-element computation, stops down to f22 and focuses to 1m. The camera has built-in parallax-corrected frames for the 50mm, 85mm and 135mm lenses. Also available were the 35mm f2.8 Jupiter 12, the 85mm f2 Jupiter 9 and the 135mm f4 Jupiter 11. The 35mm lens required a separate viewfinder. Apart from the Leica screw-mount the Leningrad has few similarities to the Leica. It has some similarities to the Contax, however, especially with regard to the removable back door.

122 **Canon P**

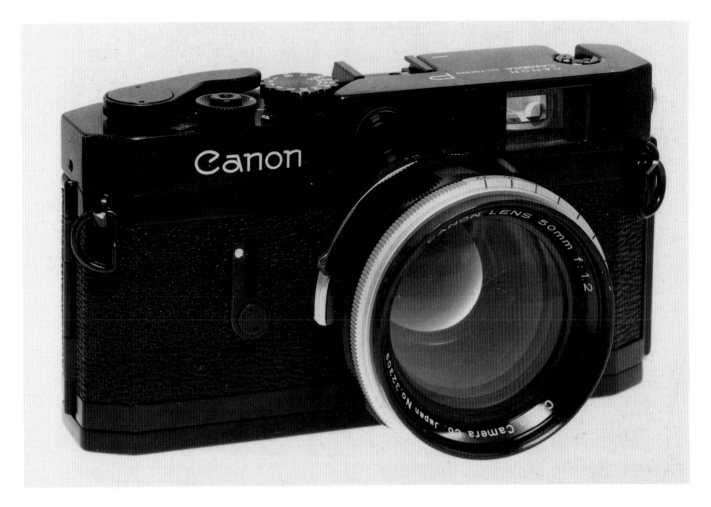

1958-61
SN 706326
Lens 50mm f1.2 Canon, SN 32309 by
Canon Camera Co, Japan.
Designed and manufactured by Canon
Camera Co

See colour plate VII

The Canon P rangefinder camera was this company's first really successful
model, nearly 90,000 being produced. The design owed much to previous models
and was a culmination of Canon models from 1952 onwards.

The shutter consisted of horizontally travelling metal curtains and the speeds
were X, B, and 1 to 1/1000 sec on a single dial. The finder outlined the fields of
view for 35mm, 50mm and 100mm focal lenghts and these outlines were
parallax-corrected.

The lens mount was of the Leica screw variety and the following lenses were
offered by Canon in conjunction with the P:

25mm f3.5	50mm f2.8	100mm f3.5
28mm f3.5	50mm f1.8	135mm f3.5
35mm f2.8	50mm f1.4	M200mm f3.5
35mm f2	50mm f1.2	M400mm f4.5
35mm f1.5	85mm f1.9	M800mm f8

The last three lenses could be used only in conjunction with a mirror box which
would enable the lens to be focused in a reflex manner.

The Canon P was available in chrome finish and a few were produced in black.

123 Nikon S3

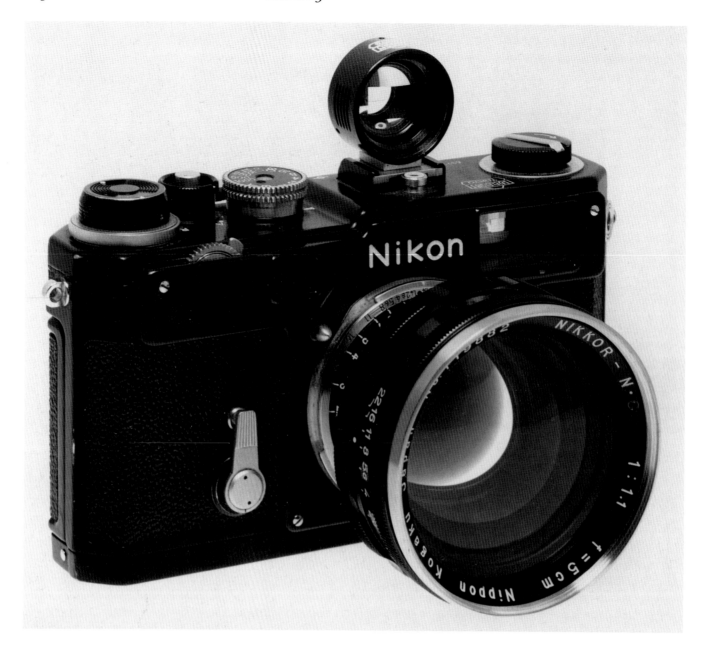

Introduced 1958
SN 6322047
Lens 5cm f1.1 Nikkor N.C., SN 119882
by Nippon Kogaku, Japan
Designed and manufactured by Nippon
Kogaku

The Nikon S3 was introduced as a companion model to the Nikon SP; it is a coupled rangefinder camera for up to thirty-six 24 × 36mm exposures. The coupled rangefinder unit incorporates etched parallax-corrected lines for the 35mm, 50mm and 105mm lenses. The S3, apart from its viewfinder, was identical in all other respects to the SP. It retailed at a lower price than the SP. The S3 could either be bought as a second body or as a first model for those wishing to use only the 35mm and 105mm lenses. The Nikon S3 was available in either black or chrome.

The 5cm f1.1 Nikkor N.C., introduced in 1956, is the fastest of all the Nikkor lenses and consists of nine elements in six groups. It was the fastest lens for any rangefinder camera until the Canon f0.95 'Dream' lens was produced in the 1960s. It would stop down to f22 and the minimum focusing distance was 3ft. At 12oz the lens was very heavy, and the internal bayonet mount would suffer substantially as a result; later models therefore had an external bayonet mount. A special 50mm viewfinder was produced as the size of the lens obstructed the field of view of the viewfinder/rangefinder unit.

124 Zorki C

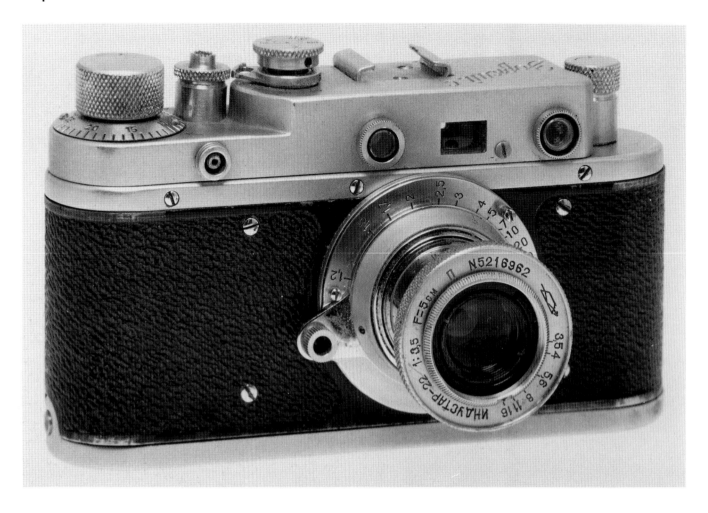

1959
SN 56028236
Lens 5cm f3.5, Industar SN 5216962
Manufactured by Kharkov Kombinat,
Kharkov

The Zorki C is the last in a long line of Russian-made Leica-inspired cameras. This tradition began in 1934 with the Fed, which was named after the infamous founder of the NKVD, Theodore E. Dzerzhinsky. Starting as a copy of the Leica II, the Fed was produced in considerable quantities, even extending to downright Leica forgeries discovered (in 1941) by advancing German troops in the Kharkov factory.

The Zorki C continued the Fed tradition in having a 1/500 sec top shutter speed and no speeds below 1/25 but it added a variable flash synchronisation with settings of 0 to 25 millisecs delay.

The lens flange is of the Leica screw mount type, and unlike its counterpart the Fed is of accurate Leica-Canon register. The Industar lens is in a Leica Elmar-type retractable mount and is of Zeiss Tessar four-element construction. It is better assembled than the Fed, has a coating and produces surprisingly good results.

The body of the Zorki C is of heavy dye-cast alloy, as with most contemporary 35mm cameras, with brass parts finished in very good satin or bright chrome plating. The body covering is of a grey plastic material. The Zorki C was replaced by the Zorki 6 and Fed 4, which were cheaper to make, and which still used Leica thread-register but were totally Russian designed and styled. The Jupiter range of accessory lenses continued, as did a left-hand version of the Kiev Universal viewfinder.

125 Nikon S4

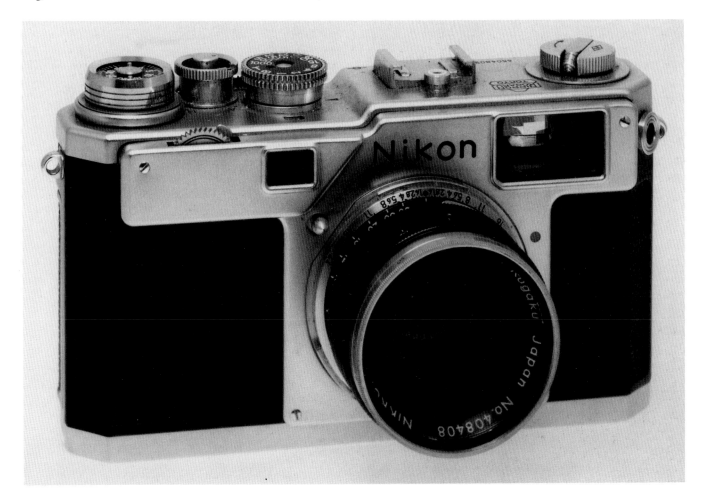

1959-61
SN 6504803
Lens 5cm f1.4 Nikkor – S, SN 408408 by
Nippon Kogaku, Japan
Designed and manufactured by Nippon
Kogaku

The Nikon S4 was the last full-frame Nikon rangefinder produced, and very much a sub-model of the S3. This coupled rangefinder camera producing up to thirty-six 24 × 36mm exposures was virtually identical to the S3, but cheaper as it did not have either the 35mm frame lines or the self-timer. Further, the frame counter was of the non-automatic resetting kind. The Nikkor lens would stop down to f16 and focus to 3ft.

Less than 6,000 were produced, only in chrome and all with cloth blinds. Like the S3, the S4 is a derivative of the SP.

126

1959-66
Body SN T90634
Lens 50mm f2 Planar, SN 2377636 by
Carl Zeiss, Oberkochen
Designed and manufactured by Zeiss-
Ikon, Stuttgart

Contarex I

In 1953 Zeiss-Ikon brought out an eminently successful 35mm single lens reflex camera, the Contaflex, and gained considerable experience of this camera after making over half a million models of it. Since 1932 Zeiss-Ikon had also produced an equally successful 35mm rangefinder camera, the Contax. With the advantages of both types combined, the Contarex came into being; the most beautiful (and therefore expensive) 35mm single lens reflex camera ever produced by the company.

The Contarex derives its focal plane shutter with vertically travelling metal blinds from the Contax. The shutter is very close to the film, as with the Contax, so that the rear elements of the extreme wide-angle lenses do not interfere with the mechanism. The Contarex speeds are B and 1 to 1/1000 sec.

The Contarex derives its single lens reflex design from the Contaflex. The brilliant finder image shows two focusing systems workable with all the lenses, with the exceptions of the shortest of the lenses. Unlike the Contaflex, the Contarex has an instant return mirror.

In addition to combining the above Contarex and Contaflex features, the Contax also has a built-in semi-automatic exposure control linked with the built-in photoelectric exposure meter.

The following lenses were introduced with the Contarex in 1960:

21mm f4 Biogon
35mm f4 Biogon
50mm f2 Sonnar (and the later 50mm f1.4 Sonnar)
50mm f2.8 Tessar
85mm f2 Sonnar
135mm f4 Sonnar
250mm f4 Sonnar

The lenses from 35mm to 135mm are of the automatic aperture variety. The 21mm is of a non-retro-focus design, hence the mirror is locked up and a separate 21mm viewfinder is slipped into the accessory shoe. The 250mm f4 Sonnar is of a reflex variety but the aperture is not automatic.

The camera is not fully automatic in that on releasing the shutter the lens opening closes down to the setting determined by the exposure reading. When the mirror swings back after the exposure, the lens remains stopped down to the pre-selected value. With small aperture settings the rangefinder circle in the centre of the finder remains dark – this also acts as a reminder to wind the Contarex before taking the next shot.

The Contarex accepts all 35mm film. The normal Contarex back may be replaced by a Contarex interchangeable magazine back without loss of frames, re-winding or other time-wasting procedures. This is obviously particularly useful when working with different films. The magazine back takes the place of the Contarex back. It is slightly thicker and holds the film completely light-tight. It incorporates a dark slide; this is like a plate-holder which is pulled out when the magazine is fitted to the Contarex.

The system of accessories aims to maximise versatility with the minimum of extra equipment. Here the Contarex differs from the Contax. The significant accessories consisted of the series of lenses, extension bellows unit and the special viewfinder for the 21mm f4 Biogon. The only other accessories were filters, lens hoods, a supplementary lens and special copying and micro equipment.

The Contarex was nicknamed the 'Bullseye' or 'Cyclops' owing to the protuding meter cell over the lens.

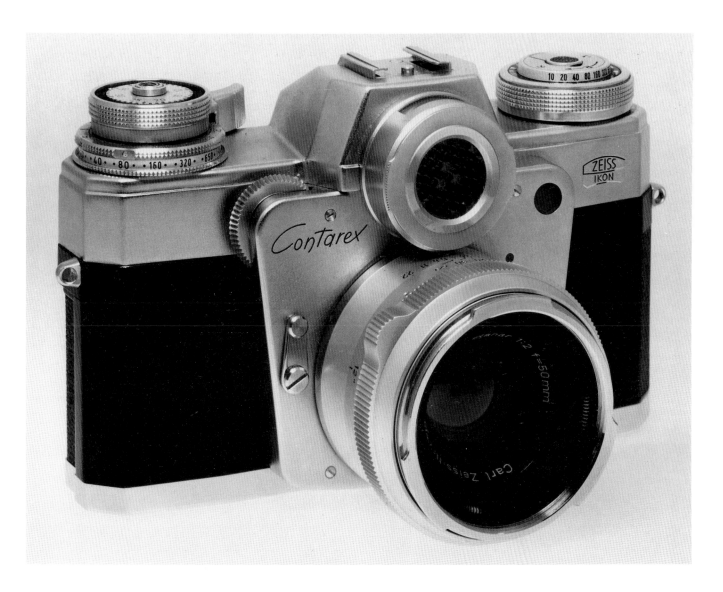

The camera was commercially available only in chrome, although five black ones were reputedly made to order. Later versions have a slot in the back which enables a data strip to be inserted. Later versions also have a lockable exposure meter cover. Thus four varieties of the Contarex exist.

In 1960 a companion model to the Contarex was introduced, the Contarex Special. This camera was a scientific model in that it lacked a meter but had interchangeable viewfinders of the reflex or prismatic type. Finder screens were also interchangeable. The standard lens was the 50mm f2.8 Tessar which focuses down to 14in.

The Contarex was a most successful camera and over 30,000 were produced. Both the Contarex and the Contarex Special were discontinued in 1967 in anticipation of the Contarex Super, which was introduced in 1968.

127

1959 onwards
SN 7450195
Lens 55mm f1.2 Nikkor-S Auto,
SN 970311 by Nippon Kogaku, Japan

Nikon F

This single lens reflex camera for up to thirty-six 24 × 36mm exposures is the first in a long line of single lens reflex cameras that were to be immensely successful. More than any other camera, the Nikon F set the trend towards single lens reflex cameras and heralded the decline of the rangefinder.

The Nikon F, however, is similar in design to its rangefinder companions, with the obvious exception of its reflex focusing mechanism. The layout of the controls at the back is almost identical. Both rangefinder and reflex Nikons show a degree of Contax inspiration, particularly in body shape, back and base catch. There is also a Leica-type cable release fitting, but in most other respects the camera is original. The shutter is of the focal plane variety and consists of two titanium metal foil blinds travelling horizontally; it offers the speeds of T, B and 1 to 1/1000 sec with a variable delayed action option.

The Nikon F prism is interchangeable. Initially the prism had no metering system but later models have a CDS meter, then even later, a through-the-lens metering system. The first metering system offered was the clip-on selenium coupled meter but this did not incorporate a pentaprism. The second model, incorporating a pentaprism, was the Photonic coupled CDS, the third was the pentaprism Photonic T coupled CDS, and the fourth was the pentaprism TTL Photonic TN CDS meter.

A thirty-six exposure motor drive for up to three frames per second met with great success. If the mirror was locked and a direct finder was used, then up to four shots per second could be obtained. The motor drive was inherited from the rangefinder series. First models had a separate battery pack and later a built-in battery pack, the Remo pack. A 250-exposure motorised back was also available, as it had been for the rangefinder series. The camera had a stainless steel bayonet mount which presumably never wears out. This was in anticipation of the frequent use of a whole array of lenses first introduced for the Nikon F from 21mm to 1,000mm focal length lenses:

21mm f4 Nikkor (non-reflex), this lens had to be used with an accessory 21mm
 viewfinder
28mm f3.5 Nikkor Auto
35mm f2.8 Nikkor Auto
50mm f2 Nikkor Auto
55mm f3.5 Micro-Nikkor Auto
58mm f1.4 Nikkor Auto
85mm f1.8 Nikkor Auto
105mm f4 Nikkor Pre-set, a rangefinder lens adapted to the reflex mount
135mm f3.5 Nikkor Auto
180mm f2.5 Nikkor
200mm f4 Nikkor Auto
250mm f4 Nikkor
350mm f4 Nikkor
500mm f5 Nikkor
1,000mm f6.3 Nikkor

Zooms:
43mm-86mm f3.5 Nikkor Auto
85mm-250mm f4 Nikkor Auto
200mm-600mm f9.5 Nikkor Auto

The 180mm, 250mm, 350mm, 500mm and 1,000mm lenses are all Nikon rangefinder lenses which have to be used with an adaptor, hence they are non-automatic. Later many automatic lenses were added to the range available for the Nikon F. The Nikon F was initially available only in chrome, but demand from professionals for a less visible black body was later met.

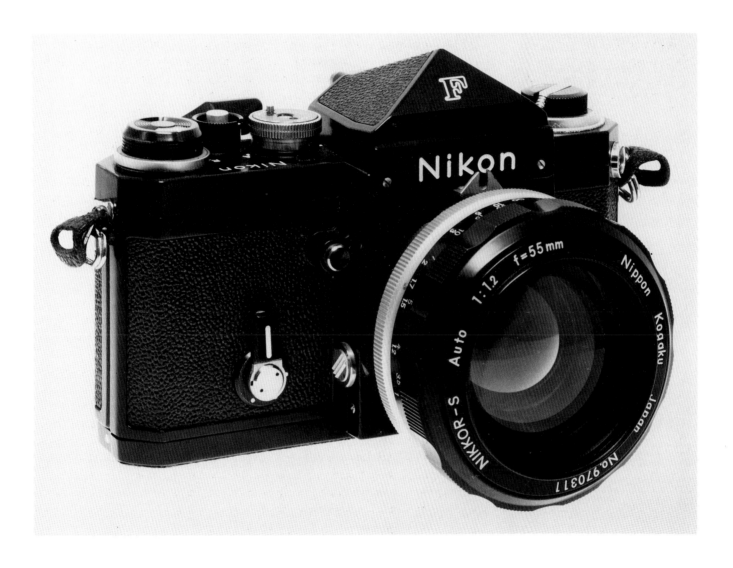

128

Introduced c.1959
SN 777262
Lenses 25mm f2.8, pair of Tessinon
Designed and manufactured by Concava
AG, Logano-Cassarate, Switzerland

Tessina L

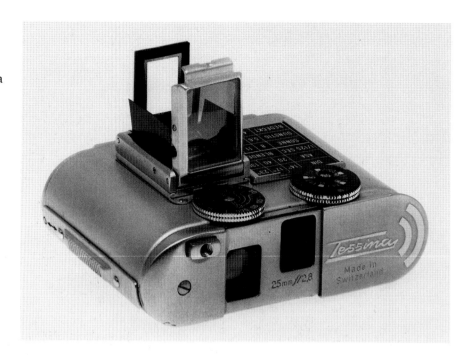

The Tessina L, a twin lens reflex camera for up to twenty-four 12 × 18mm black and white exposures or eighteen 12 × 18mm colour film exposures, is the world's smallest (2 ½ × 2 × 1in) and lightest (5 ½oz) camera using 35mm film.

The lenses are parallax-corrected and haze-filtered. The one to the right is the viewing lens and the one to the left is the picture-taking lens. The taking lens works through a 90° prism which helps to reduce overall dimensions. The lens will stop down to f22, focuses to 0.3m and is set in a shutter with speeds of B and ½ to 1/500 sec. A knob at the rear of the camera will wind up a clockwork driven motor which operates both the shutter and the film transport mechanism. It is possible to obtain up to six to ten exposures by winding the motor on a one-to-one exposure basis or by rapid sequence exposures. Focusing is of the twin lens reflex kind, either reflex or sportsfinder. Also available is a prismatic finder and an 8x magnifier for precision work. A small exposure meter is also available which can be cross-coupled to the camera.

The downfall of most sub-miniature cameras has always been the smallness of the negative and the difficulty of finding the appropriate film. In the case of the Tessina the film supply problem is alleviated in that whilst photographic dealers offer Tessina cassettes that are already loaded with certain types of film, a daylight self-loader enables Tessina cassettes to be loaded with any 35m stock. The Tessina cassette will hold either 41cm black and white or 36cm of the thicker colour stock. A wristwatch strap is available as an accessory.

The Tessina L is still available in a choice of either gold (as the illustrated specimen), chrome, black or red. The Tessina L replaces the original Tessina which could not accept a cross-coupled meter.

129 **Argus Autronic**

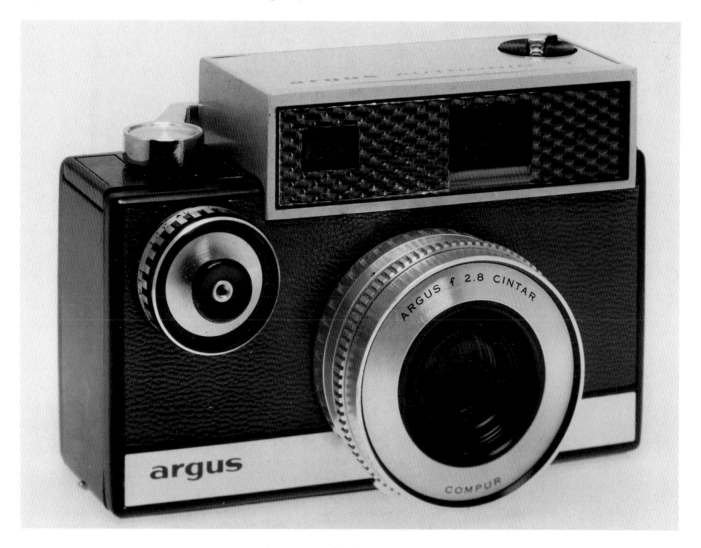

1960-62
Lens 50mm f2.8 Cintar by Argus
Designed and manufactured by Argus,
Ann Arbor, Michigan

The Argus company first started manufacturing cameras in 1936 with the 35mm cartridge model, the Argus A. These cameras became very popular, more sophisticated, heavier and more and more brick-like in design. The Autronic I, a coupled rangefinder for up to thirty-six 24 × 36mm exposures, was the last of the brick-shaped models, and the only one to incorporate an exposure meter.

The Cintar lens is set in a shutter with speeds of 1/30 to 1/1500 sec. The three-element lens focuses to 1m and stops down to f22. The camera incorporates a coupled rangefinder and an exposure meter which can be set for automatic or for manual override.

130

1961-65
SN 839449
Lens 35mm f2 Canon, SN 11343
Designed and manufactured by Canon
Camera Co, Japan

Canon 7

This rangefinder 35mm camera for up to thirty-six 24 × 36mm exposures was the penultimate Canon rangefinder produced, the last being the Canon 7S, a variant of the Canon 7. The design of the Canon 7 was completely different from that of previous models, being intended to compete with the highly successful Leica M3s and M2s.

The shutter consisted of two horizontally travelling metal curtains and the speeds were X, T, B and from 1 to 1/1000 sec. The finder was of the projected frame variety and was for the focal lengths of 35mm, 50mm, 85mm, 100mm and 135mm. A selector-knob on the top-plate of the camera was used to bring in these frames. The frames would not come in automatically, in contrast to the M3 Leica. At the same time as the 7 was introduced, Canon launched the massive seven-element 50mm f0.95 lens, the so-called 'Dream lens' faster than the human eye, which was most enthusiastically received by press reporters world-wide. This high-aperture lens required precise focusing, hence the extra-long-base rangefinder.

The Canon 7 was the first Canon to have both a screw mount and an outer bayonet mount. The outer mount was used for the massive, and therefore very heavy, 50mm f0.95 lens and also for the mirror box model II with a 135mm and up to 1,000mm line of lenses.

The Canon 7 was also the first Canon to have a built-in selenium exposure meter. The meter was coupled to the selected shutter speed and the indicated aperture had to be transferred on to the lens. A small wheel to the right of the rangefinder window would select high or low sensitivities.

The Canon 7 was available in chrome although a few were also produced in black. Only a modest range of accessories was available, such as flash, extra viewfinders, lens hoods and filters. Over 100,000 Canon 7s were produced, making it by far the most successful Canon rangefinder camera. The 7 was discontinued in 1965 in favour of the 7s, which was basically a 7 with a battery powered CDS exposure meter.

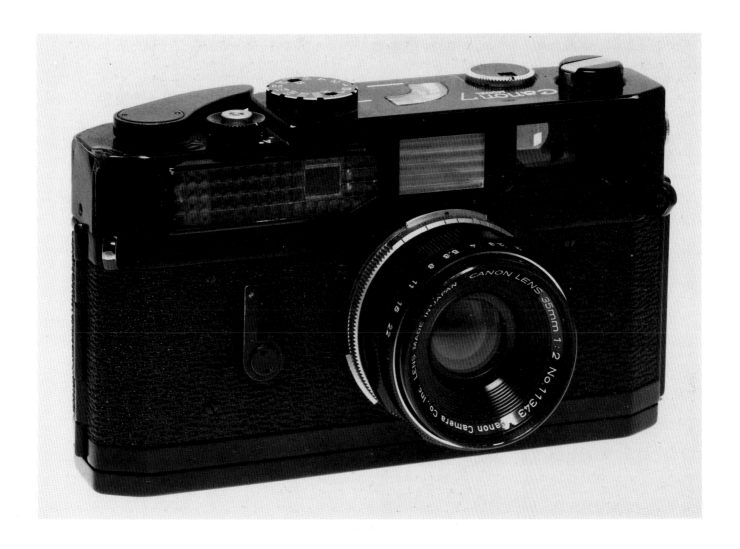

131 Bessamatic De Luxe

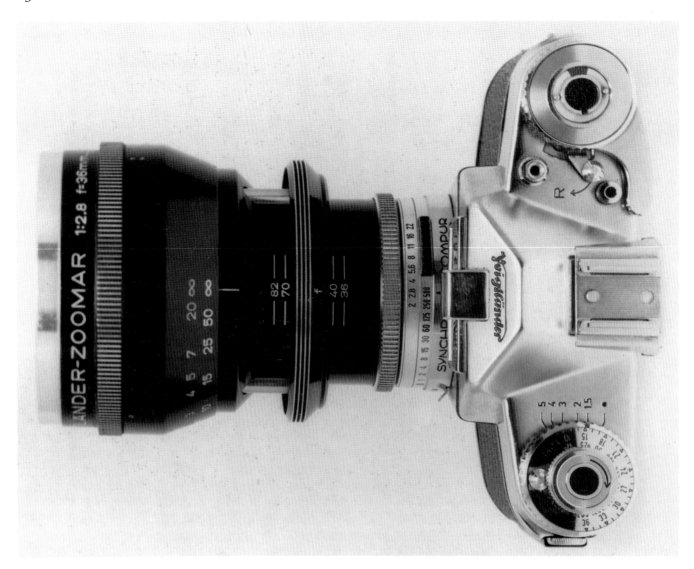

c.1963
SN 224863
Lens f2.8 36-82mm Voigtländer
Zoomar, SN 4935516 by Voigtländer,
Braunschweig
Designed and manufactured by
Voigtländer

This single lens reflex for up to thirty-six 24 × 36mm exposures uses the first zoom lens for a 35mm still camera, introduced by Voigtländer in 1959. Zoom lenses were used by cinematographers before World War II, but when the Zoomar was shown at Photokina in 1958 it was the first zoom produced specifically for a 35mm still single lens reflex camera. The Zoomar has fourteen elements in eleven groups, two of which move and give surprisingly high image quality. The trombone setting enabled adjustment of focal length. In its wide-angle setting the maximum aperture was f2.8. In the telephoto setting the maximum aperture would drop by at least half a stop; this is common to most zoom lenses but is rarely admitted by most manufacturers. The Zoomar would stop down to f22 and focus up to 1.3m. This lens dominated the market for at least a decade although it was offered only in a Bessamatic fitting.

The Bessamatic De Luxe has a built-in synchro Compur shutter with speeds of B and 1 to 1/500 sec. The built-in CDS meter has a small meter cell just above the lens mount. Diaphragm and shutter speeds are visible in the finder and the meter has sensitivities from 12 to 3200 ASA.

The Bessamatic was manufactured of beautifully chromed brass with a black rubberised body covering.

132 Calypso

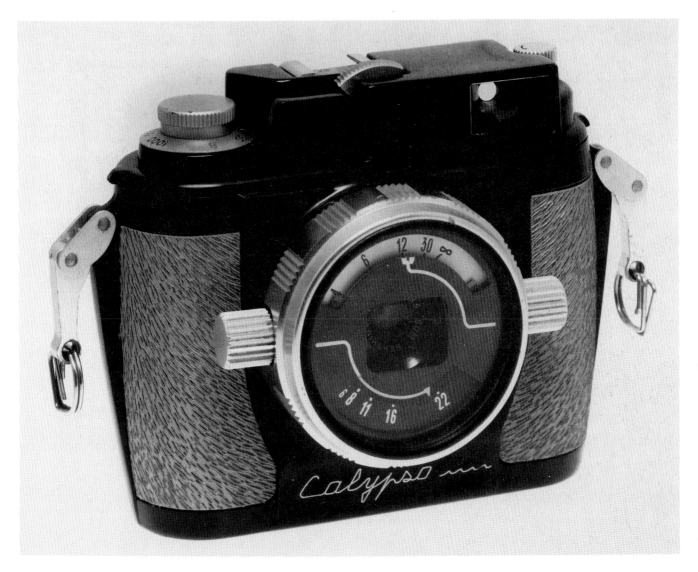

1964
SN 1498
Lens 35mm f3.5 Som Berthiot,
SN 00644
Designed and manufactured by
La Spirotechnique, Levallois-Perret,
France

The Calypso, an underwater camera for up to thirty-six 24 × 36mm exposures, is the first camera that can be operated under or above the water without any form of special housing.

It was designed by the Belgian engineer Jean de Wouters d'Oplinter in cooperation with the needs of Commandant Jacques Cousteau. The camera was named after Cousteau's favourite boat, the *Calypso*.

The shutter is of the guillotine variety with speeds of B and 1/30 to 1/1000 sec. The camera incorporates an optical viewfinder but no rangefinder. The film-winding mechanism is operated by a lever which also serves as a shutter release. The lens is interchangeable. The top plate and the inside mechanism lifts out of the outer shell and it is the lens that locks both into position. The camera makes use of 'O' rings which have to be cleaned and lubricated with Vaseline to be effective against water penetration. The Calypso was also available with the 45mm f2.8 Angénieux lens and a 28mm f3.3 Berthiot.

The camera was of an entirely metal construction with grey plastic covering and aluminium fittings. It was very successful, but La Spirotechnique lacked the worldwide marketing facilities to do justice to such a successful design. Nikon bought out the patents and went on to produce their very successful Nikonos camera series. The current Nikonos V is still very close in design to the Calypso.

133 Leicaflex

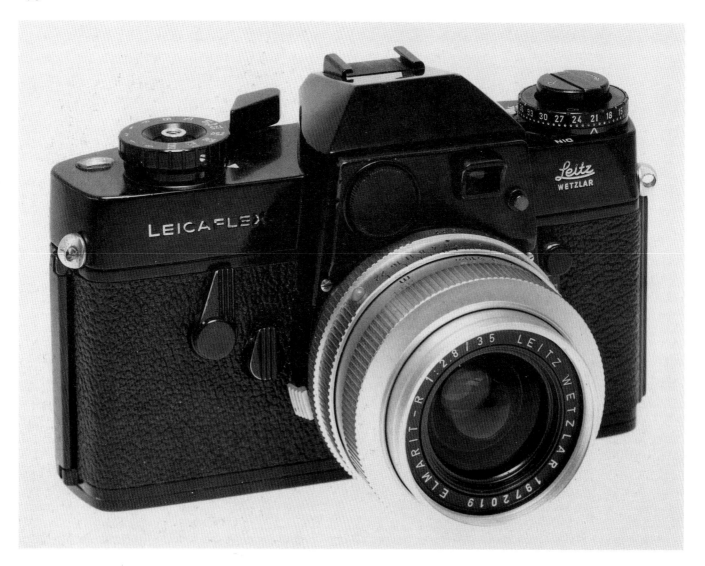

1965-68
SN 1084359
Lens 35mm f2.8 Elmarit-R, SN 1972019
by Ernst Leitz Wetzlar
Designed and manufactured by Ernst
Leitz

See colour plate VIII

Ernst Leitz's first single lens reflex camera, for up to thirty-six 24 × 36mm exposures, appeared some forty years after the Leica. The shutter is of the focal plane variety with two cloth blinds travelling horizontally with speeds of B and 1 to 1/2000 sec. This was Leitz's first camera with a top speed of 1/2000 sec. The camera has a CDS exposure meter with a 21mm angle of metering and sensitivities from 8 to 3200 ASA. Bayonet lenses for the Leicaflex were available from 21mm to 180mm fold length. Leica M lenses for 65 to 560mm could also be used with a special adaptor, but the iris would be manual. A 21mm f3.4 Super Angulon was also available but necessitated the use of an accessory 21mm viewfinder as it was not retrofocus and the mirror had to be locked in the upper position. All the Leicaflex lenses were black although initially a few were made in chrome. The production chrome lenses were abandoned as the reflection from the chrome would affect the CDS meter just above the lens. The screen was exceptionally clear and had a central focusing spot.

The shutter speeds were visible in the lower part of the viewfinder and the exposure was set by matching the needles. Early specimens had a pie-shaped exposure counter and later models had a round exposure counter with a meter switch-off through the film-winder. The Leicaflex was produced in chrome and later a few with a black enamel finish.

Although the Leicaflex was exceptionally well designed it was in gestation for a long time, which would explain its lack of a TTL metering at a time when most makes had gone over to metering. The introduction of the SL in 1968 alleviated this problem.

134 Pentax S1A

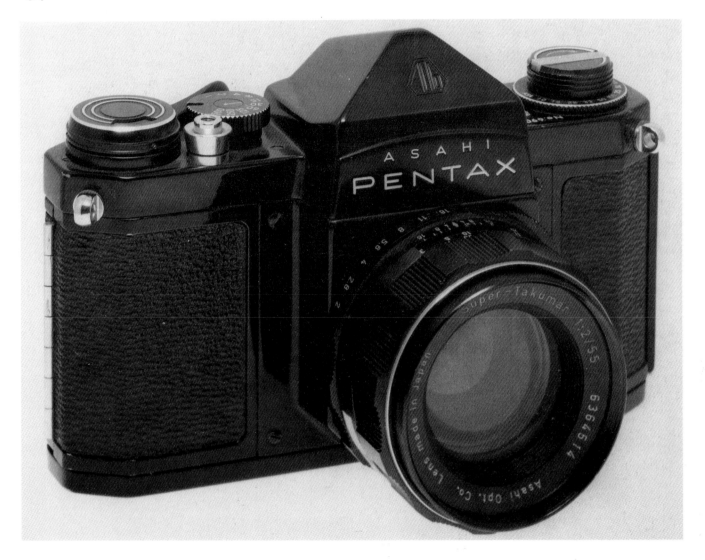

c.1966
SN 690153
Lens 55mm f2 Super-Takumar,
SN 6364514 by Asahi Optical Co, Japan
Designed and manufactured by Asahi
Optical Co

This single lens reflex for up to thirty-six 24 × 36mm exposures was much smaller and cheaper than most rival Japanese designs of comparable quality and was sold in great quantities. The camera was also offered with a very useful optional clip-on CDS exposure meter which coupled to the shutter speed dial. It was offered with a wide range of accessories with no less than twenty-four lenses from the 18mm f11 fish-eye to a 1000mm f8 tele including a 70-150mm f4.5 zoom.

The screw-mounted Super-Takumar stops down to f16 and focuses to 0.45m. The camera has an automatic diaphragm although there is an over-ride facility for manual operation of the iris. The instant return mirror was a Pentax first and it contributed much towards the popularity of the camera. The shutter is of the focal plane type consisting of two horizontally travelling cloth blinds with speeds of T, B and 1 to 1/500 sec. The film is advanced by a lever and the frame counter is automatic. The camera was available both in chrome and in more expensive black finish.

The companion model, the SV, differed only in offering a 1/1000 top shutter speed and delayed action facility.

135 Contarex Professional

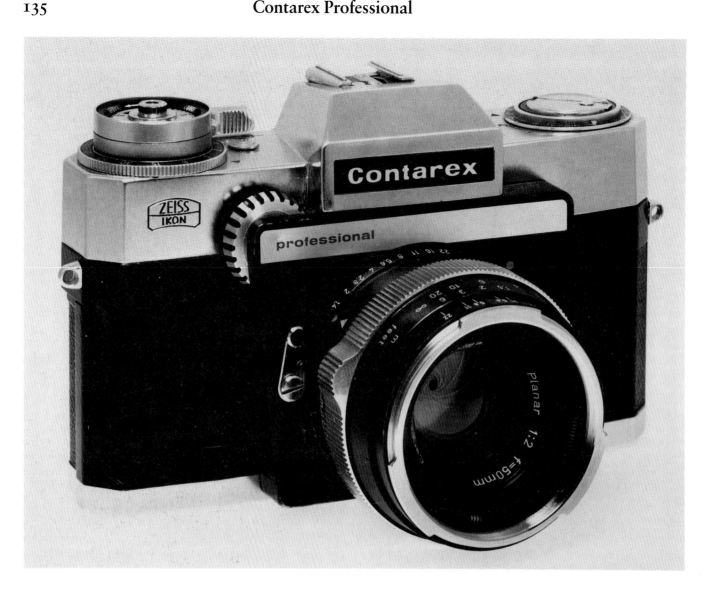

1966-67
Body SN K45516
Lens 50mm f2 Planar, SN 4803289 by
Carl Zeiss, Oberkochen
Designed and manufactured by Zeiss
Ikon, Stuttgart

The Contarex Professional has no metering system at all, hence the denomination 'P'. It has a non-removable prismatic viewfinder. The 'P' has a different shape altogether from the Contarex I or the Contarex Special; it is more angular at the top.

The Contarex Professional is a single lens reflex for up to thirty-six 24 × 36mm exposures. It has a focal plane shutter with speeds from 1 to 1/1000 sec and B. The camera is compatible with all Contarex I accessories excluding the 21mm Biogon which requires a mirror lock-up.

The Contarex Professional was produced for only one year and only in chrome, and less than 1,500 units in all. The 50mm f2 Planar is the standard Contarex lens and has a six-element construction in four groups. The lens was available from 1957 to 1973 in both chrome and black, and more than 37,000 were produced.

136 Contarex Super

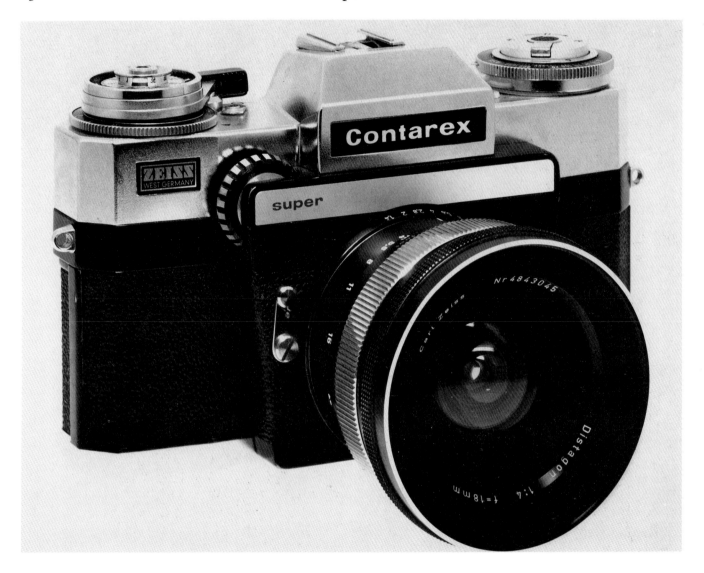

1967-75
SN R52241
Lens 18mm f4 Distagon, SN 4843045 by
Carl Zeiss, Oberkochen
Designed and manufactured by Zeiss
Ikon, Stuttgart

The Contarex Super is a single lens reflex for up to thirty-six 24 × 36mm
exposures. It has a focal plane shutter with speeds from 1 to 1/1000 sec and B. It
has a CDS through-the-lens metering system of the spot variety; the battery to
operate the meter is located under the mirror in a rather unusual position. The
Contarex Super accepts all Contarex I lenses with the exception of the 21mm
lens as it has no mirror lock-up.

The Super has the same shape as the Contarex Professional but it has a
through-the-lens metering system. The camera was available in chrome and a few
were later available in black. The total production was 13,400 units. Early models
are engraved 'Zeiss-Ikon' and later ones 'Zeiss West Germany'. There are two
variants. The first has a light meter switch on the front of the camera to the right
of the lens and the second version has a meter switch below the wind-on lever.

The 18mm f4 Distagon lens was available from 1967 to 1972 and is the widest
non-fish-eye lens produced for the Contarex series. It consists of ten elements in
nine groups and is optically a great achievement. Because of the high cost
only approximately 1,500 were produced. The Contarex Super also had
interchangeable screens and a slightly pinkish screen was recommended for
use with the 18mm f4 Distagon.

137

1967-75
SN 1181693
Lens 21mm f3.4 Super Angulon
SN 2054613 by Ernst Leitz, Wetzlar
Designed and manufactured by Ernst
Leitz

Leica M4

The Leica M4 is one of the great cameras. It was reintroduced by popular demand on two separate occasions, in slightly modified forms.

The Leica M4 is in essence a combination of the viewfinders of the M3 and M2 cameras with the resulting parallax-corrected frames for the 35mm, 50mm, 90mm and 135mm lenses. The camera also has a much easier system for loading the film and faster re-wind is effected through an angled cranked handle. The frame counter is of the M3 variety and automatically re-sets to zero. The shutter consists of two cloth blinds travelling horizontally with speeds of B and 1 to 1/1000 sec. The camera was first available in chrome finish and later in black enamel. From 1974 it was available in a black anodised finish. In 1970 a special model, the KE7, was made to order for the US government. This camera had a 'winterised' shutter and had a special dust-proof mechanism coupled with a special lens, the 50mm f2 Elcan.

In 1968 the M4 appeared in a motorised version as the M4-M. In 1969 and 1970 it appeared as the M4 Mot. In both cases the electric motor replaced the base-plate and the motor would reach speeds of up to three or four frames per second.

In 1975 the M4 was discontinued in favour of the TTL-metered Leica M5. However, by popular demand the M4 was reintroduced in the form of the M4-2, which was produced at the Midland, Ontario plant in a black anodised finish and later in chrome. A special version of this camera was produced in chrome with markings for the fiftieth anniversary of the Leica I. The M4-2 is identical to the M4 but has no delayed action.

A limited edition of M4-2 cameras were finished in gold with lizard skin and were available to commemorate the centenary of the birth of Oskar Barnack, the inventor of the Leica. Another version of the basic M4, the M4-P, was introduced in late 1980, superseding the M4-2. The M4-P is in essence an M4 but with an enlarged viewfinder unit to match the new 75mm f1.4 Summilux and the recomputed 28mm f2.8 Elmarit lenses. By using the outer margin of the viewfinder it was possible to squeeze in the 28mm frame. A 75mm frame required by the newly available 75mm f1.4 Summilux was also added. The M4-P therefore covered six fields of view: 28mm, 35mm, 50mm, 70mm, 90mm and 135mm. In all other respects the M4-P is similar to the M4-2.

The 21mm f3.4 Super-Angulon was manufactured to a Jos. Schneider design and consists of eight elements. The 21mm Super-Angulon was highly successful and for a long time was the standard 21mm lens until it was superseded by the 21mm f2.8 Elmarit in 1980.

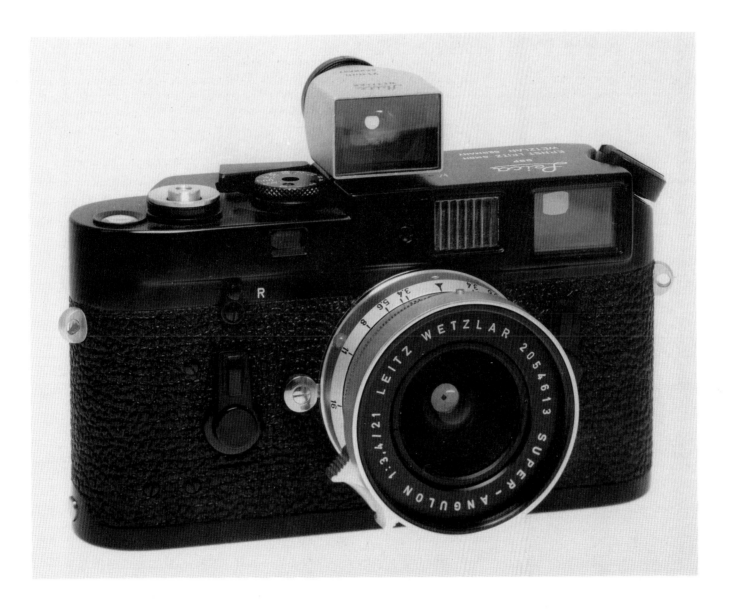

138 Olympus Pen FT

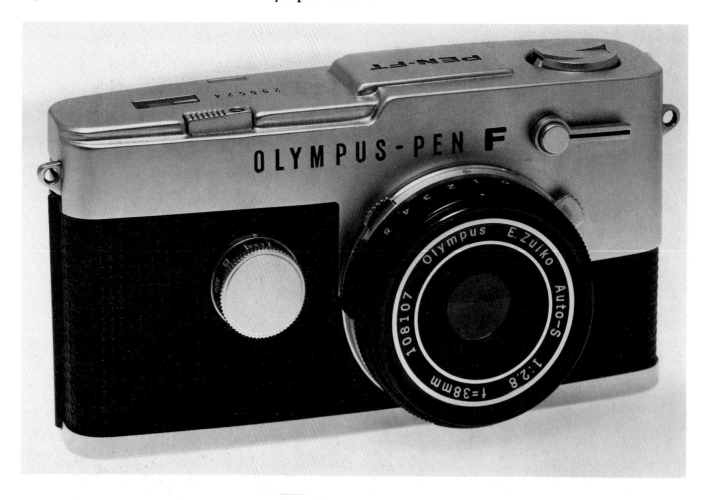

1967
SN 295524
Lens 38mm f2.8 E. Zuiko Auto-S,
SN 108107 by Olympus Optical Co,
Tokyo
Designed and manufactured by
Olympus Optical Co

The Olympus Pen FT is the first and only camera especially designed as a half-frame 35mm single lens reflex. It was the most advanced of all the half-frame cameras of its time and the only reflex model accepting interchangeable lenses. It could produce up to seventy-two 18 × 24mm exposures. It has a built-in focal plane shutter with speeds of 1 to 1/500 sec and B. A wide variety of bayonet-mounted interchangeable lenses were available including zoom lenses.

The camera has a built-in CDS photo-electric exposure meter operating from a semi-transparent porroprism mirror meter reading transferred to a diaphragm. The metering is of the open aperture variety. The camera was available both in chrome and later in black finish and was a most successful attempt to capture the fast disappearing market for half-frame lenses.

139 Chaika 3

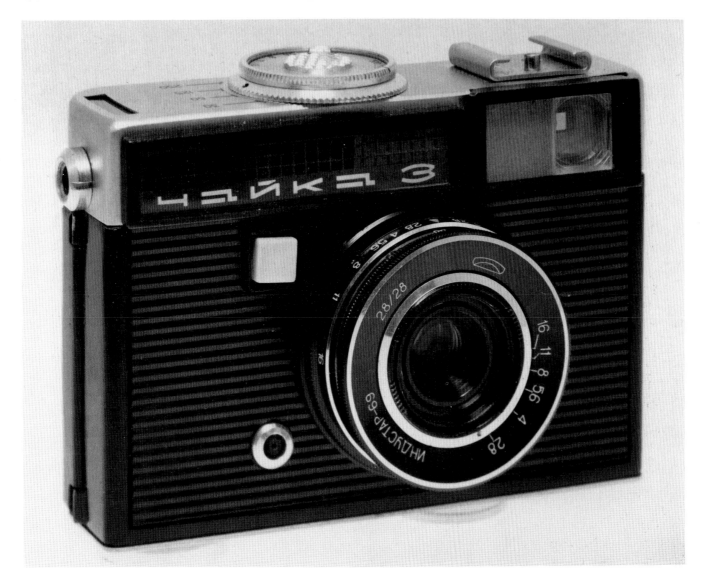

1968
SN 3416323
Lens 28mm f2.8 Industar 69
Designed and manufactured by
Leningrad Combinat

The Chaika 3 is a half-frame camera producing up to seventy-two 18 × 24mm exposures. The Industar lens is permanently attached to the camera and is set in a Compur shutter with speeds of 1/30, 1/60, 1/125 and 1/250 sec. The lens stops down to f16 and focuses to 0.8m.

There is an optical viewfinder built into the camera but no rangefinder; the focus has to be set manually by estimation. The camera has a small built-in meter which is cross-coupled to shutter speeds, hence relevant f stops have to be transferred manually to the lens. The Chaika 3 is well built and is probably the only half-frame Russian camera produced.

140 Contaflex S

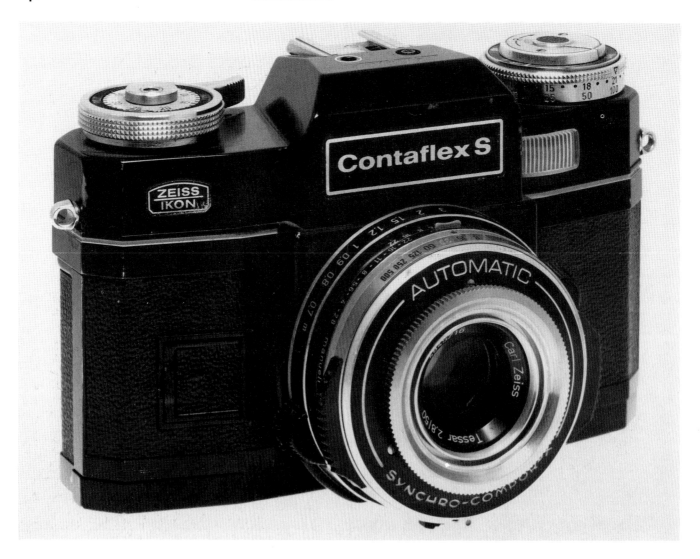

1968-75
SN P 85111
Lens 50mm f2.8 Tessar, SN 4845716 by Carl Zeiss, Oberkochen
Designed and manufactured by Zeiss Ikon, Stuttgart

The Contaflex S single lens reflex is the last of the Contaflex cameras. The original Contaflex was introduced in 1953 and had a fixed lens with no meter. In the late 1950s the production of the Contaflex was running at some 300-400 cameras per day, which in those days was quite a record for camera production. The Contaflex series must be the most sold of all the West German single lens reflex cameras. It could be described as everyman's reflex camera, although the prices were staggeringly high compared with today's prices.

The Contaflex S takes up to thirty-six 24 × 36mm exposures. It has a 'Synchro-Compur-X' shutter with speeds of B and 1 to 1/500 sec. The lens is a four-element, three-component Tessar. The front element is detachable and the following lenses are available:

Pro-Tessar 35mm f4
Pro-Tessar 35mm f3.2
Pro-Tessar 85mm f4
Pro-Tessar 85mm f3.2
Pro-Tessar 115mm f4

There was also a Pro-Tessar Macro lens for 1:1 ratio. The camera has an automatic TTL metering system of the CDS variety. The small battery is housed in a compartment to the left of the lens. There is also a match needle indicator on the top-plate and the sensitivity of the meter is from ASA 6 to 800.

The camera takes interchangeable backs which can contain a variety of colour and black and white films. Most of the Contaflex S cameras were manufactured in chrome but a few were also manufactured in black enamel.

141 Contarex Super Electronic

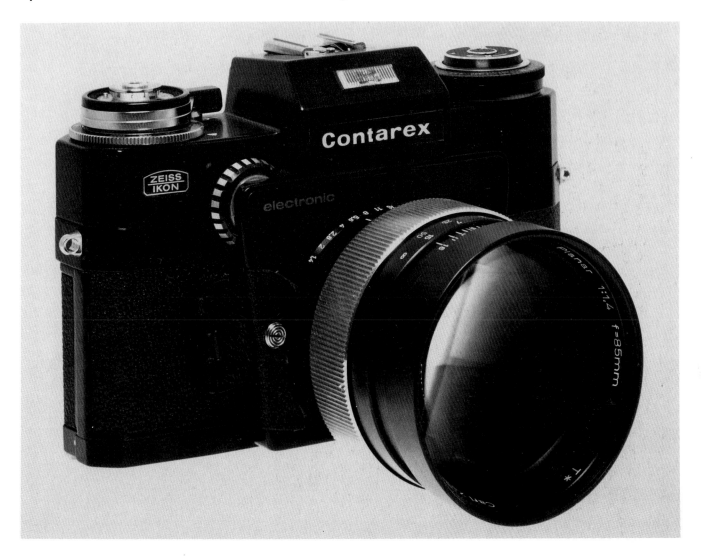

1968-75
SN G36038
Lens 85mm f1.4T* Planar, SN 5771117
by Carl Zeiss, Oberkochen
Designed and manufactured by Zeiss
Ikon, Stuttgart

The Contarex Super Electronic is a single lens reflex for up to thirty-six 24 × 36mm exposures. It has a focal plane shutter with speeds from 1 to 1/1000 sec and B. Although the shutter was mechanical it deserved its electronic appellation in that it was offered with a range of accessories that enabled the camera to be operated from a distance. The camera has a TTL metering system and the required aperture/shutter speeds can be set automatically with the Tele-Sensor. Two Tele-Sensors were available: one with a metering angle of 12° and another with a metering angle of 25°. An electronic control box would enable the operator to control the camera at a distance. An electric motor was available to advance the film and a special bulk film back for up to 17m of film was also available.

The camera body was available in chrome and a few were manufactured in black. Two different logos exist, the first 'Zeiss-Ikon' and the second 'Zeiss West Germany'. A total of only slightly more than 3,000 Contarex Super Electronic cameras were produced, making it one of the rarest of the Contarex cameras and certainly the most advanced.

The 85mm f1.4 Planar was available only for one year in 1974, right at the end of the Super Electronic production. The fastest Zeiss tele lens for the Contarex, it consists of six elements in five groups. It is only one of two Contarex lenses to have T*-coating, the other being the 16mm fish-eye.

142 Leicaflex SL

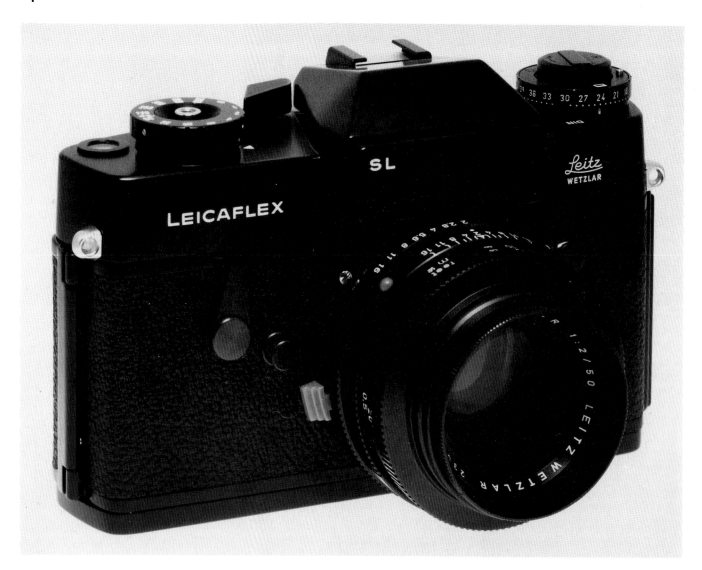

1968-74
SN 1217870
Lens 50mm f2, Summicron-R
SN 2303211 by Ernst Leitz, Wetzlar
Designed and manufactured by Ernst
Leitz

Leitz's second SLR and the first with TTL metering, is excellently designed and exceptionally well built. It takes thirty-six 24 × 36mm exposures. The SL stands for selective lighting and the TTL metering is of the spot variety, the angle being 8° with a 50mm lens. Meter sensitivity is from 8 to 3200 ASA. The shutter consists of two cloth blinds travelling horizontally and the speeds are B and 1 to 1/2000 sec. The camera has a microprism screen which enables focusing on the whole area although a plain ground glass was also available, but only to order.

The Leicaflex SL was produced in chrome, and a few were later available first in black enamel and later in black chrome. In 1972 a special issue was introduced to commemorate the Olympic Games and duly engraved with the Olympic Symbol and special SN. A motorised version of the SL, the SL Mot, was also available. The SL Mot was available only in black finish; it had no delayed action as the motor would run to a maximum of four frames per second. The SL had no mirror lock-up, hence the 21mm f3.4 Super-Angulon could not be used and a new retrofocus model, the 21mm f4 Super-Angulon, was introduced specifically to solve this problem.

143 Hologon

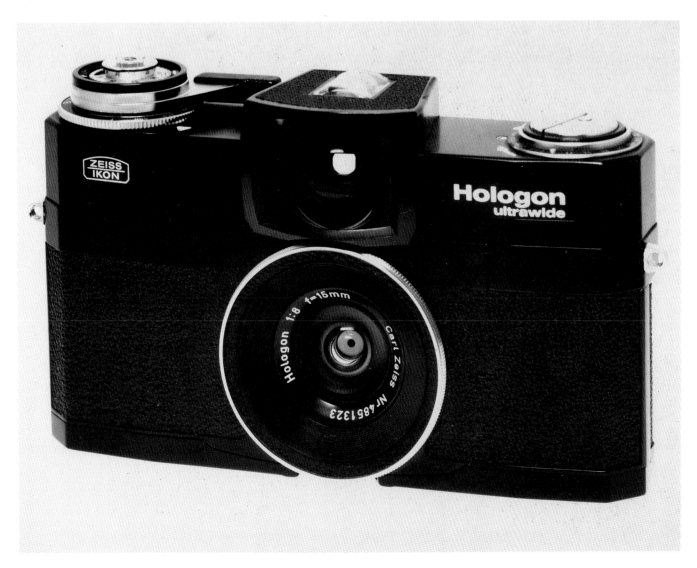

1969-75
SN P76179
Lens 15mm f8, Hologon, SN 4851323 by
Carl Zeiss, Oberkochen
Designed and manufactured by Zeiss
Ikon, Stuttgart

The camera takes its name from its non-removable fixed focus ultra-wide-angle lens, which consists of four elements in three groups and is rectilinear in its performance, *ie* it has no fish-eye tendency. The lens also has a fixed aperture at f8, although its supplied neutral density filter reduces the aperture to f16. The camera has a small built-in 15mm viewfinder with a case level visible from inside the viewfinder. The body style closely resembles that of the Contarex. The camera has a focal plane shutter consisting of a cloth blind travelling horizontally with the speeds of 1 to 1/500 sec, B and T. A specially designed handle enables the camera to be held without fingers obstructing the field of the lens. The camera was much favoured by architectural photographers and was available only in black finish. Less than 1,500 were produced.

It should also be mentioned that Carl Zeiss produced the 15mm f8 Hologon lens in a Leica M mount. This lens was most successful and came with a separate optical viewfinder. The Hologon lens for the Leica was slightly different in that it was possible to focus it.

The Hologon camera, taking thirty-six 24 × 36mm exposures, is the first camera to incorporate such a fixed ultra-wide lens.

144 Minolta SRM

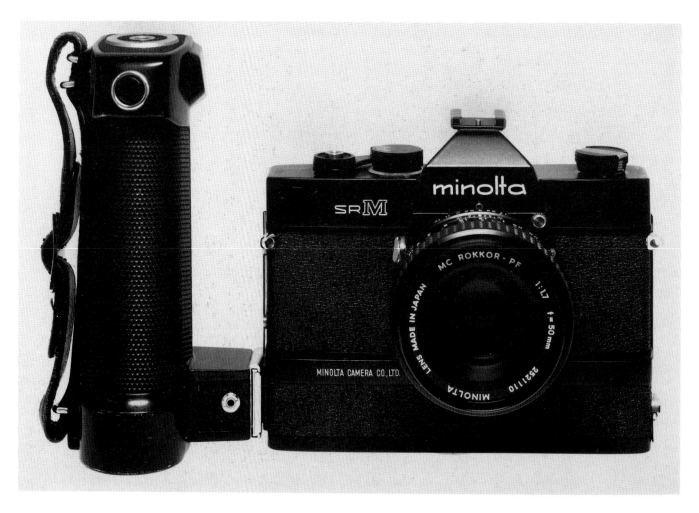

1970
SN 1001056
Lens 50mm f1.7 MC Rokkor-P-F,
SN 251110 by Minolta, Japan
Designed and manufactured by Minolta

The Minolta SRM, a single lens reflex camera for up to thirty-six 24 × 36mm exposures, is the first Minolta SLR to incorporate a built-in motor for exposures at a rate of up to three frames per second. The camera also has a mirror lock-up control which enables the motor to reach up to 3 ½ frames per second. The handle, which is detachable, contains eight 1 ½ volt batteries. This handle therefore has a double use; as a battery container and as a grip. The motor has a cut-off mechanism which limits it to a selected number of exposures.

The focal plane shutter consists of two cloth blinds travelling horizontally and has speeds of T, B and 1 to 1/1000 sec. The camera has a bayonet mount and the lens focuses to 0.5m and stops down to f16. A full range of lenses was available for the Minolta SRM but the camera has no metering system as is common with the early motorised cameras.

The SRM was only available in black. Also available was a 250 exposure accessory back and radio-controlled remote operation equipment.

145 Leica M5

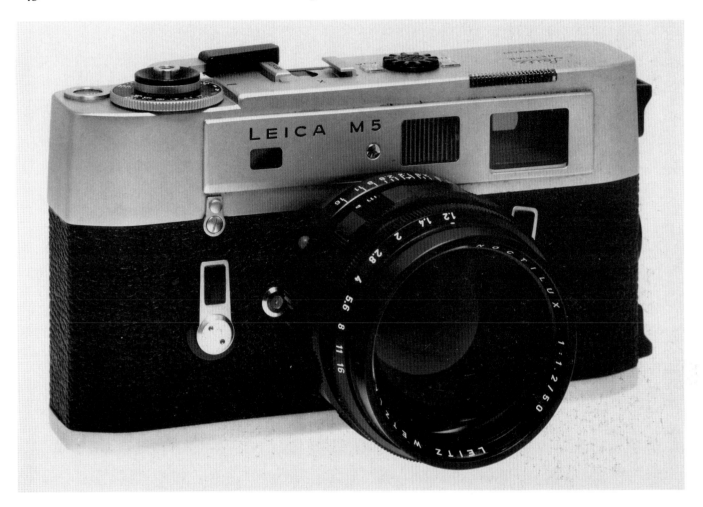

1971-77
SN 1291861
Lens 50mm f1.2 Noctilux, SN 2556908
by Ernst Leitz, Wetzlar
Designed and manufactured by Ernst
Leitz

This coupled rangefinder camera, for up to thirty-six 24 × 36mm exposures, was the first Leica to incorporate a through-the-lens metering system. The M5 has the same field of view as the M4, *ie* it has 35mm, 50mm, 90mm and 135mm frames but it also incorporates a retractable arm which gives a reading in front of the focal plane. Upon activating the shutter release, the arm, having taken a meter reading, retracts into the upper part of the camera. The M5 is the first Leica M camera to have a substantially different shape, this being due to its metering facility. It is much taller than the other M series cameras and hence it does not have that special Leica M feel. The re-wind lever is incorporated into the base of the camera.

The M5 was a moderately successful design and was first available in chrome and later in an anodised black finish. In 1975 a special version was available in both black anodised and chrome finish to commemorate the fiftieth anniversary of the Leica. Available from 1966 onwards, the six-element Noctilux, initially conceived as a prestige item, nonetheless met with considerable success.

146 Leicaflex SL2

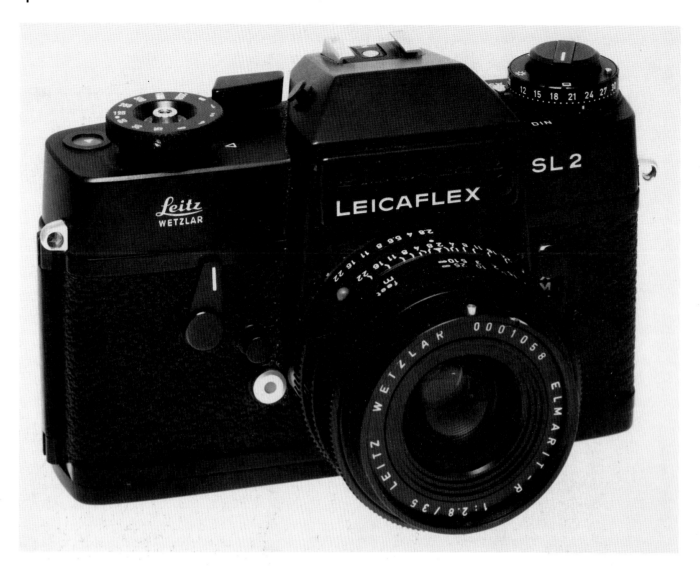

1974-78
SN 1390075
Lens 35mm f2.8 Elmarit-R, SN 0001058
by Ernst Leitz, Wetzlar
Designed and manufactured by Ernst
Leitz

The Leicaflex SL2, a single lens reflex camera for up to thirty-six 24 × 36mm exposures, incorporates a TTL metering system and is a refined version of the SL Leicaflex which it replaces. For the first time both the aperture and the speeds are visible inside the viewfinder and extra illumination is available by pressing the button on the prism. A special battery, located in the prism, powers the light. The meter on the camera is three times more sensitive than that of the Leicaflex.

The 35mm f2.8 Elmarit-R lens is the classic wide-angle lens for the Leitz reflex series of cameras; it is of a seven-element composition. The shutter consists of two cloth blinds travelling horizontally with speeds of B and 1 to 1/2000 sec. The camera was available in either a chrome or a black anodised finish. To commemorate the fiftieth anniversary of the Leica I in 1975 the SL2 was available in both black and chrome with an anniversary logo and special serial numbers.

A motorised version of the SL2 was also available, the SL2 Mot, with a special removable motor enabling it to perform at up to four frames per second. The camera has no delayed action.

Until the introduction of the mechanically shuttered R6 at the October 1988 Photokina, the SL2 was the last mechanically shuttered Leica reflex camera available. It was much favoured by professional users who never really accepted the electronically shuttered R3s, R4s and R5s. The SL2 has been reintroduced by popular demand in the form of the R6. The R6 has a mechanical shutter and a much simpler exposure system than its predecessor, the R5. The R6 is the result of increasing demand for basic mechanical cameras with straightforward metering systems.

147 **Canon F1 High Speed**

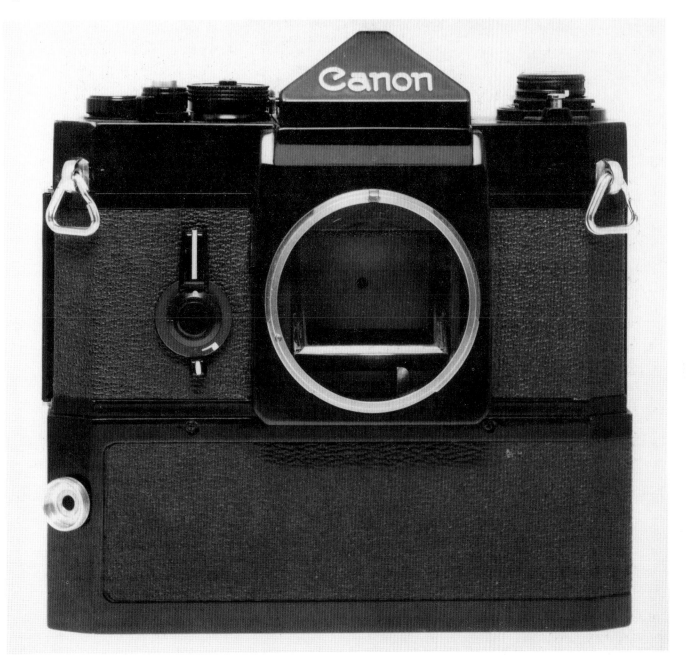

c.1975
SN 100125
Designed and manufactured by Canon
Camera Company, Japan

The Canon F1 High Speed is a special camera for up to thirty-six 24 × 36mm
exposures, a modified F1 incorporating a Pellix mirror, consisting of a pellicule of
semi-silvered plastic membrane. The modified high speed motor actuates the F1
to speeds of up to nine frames per second. The high speed motor requires the
Pellix mirror; a normal mirror could well have jammed at such speeds.

The camera has no winding lever and shutter speeds below 1/60 sec are
blanked off to avoid use of a high speed motor at those speeds. The shutter speed
range is from 1/60 to 1/1000 sec and the two cloth blinds travel horizontally. The
motor, powered by separate battery packs containing ten pencells, has high and
low settings and a counter to select a number of burst shots, avoiding the danger
of ripping the film from the spool. The camera has a bayonet mount and accepts
all f1 lenses.

The camera was introduced for the Lake Placid Olympic Games and was
much used there. Only a handful of such cameras were produced, and they are
very rare.

148 **Red Flag 20**

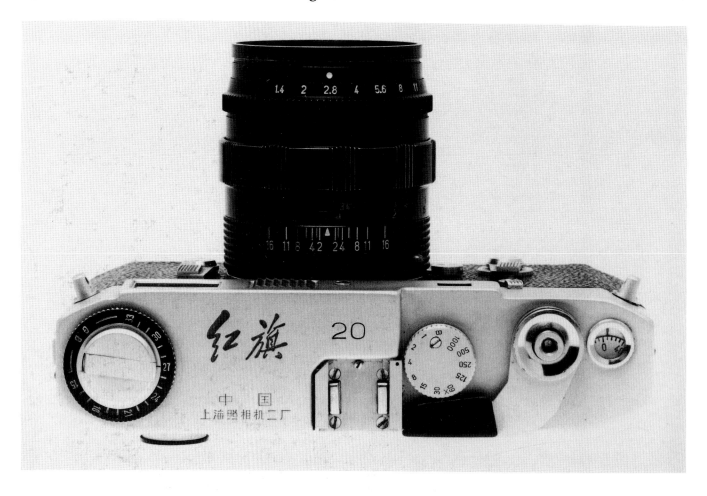

1975
SN 75631
Lens 50mm f1.4, SN 946312
Designed and manufactured by the
Shanghai Camera Factory,
Near Shanghai

The Red Flag 20, a coupled rangefinder camera for up to thirty-six 24 × 36mm exposures, is a Chinese copy of the Leica M5 in shape, but it does not have a metering system. The focal plane shutter consists of two cloth blinds travelling horizontally with speeds of B and 1 to 1/000 sec. The rangefinder combined viewfinder unit has parallax covered frames for the 35mm, 50mm, 90mm and 135mm lenses. The lenses are of a bayonet mount exactly similar to that of the Leica M series. The following lenses were available: 50mm f1.4, 35mm f1.4, 90mm f2.8 and 135mm f2.8. The film advance is by lever wind and the camera incorporates a delayed action.

No more than 200 units would appear to have been produced. The price in 1984 was 4,000 Chinese dollars. Whilst the factory might produce more of these cameras, officials in China explain that the price and the limited number of interchangeable lenses have made sales look doubtful.

The large Shanghai Camera Factory, situated 40km outside Shanghai, employs some 400 people and its main products are the Seagull-based 2 ¼ × 2 ¼in twin lens reflex and the 35mm single lens reflex. The factory also does its own metal cutting, manufactures its optical glass and assembles the camera and lenses. It also produces an obvious copy of the Hasselblad 500C, the 'East Wind', with an 80mm f2.8 lens and a leaf shutter having speeds from 1 to 1/500 sec, and two accessory lenses, the 50mm f4 and the 150mm f4. This camera is not well finished, but the lenses are well produced; however, at some 9,000 Chinese dollars it is expensive.

149

Super Elmar R 15mm f3.5 lens for the Leica R

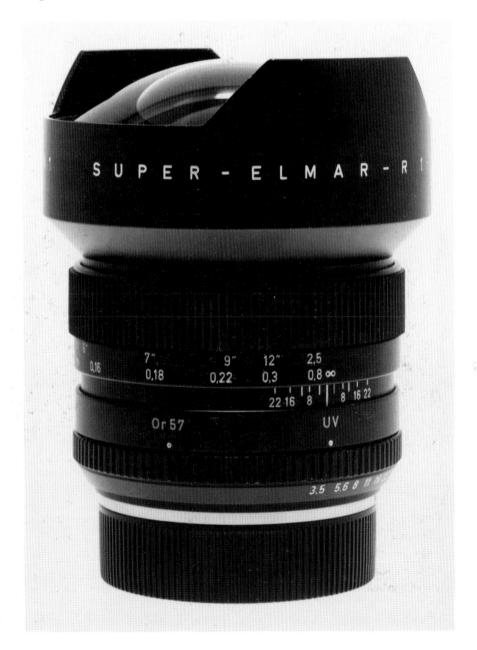

1981 onwards
SN 5175341
Designed by Carl Zeiss, Oberkochen
Manufactured by Leitz Wetzlar

Introduced in 1981 for the Leica R4 reflex camera, this lens is at 110° angle of view, making it the widest Leica lens. It is not only perfectly rectilinear but it also shows no fall-off at the edges, making it an outstanding lens. Its life is a reason for its past and present success.

The lens is in fact a Zeiss Distagon which has been mounted by Leitz. It was designed in 1972 by Carl Zeiss for the Contarex reflex camera, but owing to the early demise of the Contarex the lens did not go into production. However, a few years later the lens went into production as the 15mm f3.5 Distagon for the Yashica Contax RTS camera. In 1981 the same lens appeared in a Leica R mount and was marketed under the lens name of Super Elmar.

The lens is of a complex thirteen-element construction in twelve groups. Floating elements correct the optical aberration. The lens focuses down to 0.16m and stops down to f22. Since its front element is highly curved the lens has a built-in filter turret for UVA, orange, yellow and blue filters.

150

1985 onwards
SN 1668089
Lens 35mm f2 Summicron M,
SN 3307546 by Leitz, Ontario
Designed and manufactured by Ernst
Leitz, Wetzlar

Leica M6

The Leica M6 is a 35mm coupled rangefinder camera for up to thirty-six
24 × 36mm exposures. It has a focal plane shutter consisting of two cloth rubber
blinds travelling horizontally with speeds of B and 1 to 1/1000 sec. The camera
has a built-in rangefinder with fields of view for 28mm, 35mm, 50mm, 75mm,
90mm and 135mm focal length lenses. When a lens is inserted the appropriate
frame appears in the viewfinder. The rangefinder is of the split image version and
its base is sufficiently long, at 49.9mm, for even, accurate focusing with the
135mm lens. The camera is offered in conjunction with the following lenses:

21mm Elmarit M f2.8	50mm Summicron M f2
28mm Elmarit M f2.8	75mm Summilux M f1.4
35mm Summilux M f1.4	90mm Summicron M f2
35mm Summicron M f2	90mm Tele-Elmarit M f2.8
50mm Noctilux M f1	135mm Elmarit M f2.8
50mm Summilux M f1.4	135mm Tele-Elmar M f4

The camera has a built-in through-the-lens metering system. In the centre of one
of the blinds there is a small 12mm circle off which the exposure is measured.
The exposure measurement is of the spot variety and consists of approximately
23% of the viewfinder image of the lens in use. The exposure meter is adjusted
by light balance (two LEDs at the bottom edge of the viewfinder image). The meter
is for a film speed range ASA 6 to 6400. The camera is also offered in conjunction
with a Leica Winder M which enables up to three frames per second to be taken.
This is a compact handy winder which replaces the base-plate. The camera was
first offered in black only and more recently in chrome.

The Leica M6 is Leitz's third rangefinder camera offering TTL metering. The
other two are the M5 and the CL. Neither the M5 nor the CL in particular had
the Leica feel and hence they met with only limited success. The M6 however is a
direct descendant of the M3 in shape, and its only weakness is the lack of any
exposure information inside the viewfinder. It is nevertheless a superb instrument
from one of the few remaining classic marques.

In autumn 1989 Leitz produced a special platinum edition of the Leica M6
engraved '150 years of photography, 75 years of Leica photography', taking 1914
as the date of the first Leica in its prototype stage.

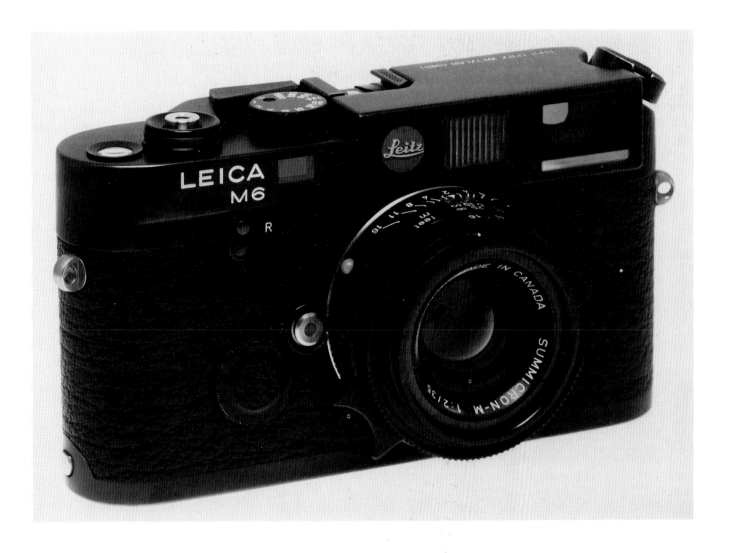

Glossary

Achromatic: a photographic lens is said to be achromatically corrected when the visual image as focused upon the ground glass falls upon the same plane as the different-coloured rays of light that form the impression upon the sensitive surface. Lenses are often achromatically corrected by combining two elements of different refracting powers.

Actinograph: an instrument for estimating the exposure necessary for a photographic plate, invented by Ferdinand Hurter and Vero Driffield.

Albada viewfinder: a viewfinder of the optical variety. The subject is seen life-size, a suspended frame outlining the camera image.

Anastigmat: a lens free from the defect known as 'astigmatism'. An astigmatic lens is unable to render vertical and horizontal lines with the same degree of sharpness. The lack of sharpness is more noticeable towards the edges of the field, the centre being quite free from the defect. Astigmatism may be minimized by the employment of a small aperture, but it cannot be entirely removed. In 1888 in Jena, Ernst Abbe and Jos Schott discovered new glasses that led to an anastigmat lens in 1892.

Angle of view: the angle made by two lines drawn from a lens's angle of emergence (the angle at which the subject emerges from the lens) to the corners of the plate in use.

Aperture: the diameter of a beam of light admitted by a lens, which may or may not coincide with the diameter of the STOP or DIAPHRAGM.

Aplanat: a lens sufficiently well corrected for chromatic and spherical aberrations to define well at a large aperture. The name is usually applied to lenses of the Rapid Rectilinear type.

Apochromatic: a term applied to lenses in which light of more than two colours is brought to a focus. In the ordinary ACHROMATIC construction, the green and yellow rays near the D-line in the spectrum and the violet and blue rays near G are combined; but in the apochromatic lenses the red rays also focus on the same plane. This quality is invaluable for three-colour work.

Autochrome process: a process of screen plate colour photography invented by the Lumière brothers in 1904.

Back focus: a term used to denote the distance between the back surface of a lens and the sensitive plate/focal plane.

Baseboard: the board serving as the foundation of any photographic apparatus, for example the camera itself or an enlarger. Except in studio and process cameras it is generally hinged to the body in order to fold up. The rigidity and stability of the baseboard are of vital importance.

Bayonet mount: a lens mount that locks into one single position, as opposed to a screw mount.

Bellows: the light-tight collapsible connection between the back and front of the camera, usually made of leather or cloth-lined with fabric. Bellows are to be found in different shapes: square/parallel bellows, conical or pyramidal bellows, with or without truncated corners. A bellows with truncated corners has the advantage that it closes in a smaller space.

Binocular: another name, in photographic context, for STEREOSCOPIC.

Box form camera: a non-folding hand camera in the shape of a box; generally of fixed focus, though sometimes there is a focusing adjustment.

Camera: the photographic camera is essentially a light-tight box, having a lens at one end and provided at the other with a device for the insertion and withdrawal of the sensitive plate or film.

Camera lucida: an instrument used for delineating views from nature and for copying drawings. Invented by William Wollaston in 1828, the camera lucida consists of a four-sided prism fixed by a movable joint to an upright rod. The image of the subject is projected onto paper, aiding the operator to trace it.

Camera obscura: also known as a 'dark chamber'. An enclosed space from which light is excluded, and in one wall of which a tiny hole is made through which a small reversed image of the view outside will under favourable circumstances be thrown on the opposite wall. The effect is improved by using a convex lens instead of a hole. The principle of the dark chamber has been employed in a whole building with a hole in the roof, a portable tent with a hole at the apex, and finally a small box form camera.

Dark slide: a light-tight case to hold the sensitive plate or film, always furnished with a shutter or shutters, and made to fit closely at the back of the camera.

Depth of field: a range within which objects are rendered with a satisfactory degree of sharpness. The two chief factors regulating the depth of field are the focal lengths of the lens and the size of the APERTURE or the STOP.

Detective camera: a term used for a camera that does not look obviously like a camera and/or does not necessarily need to be directed at the subject being photographed. Detective cameras have been concealed in watches, canes, guns, spy-glasses and handbags.

Development: a process in which an agent (known as the 'developer') is used to render visible the latent image produced by the action of light upon any sensitive salt.

Diaphragm or Stop: the aperture, fixed or removable, on the front of a single lens and between the combinations of a double lens. The three types of stop most encountered are known as (1) the rotating, (2) the 'Waterhouse' and (3) the iris.

(1) Very cheap lenses and those of obsolete pattern are usually fitted with fixed stops or pierced circles of metal which are let into the core lens tube. Rotating stops are mostly fitted to wide-angle and landscape lenses and are employed in many hand-and-stand cameras. A rotating stop consists of a series of circular holes of various sizes pierced round the margin of a revolving disc fitted to the lens mount.

(2) The Waterhouse stop was invented by John Waterhouse of Halifax in 1858 and consists of a circular aperture cut into a thin piece of sheet metal which is inserted into a slot in the lens mount.

(3) The iris stop consists of a series of curved plates of metal, vulcanite or other material fitted inside the lens tube and attached to a ring on the outside of the lens mount.

Direct finder or viewfinder: a viewfinder in which the view or object to be photographed is inspected direct, the camera being held up to eye-level.

Double extension: a camera is said to be of double extension when its construction allows the racking out of the bellows to be about twice the focal length of the lens that is fitted. Triple extension cameras are also produced.

Doublet: a term used from the late 1840s to denote a double combination lens usually composed of two cemented meniscus lenses.

Dry plate: sheet of glass of a given size coated with gelatin emulsion.

Emulsion: a usually viscous liquid containing light-sensitive salts, with which a plate or film is coated.

Exposure meter: an instrument for ascertaining the necessary duration of exposure when taking a photograph.

Field camera: a camera designed to obtain the maximum of compactness and the minimum of weight consistent with steadiness. In the 'field' a tripod and focusing screen are almost always used.

Film pack: a holder for successively exposing a number of cut films.

Fish-eye camera: a camera with a lens of such an extreme angle of view that the photographs it takes resemble the views that would be seen by the eye of a fish.

Fixed focus camera: a camera in which the relative positions of lens and plate or film are fixed.

Flap shutter: a shutter in which the exposure is made by the rise and fall of a hinged flap.

Focal length: the distance between the centre of a lens and the screen or plate upon which the image of a distant object is sharply depicted.

Focal plane shutter: a shutter that works immediately in front of the plate or film.

Focus: the point at which the rays of light emitted by any luminous body converge after passing through a lens to form the image of such a body.

Focusing: the action of adjusting the extension of the camera or the mount of a lens until the image is sufficiently sharply defined on the ground glass FOCUSING SCREEN.

Focusing scale: a graduated scale or dial fitted on cameras enabling objects at various distances to be focused, by the movement of a pointer, without inspecting the FOCUSING SCREEN.

Focusing screen: the screen upon which the image formed by the camera lens is focused before exposing the plate, in order to secure sharp definition.

Folding camera: any camera made to close by collapsing the bellows and folding the baseboard.

Ground glass: another term for FOCUSING SCREEN.

Hand camera: a camera sufficiently light and portable to be used in the hand instead of on a stand. The box form fixed focus, the box form focusing, the folding hand camera, the folding plate camera and the folding focal plane camera are all examples of hand cameras.

Hand and stand camera: the hand and stand camera is more elaborate than a hand camera and can be used for all types of work either hand held or on a tripod stand.

Infinity: a distance beyond which no adjustment of focus is necessary to secure a sharp image of more distant objects.

Kodak: a trade name so familar that many suppose it to apply to all hand cameras, although it is the registered property of the George Eastman company.

Lens or Objective: photographically, a combination of two or more glasses capable of producing an image. Simple lenses consisting of one piece of glass are occasionally used to obtain special effects, but the single ACHROMATIC combination may be taken as the starting point in the evolution of the modern photographic objective.

Magazine camera: a camera carrying a number of plates or flat films in metal sheaths with provision for exposing them successively.

Meniscus lens: a convexo-concave lens in that both sides of the lens are curved in the same direction, but not necessarily to the same degree.

Panoramic camera: a camera for obtaining panoramic views.

Parallax error: parallax error is noticeable when the outline of the subject given by the viewfinder is different from that which appears on the negative.

Pocket camera: a very small HAND CAMERA.

Printing: the exposing of a sensitive surface in contact with a negative or positive transparency to the action of light.

Rack and pinion: the mechanical device by which the distance between LENS and FOCUSING SCREEN is regulated. It consists of a steel pinion working on a brass track.

Rangefinder: an instrument to measure distance between the FOCAL PLANE and the subject-matter.

Rapid Rectilinear lens: the most popular type of photographic lens until the 1920s.

Reflex camera: a camera in which the image is focused through the taking lens, usually with the aid of a silvered mirror inclined at an angle of 45°.

Repeating back: an arrangement allowing two or more photographs to be obtained on the same plate.

Revolving back: an arrangement whereby the FOCUSING SCREEN or DARK SLIDE may be changed from a vertical to a horizontal position.

Shutter: a mechanical device for exposing the plate. There are many kinds of shutter but they basically fall into the following three categories: those working either behind the lens, in front of the lens or between the lens elements.

Single lens camera: term used in the early days of photography to denote a camera with a simple landscape lens.

Single lens reflex: a term denoting a camera in which the taking lens is also used to view and focus the subject. Not to be confused with a SINGLE LENS CAMERA.

SN: serial number.

Spy camera: a small DETECTIVE CAMERA.

Stereoscopic photography: two distinct photographs of the subject are taken from standpoints corresponding to the position of the two eyes. When these photographs are viewed side by side, a three-dimensional effect appears.

Stop: see DIAPHRAGM.

Swing back: an adjustment by means of which the camera back may be inclined towards or away from the lens. The swing back is used where the camera has to be tilted to include the top of a building and converging verticals have to be rectified.

Swing front: an adjustment in which the camera front is hinged to the BASEBOARD. This movement allows an increase of the DEPTH OF FIELD.

Tailboard camera: a camera which has a hinged BASEBOARD. In the erect position the baseboard is at a 90° angle to the front panel of the camera. In the dismantled position the baseboard is parallel to the front panel, protecting the collapsed BELLOWS.

Taking lens: see VIEWING LENS.

Telephoto lens: a lens giving a higher magnification compared with ordinary lenses.

Time exposure: an exposure sufficiently long to be given by hand as opposed to an instantaneous exposure which is mechanically determined.

Tripod: a raised support for the camera to keep it steady during focusing and exposure. The most popular tripod for field cameras is usually made to fold up, the three legs being strapped together for carrying. The tripods of large studio cameras are usually known as 'stands' because of their massive construction.

Twin lens reflex: a hand camera with a full-size VIEWFINDER, having a lens of the same (or nearly the same) FOCAL LENGTH as that used for taking the photograph. The image is reflected by a fixed mirror inclined at an angle of 45° to a horizontal screen and may be focused up to the moment of exposure. Though bulkier than the SINGLE LENS REFLEX, the twin lens camera has the advantage that the image is always in view.

Viewfinder: an accessory showing the amount of subject included by the lens of a camera.

Viewing lens: in a TWIN LENS REFLEX CAMERA the top lens is the viewing lens and the lower lens is the taking lens. The top lens is used to view and focus, the lower lens for making the exposure. The twin lens reflex is not a true reflex camera like the SINGLE LENS REFLEX, in which viewing, focusing and exposing the sensitive material are effected through the same, unique lens.

Wide angle lens: a lens of short FOCAL LENGTH including a wide ANGLE OF VIEW even at close quarters.

Zoom lens: a lens which is in essence a combination of both a standard WIDE ANGLE and TELEPHOTO LENS in that it can vary its FOCAL LENGTH. Used principally for taking cine-camera pictures from distance to close-up without moving the camera; also used in still cameras.

Chronology

1816 First photochemical (negative) print by Nicéphore Niepce.

1826 First photochemical print on tin and glass.

1829 Partnership between Niepce and Daguerre.

1829 Niepce publishes *Notice sur l'Héliographie*.

1839 7 January: Arago announces the invention of the Daguerreotype to the Academy of Sciences in Paris.

1839 Daguerre publishes *Historique et description des procédés du Daguerréotype et du Diorama*.

1839 Production of the Daguerreotype camera by Alphonse Giroux under the supervision of Daguerre.

1841 Charles Chevalier produces the Photographe à verres combinés [1] and Le Grand Photographe, the first combination lens (for portraits or landscapes) and the first collapsible camera.

1841 William Henry Fox Talbot perfects the calotype.

1851 Frederick Scott-Archer makes public the wet collodion process.

1855 Taupenot invents the dry collodion plate process.

1858 John Harrison Powell's registered design for the collapsible single lens camera built by Horne & Thornwaite [5].

1862 Pantascopic panoramic camera by Johnson & Harrison [7].

1871 Introduction of gelatin silver bromide process by Dr Richard Maddox.

c.1875 Scénographe by Dr Candeze [14].

c.1880 Collapsible bellows wet plate camera by W. W. Rouch [13].

1888 First Kodak camera by George Eastman [43].

1888 Eureka detective camera by W. W. Rouch [15].

1888 Actinograph by Ferdinand Hunter and Vera Driffield [16].

1889 Luzo by J. Robinson [44].

1891 Brin's Patent camera [19].

1893 Kombi by C. Kemper [46].

1896 Cyclographe by Jules Damoizeau [47].

1901 Périphote by Lumière Brothers [48].

1903 Stereo Gaumont [23].

1907 Ticka watch face pocket camera by Houghton [49].

1908 Bijou by Voigtländer [26].

1913 Touriste Multiple by Paul-Diettz [79].

1914 Homeos by Jules Richard [80].

1915 Minigraph by Levy-Roth [81].

1923 The 'O' Series by Ernst Leitz [82].

1923 Sico by Wolfgang Simons [83].

1924 Robin Hill Cloud Camera by R. J. Beck [34].

1925 Leica I by Ernst Leitz [85].

c.1927 Rolleidoscop by Franke & Heidecke [50].

1927 Panoramic No.3A by Kodak [51].
1929 Rolleiflex by Franke & Heidecke.
1930 Leica I Interchangeable by Ernst Leitz [88].
1932 Leica II by Ernst Leitz [90].
1932 Contax I by Zeiss Ikon [91].
1934 Contaflex by Zeiss Ikon [92].
1934 Robot I by Otto Berning [94].
1934 Canon Hansa by Seiki Kogaku [95].
1934 Super Nettel I by Zeiss Ikon [96].
1935 Sport by Gomz [97].
1936 Kine Exakta by Ihagee [56].
c.1936 Coronet Midget by Coronet [57].
1937 Olympic Sonnar by Carl Zeiss [100].
1938 Super Six-20 by Eastman Kodak [59].
1938 Compass by Jaeger Lecoultre [42].
1939 Purma Special by Purma [62].
1947 Six-20 'Brownie' E by Kodak [63].
c.1947 Reid 35mm by Reid & Sigrist [106].
c.1947 Duflex by Gamma [107].
1948 Nikon I by Nippon Kogaku [108].
1950 Wrayflex by Wray [110].
1954 Leica M3 by Ernst Leitz [113].
1954 Periflex I by Corfield [114].
1956 Leica MP by Ernst Leitz [117].
1957 Leica IIIG by Ernst Leitz [118].
1957 Nikon SP by Nippon Kogaku [119].
1958 Rolleiflex T by Franke & Heidecke [68].
1959 Tele-Rolleiflex by Franke & Heidecke [70].
1959 Contarex I by Zeiss-Ikon [126].
c.1959 Tessina L by Concava [128].
1961 Rollei-Wide by Franke & Heidecke [71].
1963 Zoomar by Voigtländer.
1963 Instamatic 100 by Kodak [73].
1964 Calypso by Spirotechnique [132].
1965 Hasselblad 500C by Victor Hasselblad [75].
1967 Olympus Pen FT by Olympus [138].
c.1968 Panophic by Panox [76].
1968 Contarex Super Electronic by Zeiss Ikon [141].
1969 Hologon by Zeiss Ikon [143].
1971 Leica M5 by Ernst Leitz [145].
1985 Leica M6 by Ernst Leitz [150].

Bibliography

Christ, Yvan, *150 ans de photographie française*, Photo-Revue Publications, Paris, 1979.

Coe, Brian, *Cameras from Daguerre to Instant Pictures*, Marshall Cavendish, London, 1978.
– *Kodak Cameras: the first hundred years*, Hove Foto Books, 1988.

Emanuel, W D, and Matheson, Andrew, *Cameras. The Facts*, Focal Press, London and New York, 1960.

Freytag, H, *The Contarex Way*, Focal Press, London, New York, 1961.

Gill, Arthur T, *A Selection of 19th Century British Cameras from the Collection of Paul-Henry van Hasbroeck*, Photo-Historical Publications, London, 1979.

Hasbroeck, Paul-Henry van, *The Leica*, Sotheby's Publications, London, 1983.
– *Leica: the 'M' Series. Volume II*, Photo-Historical Publications, London, 1977.
– *Leica: the Screw Model, Volume I, Part I*, Photo-Historical Publications, London, 1978.

Hicks, Roger, *A History of the 35mm Still Camera*, Focal Press, London and New York, 1984.

Keppler's Chinese Photographic Industry Notebook, published by Modern Photography magazine.

Lecuyer, Raymond, *Histoire de la Photographie*, SNEP–Illustrations, Paris, 1945.

Lemagny, Jean-Claude, and Pouille, André, (eds), *A History of Photography*, Cambridge University Press, 1986.

Lewis, Jch E, *The Periflex Story*, Ericsen Lewis Publications, Norwich, 1983.

Lothrop, Easton S, *A Century of Cameras*, Morgan & Morgan, Dobbs Ferry, New York, 1983.

Lipinski, J, *Miniature and Precision Cameras*, Iliffe and Sons, London, 1956.

Matanle, Ivor and Wright, A Neill, *The Collector's Checklist of Contax and other Zeiss classic Miniature Cameras, lenses and accessories*, Thoroughbred Books, Faversham, 1974.

Rotoloni, Robert, *Nikon Rangefinder Camera*, Hove Foto Books, Hove, 1983.

Smith, R C, *Antique Cameras*, David and Charles, Newton Abbot, Devon, 1975.

Thomas, D B, *The Science Museum Photography Collection*, Her Majesty's Stationery Office, London, 1969.

Willsberger, Johan, *The History of Photography*, Doubleday and Company Inc, New York, 1977.

British Journal of Photography Almanac, 1890-1940.

Photographic Acknowledgements

All the black-and-white photographs represent items from the collection of the author, with the exception of items nos. 50, 56, 79, 80, 95, 97, 101, 102, 103 and 108 which show items from the King Collection. Gratitude is expressed to the King Collection for permission to reproduce these items. The black and white photographs were taken with a Linhof Kardan with a Symmar lens. The majority of them were exposed by the author and processed and printed by Steve Dobson. The remaining black and white photographs were commissioned by the author from Colin Glanfield and Matthew Ward.

The colour illustrations show items in the collection of the author and were exposed by either Colin Glanfield or Matthew Ward.

The photographs of the daguerreotype sample case (p.17) and the Thornton Pickard aerial camera (no.29) are reproduced by kind permission of Christie's South Kensington (Mr Michael Pritchard of that firm was particularly helpful). Both pieces are, however, in the collection of the author.

Index